A KANSAS YEAR

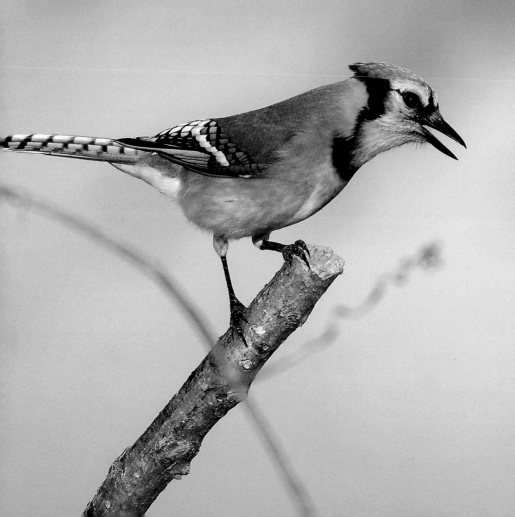

A Kansas

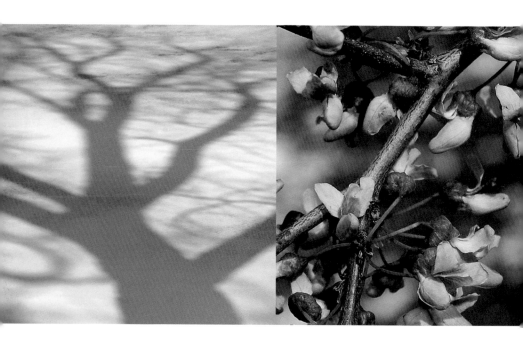

Year

MIKE BLAIR

UNIVERSITY PRESS OF KANSAS

Published by the University Press of Kansas (Lawrence, Kansas 66045), which was organized by the Kansas Board of Regents and is operated and funded by Emporia State University, Fort Hays State University, Kansas State University, Pittsburg State University, the University of Kansas, and Wichita State University

Library of Congress Cataloging-in-Publication Data

Blair, Mike.
 A Kansas year / Mike Blair.
 p. cm.
 ISBN 978-0-7006-1660-2 (cloth : acid-free paper)
 1. Kansas—Pictorial works. 2. Outdoor photography—Kansas. I. Title.
 F682.B65 2009
 917.81'02—dc22 2009006553

British Library Cataloguing-in-Publication Data is available.

Printed in China

10 9 8 7 6 5 4 3 2 1

The paper used in this publication is acid free and meets the minimum requirements of the American National Standard for Permanence of Paper for Printed Library Materials Z39.48-1992.

For my wife, Chris, and my daughters, Jennie
and Kaycie, who always patiently understood my
outdoor wanderings and made them even better
when they came along.

With thanks to our creator...

For by him were all things created, that are in heaven, and that are in earth, visible and invisible, whether they be thrones, or dominions, or principalities, or powers: all things were created by him, and for him: And he is before all things, and by him all things consist.

Colossians 1: 16–17

Contents

Preface

To the calendar-minded, a Kansas year is little more than a span of time. January–December, January–December—the annual trip around Sol checks off dates that keep things tidy in history's stream. But a Kansas year is more than that. Embrace it, and you might come to believe it has a life of its own, flowing in rhythms that adjust and change while maintaining a steady pulse through the seasons. You learn its personality, staying wary for a sudden mood shift, but resting assured that it's dependable in the long run. All in all, you can trust a Kansas year.

Fifty-five have come and gone since I started watching. That makes a difference only to me; a Kansas year is ageless. I started our friendship early, in the way that little boys will explore a honeysuckle copse to find a deer mouse or catch a honeybee. With each new discovery, I wandered a little farther. Magic waited in wild places.

The trail led to a life outdoors, stopping along the way for college where Science explained the whys and wherefores of the natural world. I bought a camera to help record the things I might forget. Through its lens, I saw the world through small windows, focused, sometimes self-explanatory, but always with a challenge to discover. Little by little, I grew familiar with a Kansas year.

I suspect you have, too. It's fun to ride along, watching for passing landmarks as familiar as lines from a favorite song. But it's the constant surprises that keep it fresh, providing new answers and raising new questions. That is the joy of a Kansas year.

Let's see time in a new way. May our calendars turn by the slant of the sun, by the coming and going of all things breathing. May each day be blessed by a secret learned. May our sense of time be transformed by natural cycles.

This orbit, may we all experience a Kansas year.

Mike Blair

Author's Note

This book represents a generic Kansas year. No two are the same, and seasonal events are rarely defined by precise dates. Flowers that bloom in May can often be found in July, depending on local conditions. Unusual weather can alter expected natural schedules. Even so, those attuned to outdoor signs can usually identify a point in a season with fair accuracy.

With this in mind, I've drawn from many years to produce this book. The reader should not be confused if one January entry is shirtsleeve warm, while the next is cold and snowy. The beauty of a Kansas year is found in its diversity, and that's why it's a compelling journey.

Extreme or not, each date is calendar accurate. Added together, these vignettes offer a reliable collage of the state's seasonal progression.

JANUARY

Snow
January 2

The turn of the year should be white and cold. Recent winters have brought warmth to January's first days, more like golden hours when you pick up walnuts in mid-October. But that's not right for the onset of winter.

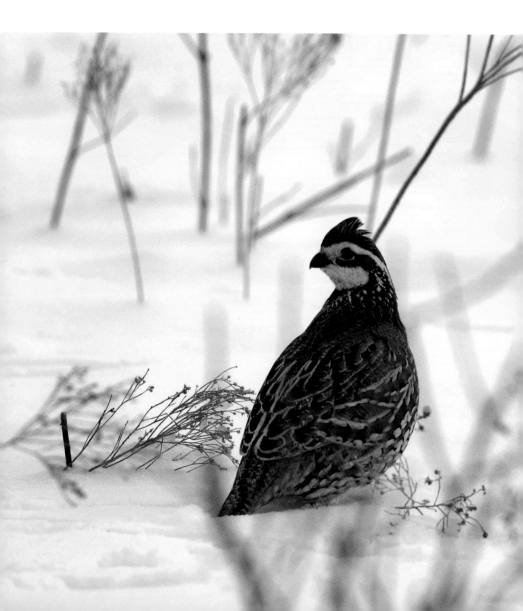

I'll take a heavy snow that settles you by a fire on a long night, and then invites you out next day to follow the first trails of the Wolf Moon. It's quiet in the white powder, shishing along as a cold wind sighs through frosted trees while woodpeckers knock as if asking for shelter. Brittle air stings the eyes, as it should on January 2. It's the start of a new year, and like any good race, who should expect the first steps to be easy?

The soft days, the holidays, are gone. It's time for another long climb that passes through four seasons, and a hike through deep drifts gets you down to business. You see and feel the outdoor world intended by the recent solstice. No shirtsleeves here.

Life must be culled. Come spring, room will be needed for all that is new. Tonight's bitter cold will call some to the long and final sleep. But for all who wake, the path leads on to a distant sun.

Moon Ring
January 4

A ring around the moon adds mystery to the night sky. This eerie sight might occur in any season, but it's probably noticed most often in winter. The ring occurs when cirrus clouds form a uniform layer of ice crystals high in the atmosphere. Each ice crystal has six sides. When moonlight shines through the crystals, it bends in a predictable manner known as refraction. Refracted light appears as a circular band around the moon.

Mathematically, light rays refract to form a halo about 22 degrees wide. The size of the ring is always the same. The dark night sky makes it easy to see. But the ring is a full circle only when the ice layer is uniform. This is uncommon.

A rare winter sight in an infant year starts the new journey in a breathtaking way. Or is it the middle or the end of an annual lap? When gauging by seasons, no date markers exist—just the endless cycle of changing rhythms as life ebbs and flows.

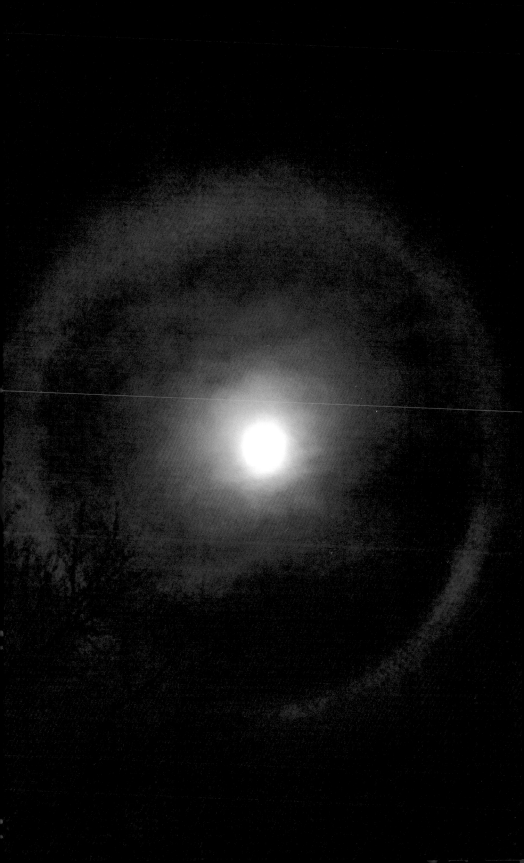

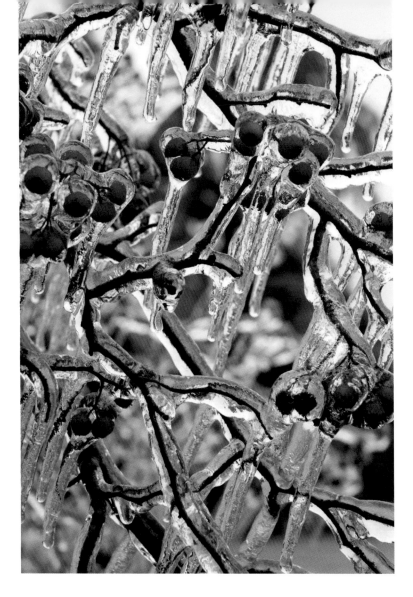

Ice Storm
January 6

The patter of rain is a harrowing sound at 31 degrees. At first it's a nuisance: glaze ice develops, and footsteps slip. Windshield wipers *whump* as slush streaks the smooth glass surface. The radio crackles warnings as low pressure wraps Gulf moisture into cold air. Temperature stalls at the freezing point for a day and night. And the rain keeps pouring down . . .

Ice grows, and trees bend. Everyone goes home to wait out the storm. Seen through windows, the silver sheath of clinging ice transforms the world. The winter day is silent, save the sound of steady rain.

Power fails. Lights snap off, and the gray gloom of filtered light is the only warmth. Outside, the burden is finally too much.

Limbs break with the sound of gunshots, each bringing a fresh wince. The trees! The trees! And still it continues as darkness falls and we slip into restless sleep. Ice and wood crash against the house, startling us to investigate. No breach—but sadness and apprehension build as we wonder what dawn will show. We burrow under the covers, listening and shivering. And it's not from the cold.

Then it's over. Warmth comes, warmth without wind, sparing greater losses had a trailing gale whipped the icy landscape. Now by morning light, we view the beauty and carnage. Ice-encased berries. Jagged, broken trees. Winter wonder . . . and great disappointment.

It's an odd year when January brings an ice storm. But a Kansas year can be like that.

Hungry Hawk
January 10

Red-tailed hawks are among the largest and most visible Kansas raptors. They often perch on power poles along roadways. Redtails are efficient predators of many small animals including rodents, snakes, birds, frogs, and even large insects. Some researchers suggest that individual redtails may develop a taste for a favorite prey, concentrating mostly on that animal when hunting.

Occasionally, redtails may scavenge. This is especially true during harsh weather when hunting is poor. But sometimes, the birds take advantage of free food even in mild conditions. Today,

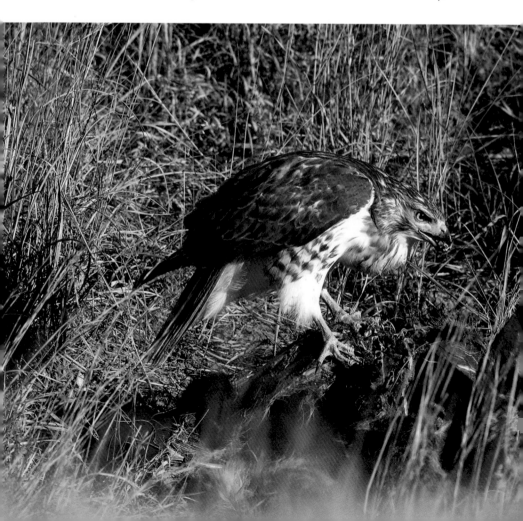

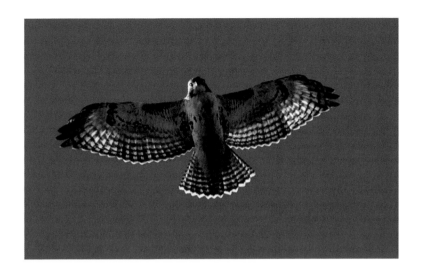

this hawk fed in a ditch on a road-killed buck. Redtails are normally skittish and difficult to approach. But this bird was hungry and ignored me as I moved close to watch it. It ate for some time, pulling bite-sized chunks from the deer's ribcage. It gorged, as evident by its distended crop.

I didn't expect this on a 60-degree day, but that's a common element of outdoor discovery. Each day is a new opportunity, and you never know when you'll encounter the next surprise—such as a redtail on a whitetail on a winter morning.

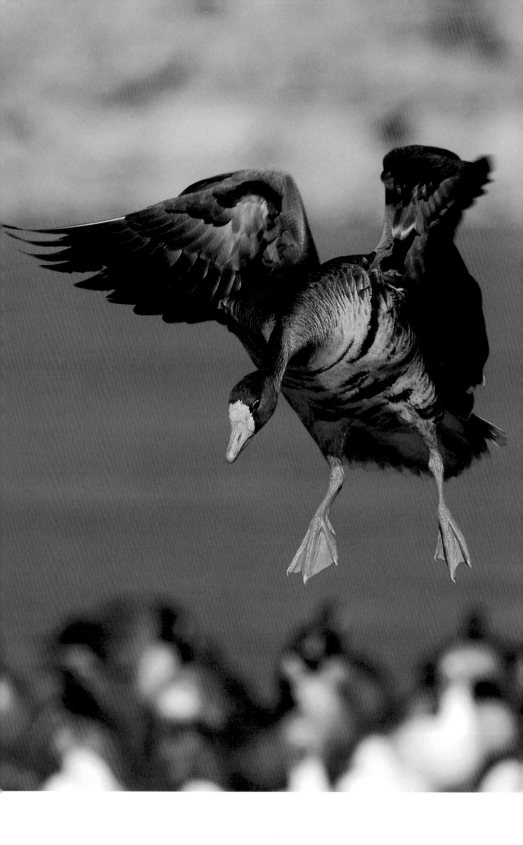

Geese
January 16

A sure sign of January is the daily parade of geese. Thousands
are overhead today, passing in ragged skeins as they return from
feeding. These large waterfowl winter on Kansas' open waters and
grain fields. Geese come here because of the big freeze farther
north.

Three kinds intermingle, living in casual association while
keeping closer ties by family groups and species. Canadas, black-
necked with white chin straps, are most familiar. Over time, these
geese have adapted to midwestern life and are now year-round
residents even in large cities. But snows and whitefronts remain
spirits of the wild north, trademarks of migration and the winter
season. Their assembly, joined by wild and homegrown Canadas in
winter groups, adds a thrilling dimension to the January skies.

It's not just the sight of the flying birds—it's the sounds. The
high, throaty *aa-runks* of talking geese catch attention like a ringing
telephone. We take the call, pausing for a minute to watch the high
Vs on their way to midday waters. And for a moment, life slows
down.

I like the cries of whitefronts. Their distinctive, two-note
laughing calls identify them even by starlight. Also called
specklebellies because of their barred breasts, these dark geese
differ from Canadas by having orange feet and bills. Canadas dress
in black.

I stand at the lake as geese funnel down, trading my lunch for a
look at these northern travelers. A whitefront breaks from its flight,
dropping to the ice nearby. I find it in the lens, feet hanging, wings
braking . . . and capture forever a temporary homecoming.

Nature's Hieroglyphics
January 19

Peel the bark on a fallen limb, and you might be surprised at spidery patterns on the wood surface. These are caused by bark beetles, small insects that spend nearly all of their lives between the bark and hard wood of a tree. Also known as *engravers*, these beetles create the unusual designs through egg-laying and subsequent growth of their young. They often attack weakened or stressed trees that are still alive, and the galleries may in turn support the growth of fungi or other decomposers that hasten the tree's death.

Galleries are orderly. Each begins as a central chamber mined by an adult male or female. After mating, the female lines each side of the burrow with eggs. Hatching beetle larvae mine away from the central chamber. Brood burrows increase in diameter as the larvae grow. Larvae avoid each other as they mine, so that brood burrows do not intersect.

When larvae mature, they pupate at the ends of their burrows and then create "shot holes" in the bark where the adults emerge. Keying on chemical scents released by stressed trees, the adults find new breeding sites and tunnel to repeat the engraving process. Their burrows are seldom noticeable under the bark of healthy trees. However, the evidence is common on fallen limbs and logs in a woodland setting. Barkless wood is often covered with these natural hieroglyphics, a fascinating study of a common but seldom seen group of insects that helps maintain equilibrium in the ever-changing outdoors.

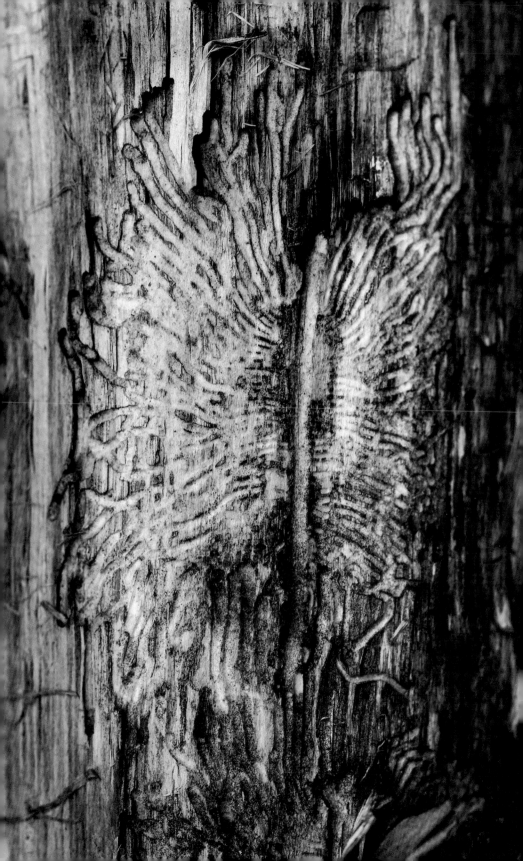

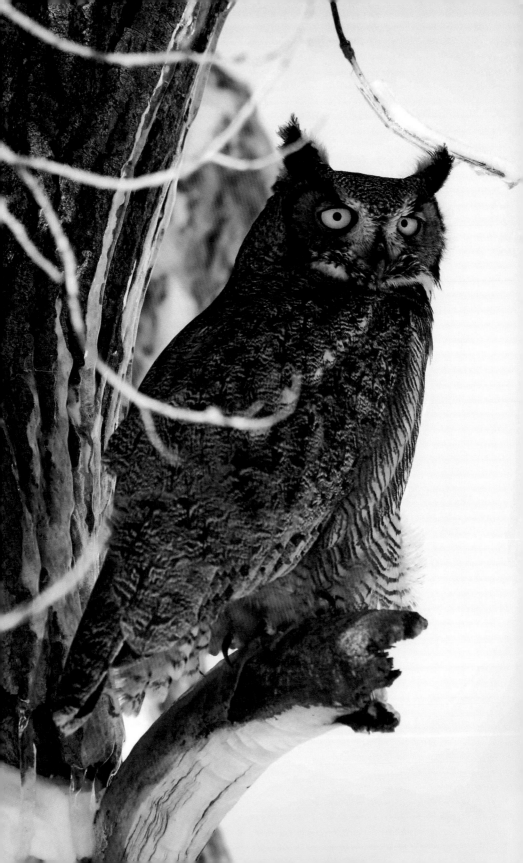

Great Horned Owl
January 21

Woodwind hoots sound from a moonlit tree. You can't see their maker, but the voice belongs to a great horned owl. This fierce raptor with the commonly recognized profile hides in deep shadows during daylight hours. Its feathers blend with tree bark or cedar boughs. It's rare to see it by day.

By night, it's a fearsome hunter. Its nickname is "winged tiger," due to its savage hunting ability. Normal prey includes rodents and rabbits, but larger creatures like great blue herons and wild turkeys are also killed. Great horneds eat most kinds of hawks and owls, reptiles, amphibians, and an assorted animal diet consisting of nearly 300 species. The owl is also a common predator of skunks.

Like all owls, the great horned has unique feathering that muffles sound and allows silent flight. Night vision is keen and aided by sensitive hearing that helps pinpoint prey in darkness. This owl often hunts from perches at dawn and dusk, utilizing twilight and providing occasional glimpses of its secretive life.

Great horned owls are most vocal in January. Males and females hoot to each other, especially around midnight and just before dawn. The owls often begin nesting during this first full month of winter—among the earliest of all birds.

Whether from the bitter cold or the vagaries of the breeding season, today brought a rare opportunity to see a great horned owl in sunlight. Braced against the north wind, this bird let me crunch through snow for a close-up look.

Now, this is the mind's-eye image I'll always see when the haunting hoots of a January night reveal unseen owls in darkness.

Winter Grasslands
January 25

Driving through the Gypsum Hills of southern Kansas today, I was struck by the splendor of this winter scene. Quiet and simple, it didn't command attention, as might Grand Teton peak on a clear day. In fact, I nearly passed the soft ridges before realizing the muted beauty of the morning landscape. I stopped and hiked among the prairie hills.

Tawny grasses sighed. A distant cloud front edged the northern sky, promising a storm and reminding of the season. Cold air caught the vapor of each breath. It felt like winter.

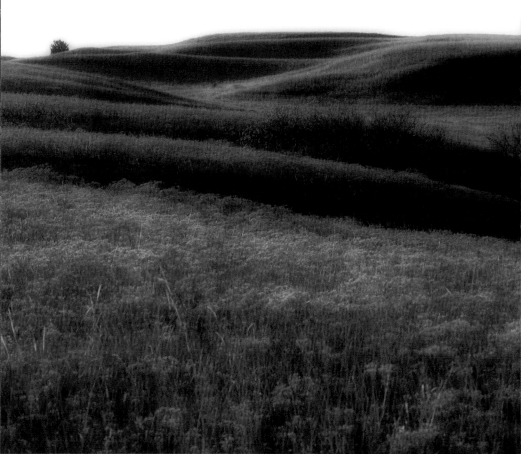

The half-hour walk was a realignment, for entering the winter prairie offers more than a view. You feel the prairie in the touch of the wind and in the coarse grasses brushing against your jeans. You hear it in the grand silence under open sky, broken only by the soft chirps of an unseen meadowlark. You measure its breadth in the long shadows of a low sun while grasses glow in the golden light. These are the things I saw and felt.

And I lived for a moment in a world of peace.

Full Flight
January 28

Waiting is uncomfortable in the spiny plum thicket along the field edge. I sit in shadows, camo-ed up and hoping to see the big white-tailed bucks I've scouted for the past several days. Toward sundown, they always file into the feed from a remote corner along a creek. Antler-shedding time is fast approaching, so I crowd my luck and set up camera gear close to the action. I hope for some great, last-minute pictures before the bucks lose their headgear.

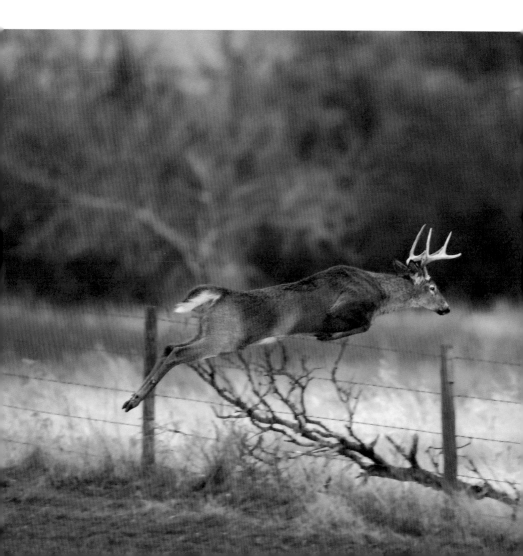

My hiding spot almost works. Half a dozen small bucks come early. Then an older male, already bald from loss of antlers, spots my camouflage tarp and decides that it doesn't belong. He moves within 40 yards, scrutinizing my setup and not liking it. But the other feeding bucks seem happy, and he finally turns and wags away without further warning. Another buck appears at the fence, and I get ready for a parade of big boys that normally hang together. The trophy bucks, older and warier, usually come into the field last.

Not this time. A doe sneaks in from behind. I'm hidden, but she smells me. She snorts, flags, and crashes through the brush, spooking every deer in the open field. The hungry buck, still on the wrong side of the fence, seems annoyed that his dinner will be interrupted. I'm surprised when he jumps into the open wheat field and stands alone for a minute before deciding not to chance it.

The sun shines through clouds as the deer starts for cover. I catch the buck in full flight just as he clears the fence. Few outdoor sights are as graceful as a running deer, spotlit and wild. The moment brightens a winter evening in the waning days of January.

Coon Den
January 31

Driving along a country road this winter morning, I spotted a hole in a cottonwood tree. Something inside the shadowed hollow didn't look quite right, so I drove a safe distance, readied my camera, and turned around.

Pulling quietly into position, I began mouth-calling the sounds of a squalling raccoon. A coon popped into the opening and stuck out its head. It looked sleepy but was curious about the noise. It watched me for 30 seconds, and then another paw emerged from below. There was major jostling as a second raccoon elbowed in for a look. Both animals, sunlight in their eyes, checked me out for a while. Then togetherness turned to annoyance.

The bottom raccoon prodded its partner in the face with a paw, trying to make more room. The top one responded by biting the other's ear, pushing it down until it was out of sight. Finally, both disappeared to resume the morning nap.

It was a warm 30 degrees, and coons were active after a recent cold snap. In harsh conditions, raccoons may enter a drowsy sleep and stay holed up for extended periods. In cold or snowy weather, it's doubtful they would have responded as they did this morning.

But today, it was a fine surprise. The picture I got will always remind me of a winter morning when masked bandits posed at their den—a calendar shot for January.

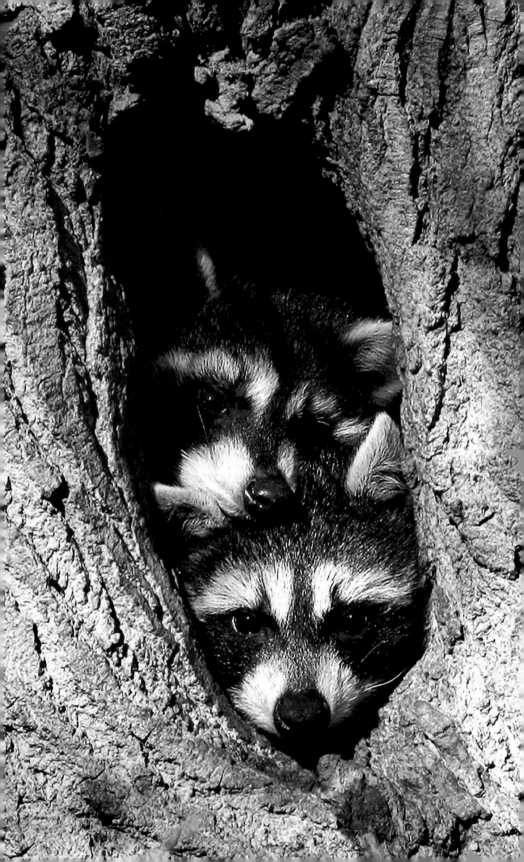

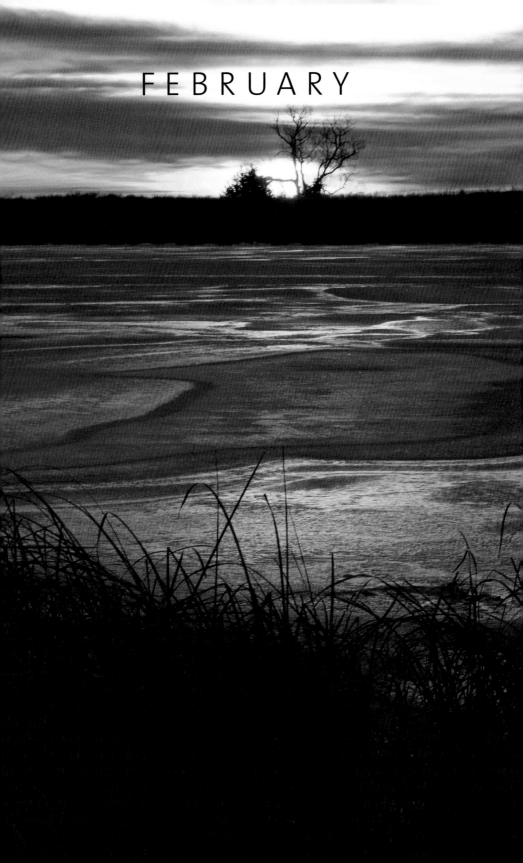

FEBRUARY

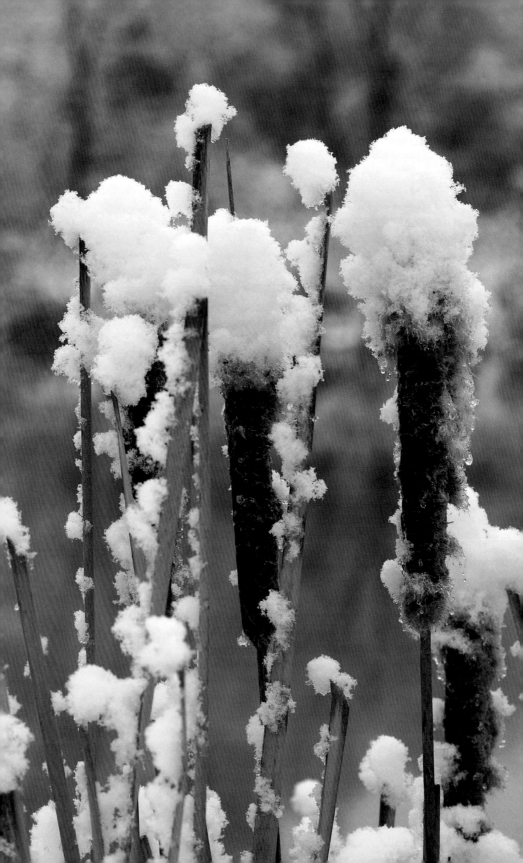

Snowy Cattails
February 1

Vanilla double dips. Limbs that droop with sticky white. Heavy air. Soft, gray ambience. All is calm.

February opens quietly. Boot tracks trail behind in snow. Breathing is the only sound as progress is made around the cattail marsh. Nothing moves. Birds are absent. Trails are covered. I alone am there to see it.

Solitude.

Heavy clouds came by night. They wrung themselves for hours, and then moved on. The world turned deep. The world turned white.

Footsteps sink in a clean blanket. No wind, no drifts. My visit is recorded. The broken line wanders clump to clump, checking all. Tracks will stay until the thaw.

Animals sleep. All were ready. Wildlife fed heavily and nestled into cover. Only later will they venture out.

Silence.

The land is different. The land is strange. The land is beautiful. February has arrived. It touches me, and I, it.

Nuthatch
February 3

Today is a nuthatch day. Unusually warm for February, the woods are quiet as animals enjoy a break from winter. Some years, this date is a cruel test of survival. But today, shirtsleeve weather has squirrels sunning on limbs.

White-breasted nuthatches are in the woods, paired and ready to cry foul. These odd, blue-and-white birds creep headfirst down tree trunks as they hunt for food. They use their spike bills to catch insects found in bark fissures, quite possible on a warm February day like this. The bulk of their winter diet, though, is seeds and grains. They especially like sunflower seeds at bird feeders. Without a heavy bill for cracking shells, a nuthatch must use ingenuity to extract nutmeats. Wedging a seed into tree bark, the bird hammers open the food.

During winter months, nuthatches often join loose groups of feeding titmice and chickadees. All are watchdog species, quick to warn of trouble. Knowing this, I decide to stir some action on an otherwise quiet day.

I stand in shadows and whistle the tremulous call of a screech owl. These small owls are nest predators that represent little threat to agile birds. Even so, many species respond with irritation, mobbing and scolding any such owl with the audacity to call in daytime. I repeat the call again and again.

Minutes later, nuthatches are first in. I hear their nasal *yanks*, and soon they hitch around nearby tree trunks. They move closer, intent on finding the owl. Their own alarm calls hasten other birds. Soon a stream of fliers ranging from wrens to robins appears, and the area buzzes with activity.

Right away, most birds see me and realize the hoax. One by one they leave, but the nuthatches stay. Soon, the plump birds

with dagger bills begin to feed again, politely staying near for observation. And the outing is complete on a nuthatch afternoon.

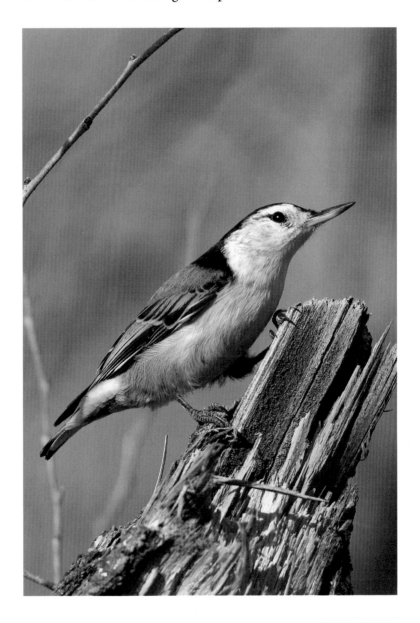

Glorious Sky
February 5

The edge between darkness and light is a wondrous time, especially in dreary February. Acclimated to winter's short days while spring is yet hidden beyond a distant hill, I eagerly accept the gift of dawn. Light comes slowly, painting the eastern horizon at first with a glow, and then, with rising color. Clouds race eastward, riding the wind to reflect red brilliance. And the canvas comes to life.

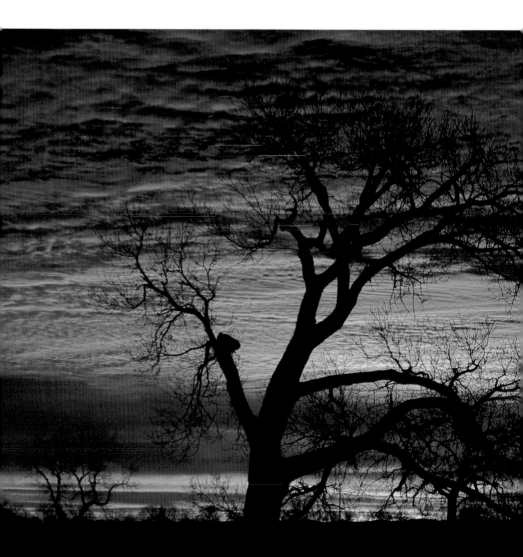

Sunrise is always special, but today, it's glorious. I choose my own subject for the living scene. Along a back highway, a lonely tree appears. The cottonwood, naked in silhouette, is a champion in its sandhills pasture. Rarely attracting attention, today it raises its arms to embrace the orange morning. I stop my car and hurry, crossing the fence and hiking to view the woody giant at a crescendo of light. For a moment, this juncture is the perfect place on Earth.

I turn back into a northwest wind. The cold is invigorating. The day brightens, and the magic spell is lost. Still, it's a new chance to live and work, prompted by a splendid sunrise.

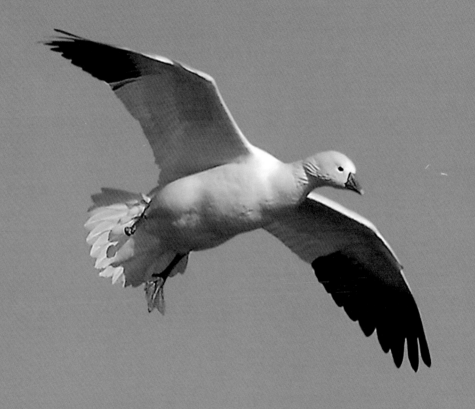

Handicap
February 8

You expect wildlife to be healthy. Wild animals nearly always are, since disease or injury drives them to cover where a quick recuperation is the only alternative to death.

But some wild creatures bear amazing scars. Some overcome a handicap to live a fairly normal life. I've seen white-tailed bucks missing an eye, the result of fighting. The dry sockets were completely healed, and though the deer were blind on one side, they seemed to get along fine. I once watched a female bluebird with a broken and withered foot raise two broods during a summer season. She could barely balance on a twig, but she was tireless in providing food for her young. Likewise, for a time, I kept track of a three-legged coyote that was otherwise healthy. It managed to live normally in spite of its setback.

Today, I saw a snow goose with a clubfoot. Such a handicap would seem to prevent the bird from swimming, walking, or taking flight. Injury? Turtle bite? Birth defect? Whatever, the leg was healed, and the bird performed no differently than its flock mates. Had I not seen the stub as the landing bird wheeled close, I would never have known by its actions. It landed in open water after returning from grain fields, preening, relaxing, and enjoying life.

You have to wonder about the pain and difficulty of adjusting to a handicap without aid. Healing can be hard enough with full care. Wild animals have no such luxuries; they must hunt and feed themselves, even as they recuperate. Sightings like this prove that recoveries occur.

Today's observation shows a common but rarely seen side of nature—a favorable end to hardship.

Leaf Scar
February 11

Details are in the details. Even when you're outdoors and paying attention, it's easy to be overwhelmed by large surroundings. Trees, the backdrop of most living stages, are overhead or over there. Rarely do we touch, climb, or study them. Especially in barren winter, what is there to see? We pass quickly and rob ourselves.

Today I examined a twig. The stout, woody finger identified it as black walnut. A blunt, grayish bud sat at the very tip, waiting to swell and burst in mid-April. Its cap was downy.

Eight inches behind this bud, a ring of faint stripes marked last year's bud scale scar. This showed new growth from the previous spring. A vigorous young walnut in full sunlight and rich soil might show several feet of twig growth in one season. But this tree, nestled among taller rivals and choked by the grassy field, settled for a modest rate.

The twig bore leaf scars. These marked the junctions of last year's leaves. Leaf scars are evident on all trees in shapes and sizes unique to each species. They are often definitive; a naturalist can sometimes identify a tree solely by these features. Such is the case with walnut.

A black walnut leaf scar looks like a monkey face. The heart-shaped boundary shows where the leaf once grasped the twig. Inside it, other tiny scars tell further stories. The "eyes" and "mouth" of the face are vascular bundle scars. These mark the arteries that once carried moisture and food between leaf and roots. Directly above the face, lateral buds wait to form branching twigs. The whole twig is covered with bristly hairs.

Eventually, twigs grow into limbs. Twig features disappear on the older wood. But regardless of tree size, terminal twigs always show the unique characteristics of their species—even at the top of 100-foot giants. Barren February revealed these secrets.

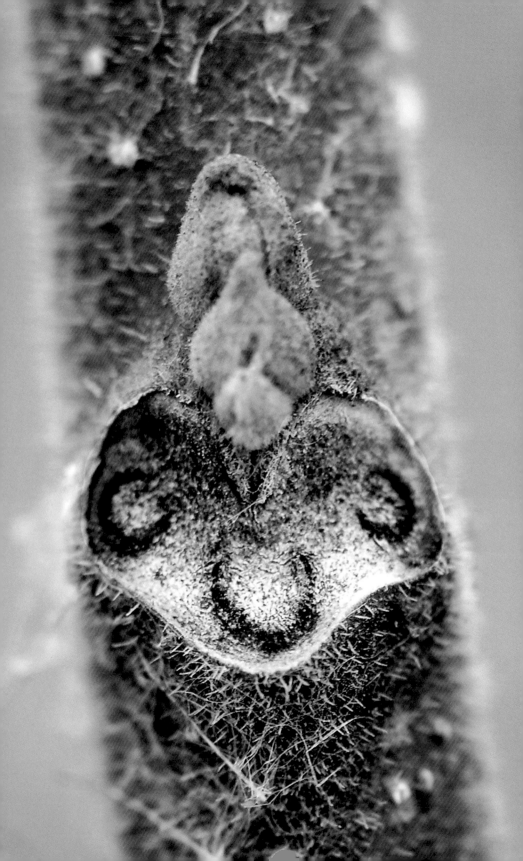

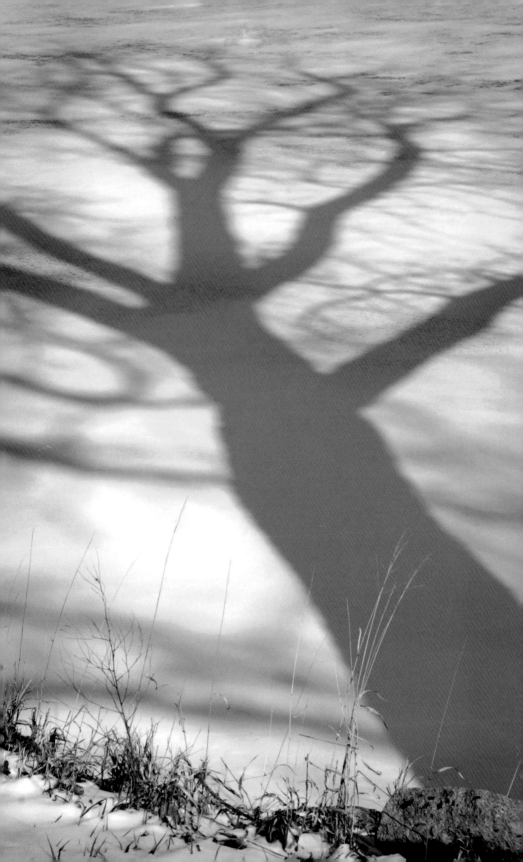

Shadow
February 14

Art appeared on the ice today. It was the *so-what* variety to those in a hurry—something you might not notice. But it was there, a natural drawing that could be unique to a single day in a calendar year. Changing as the day progressed, the earthy portrait helped to journal the season.

I stopped and studied the abstract shadow on a winter canvas. Softer than the tree that cast it, its murky outline traced the white, solid surface. Seldom did hard ice form here. Other days, the tree's shadow was all but invisible on rippled water. Today, the shadow came alive.

Its painter was the sun. Often, bitter storms leave scudding clouds that dim the source of light. Not today. Sure, this sunny aftermath could reoccur tomorrow or next December—but maybe not. The simple shadow was the product of conditions just right, seldom repeated.

The slanted light said *winter*. The shadow held no ground-hog promise, and I inferred nothing but what it offered—a natural artwork sliding eastward on a February evening.

Ice Crystals
February 16

Air temperatures near zero degrees create beautiful miniature ice sculptures—even on ice itself. Today as I explored along a winter stream, I was struck by the geometry of rime ice on the stream's frozen surface. Turkey Creek in Barber County has a fast, narrow channel, and its quick current will not freeze.

However, edge and backwater areas can have substantial surface ice that ranges from milky to clear, depending on eddy and aeration. As live currents play along this ice, water droplets splash and land on the icy surface. Frigid air and a frozen substrate cause rime shards to form instantly. In this case, the droplets created linear, feathery crystals that made interesting patterns near the flowing water.

I studied the shapes for some time. Engaged in nature's designs, I was in no hurry. That's a great value of being outdoors—you trade the alarm clock for the life-clock.

Winter is at full stride now, and it's not surprising to be in the deep freeze. Even so, February is starting to flirt with warmth, and garden time is just around the corner. Me? I'm glad to be sliding along a frozen creek, following the trail of Jack Frost. Rarely do you see such white jewels on blue ice.

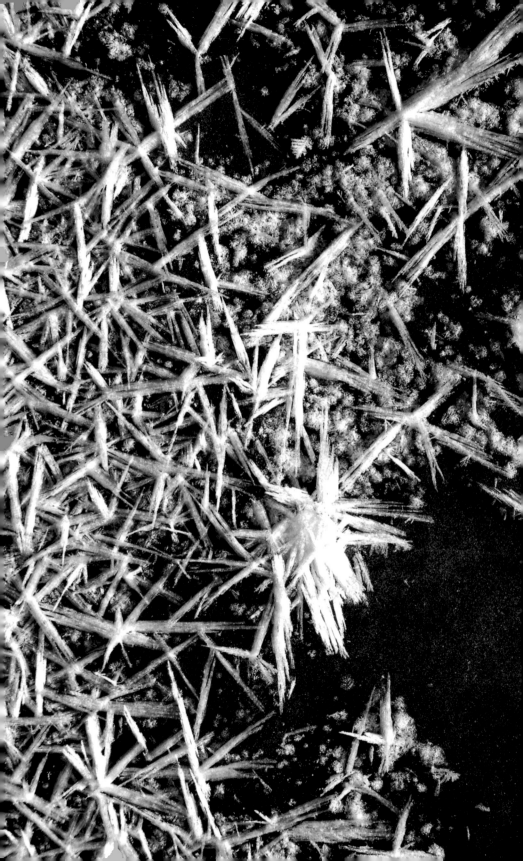

Eagle Joust
February 22

Five bald eagles sit on an ice floe drifting across an open cove. Warm air relieves the recent freeze, and the large raptors gather to eat dead shad imbedded in the ice. Although swimming waterfowl respect the powerful eagles as predators, they show little fear of the lumbering giants in their earth-bound state. Ducks can easily out-climb and out-fly the eagles from a standing start.

The same is true for crows. These black scavengers, among the smartest and most agile large birds, crowd close and pester the eagles for sheer sport. Walking close, jeering and cawing, they waddle across the ice, daring an eagle to leave a scrap of fish unguarded. The eagles watch coolly, knowing their aggressors can easily escape if they try to retaliate.

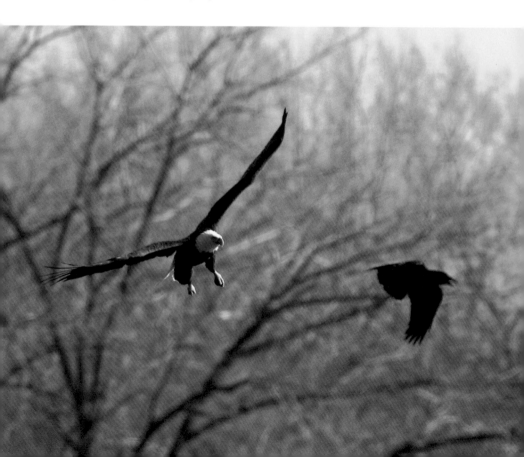

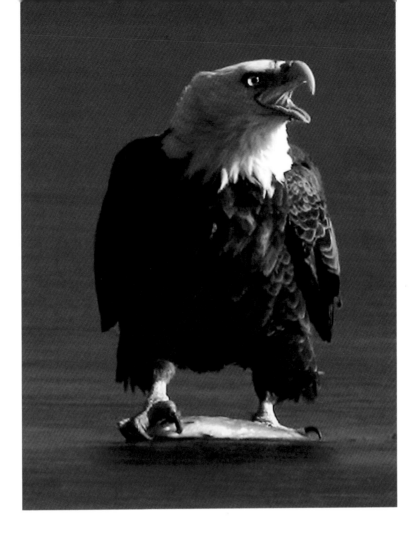

That's on the ground. In the air, it's another matter, especially for a loafing crow caught off guard. Drama erupts when a flying eagle feigns an attack. The eagle drops suddenly on the unsuspecting crow, which panics and flies for its life. The eagle, moving five times faster than its potential victim, simply fakes a strike and then turns away to land. The shrieking crow sprints for cover, quickly realizing the false alarm but taking no further chances.

From above, the eagle has full advantage. The crow was dinner, should the raptor have chosen to pluck it from the air. But shad are plentiful, and the near miss seems a friendly reminder from a taloned hunter to a raucous bandit: "Watch it, dude."

Shed Hunting
February 25

I picked up antlers today. A long walk through barren cover was rewarded with three finds. One was a magnificent, four-point side. I thought I knew every buck in the area, but this antler came from a deer I'd never seen. The wild souvenir, once a fighting weapon but now a cast bone, was a telltale sign of a living ghost.

Every year in winter, male deer lose their antlers. Shortening daylight drives timing, but after that, it's a matter of genetics. The same buck keeps a fairly rigid schedule in antler cycle throughout its life. But deer to deer, there's a wide range in timing. Antlers usually drop between January 1 and mid-March. The biggest typical buck I've

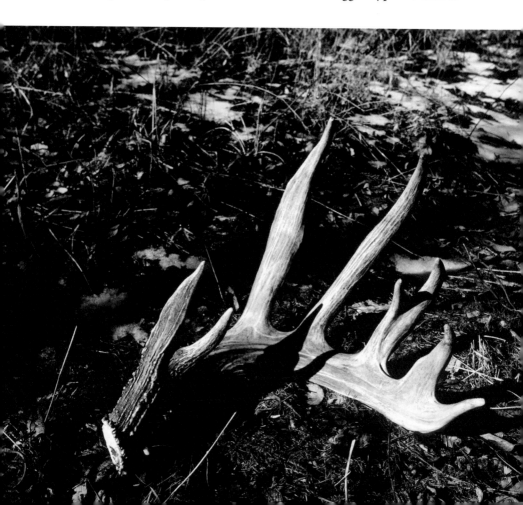

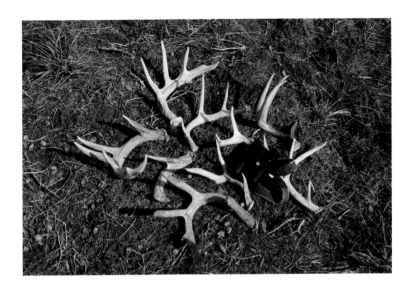

known was also the earliest. Twice, he shed his antlers by December 20.

Both antlers may be cast at the same time, or one might remain in place for days. Antlers fall where they fall—at a fence crossing, on a wheat field, or on a trail. Sometimes, a buck sticks a loosened antler in a hay bale or tree fork and simply backs away.

Hunting cast antlers is a ritual for many. Deer hunters seek shed antlers to verify that a big buck made it through another winter. You can search all day in good habitat without finding one, or you might find a sack full in an hour. Because antlers are bone, they can last indefinitely when stored out of the elements. Bring an antler into your home, and it will make a lasting, natural artwork of immense beauty.

If you're addicted to whitetails, February is another reason to be outdoors. Finding a cast antler is thrilling.

Feeling lucky? A matched set of trophy antlers, the ultimate shed-hunting find, could reward your outing in winter's thin sun. But you have to get out there . . .

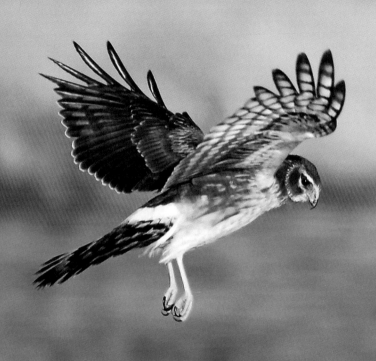

Marsh Hawk
February 28

I sit at Texas Lake on a lonely winter day, learning again the fickle timing of duck migration. Some years, a mild winter calls the birds up early. Then you can miss them as they hurry through in late February. But not this year. Late snows and marching cold fronts delayed the invitation. I hoped for early pintails, but knew better. So I watch the empty water alone.

Wait. There is movement, and a marsh hawk appears. The hunter is tireless as it courses the water's edge. This bird, correctly known as the northern harrier, is most common in Kansas from September through April. It's a slender raptor, best identified by a white rump patch in both males and females. The bird hunts low to the ground with wings held in a shallow V. It is quite agile and able to turn instantly to pounce on prey.

The marsh hawk hunts by sight and sound. Due to its preferred habitat, the sound of prey movement is often pronounced among dry reeds and grasses. The harrier will wheel and dive to investigate anything it hears in thick cover. It eats a variety of amphibians, birds, and mammals up to the size of cottontails. It circles as it hunts, sometimes flying 100 miles a day in a small area.

We pass the afternoon. The light changes on golden grasses as blue water mirrors the sky. A few mallards drop in, but it's really the marsh hawk that makes the hours worthwhile. It never strikes, but passes again and again as it hunts the series of quiet pools.

Will it leave when spring comes? Or will it stay, one of the small group of harriers that ground-nest in Kansas grasslands each year? I'll never know. But for now, we share a day on a winter marsh, hoping for better things to happen on the next pass.

MARCH

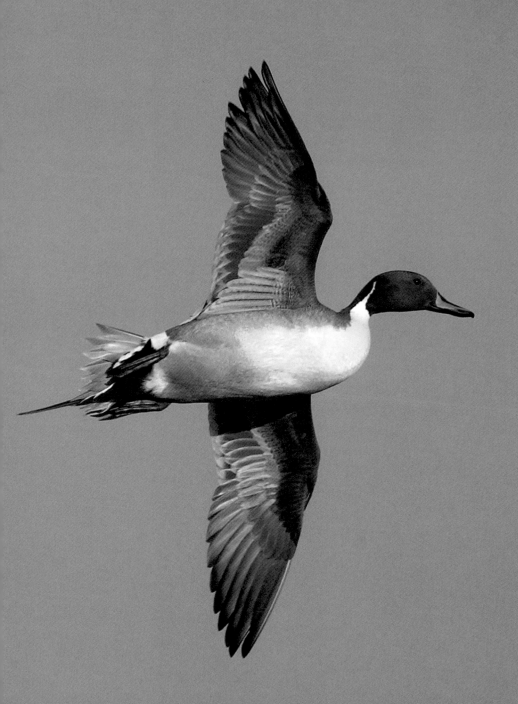

Cardinal
March 2

The sun might hide for days as March rolls around, but you can't fool the male cardinal. Let the temperature climb much above freezing, and a redbird has to sing. It's a guy thing—setting up turf, cruising for women—generally getting ready for spring. Early advertisement may not pay off for a while, but it certainly doesn't hurt. Even birds can hope to get lucky.

The clear notes of a cardinal remind me this morning that winter is near its end. The bird sings early, oblivious to such idiocies as Daylight Savings Time and eight-to-five work schedules. All he knows is, the length of daylight is increasing, and that means nesting season is just around the corner. So he stakes out a territory and defends it. The singing serves a dual purpose. It's a call to the ladies, and a warning to other male cardinals: this zone is occupied.

Even first-year males respond intuitively to longer days. They have a harder time competing, of course, since older bull cardinals claim the best nesting spots early. Mature birds stake out breeding territories of about 50 acres, or a square area about 2.5 city blocks on a side. But it's easy for encroachers to sneak into the peripheries. So the old birds sing and stay on guard.

I step out and whistle back to the calling male: *whi-cheer, cheer, cheer.* The answer comes, and another series brings the redbird into sight. He brings welcome color to the still-dreary landscape. And suddenly, the day feels just a little warmer.

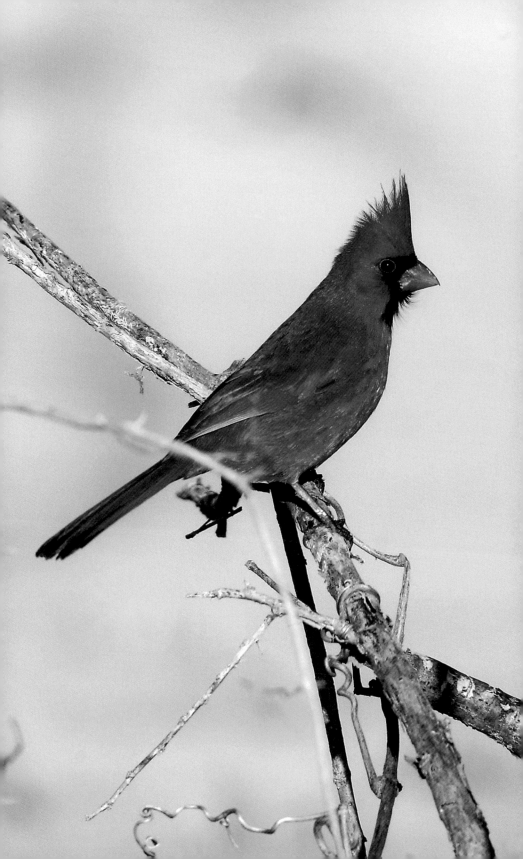

Thaw
March 5

Today's thaw is the sign of a dying season. You can feel the power of the sun now, melting ice with an urgency not felt in winter's earlier warm-ups. This thaw sheds the storm's frozen glaze like a showering rain. A hike in the woods wets you inside and out: your jacket gets soaked from the major thaw, and its protective weight is too much for the warming day. Rain and sweat produce damp clothing.

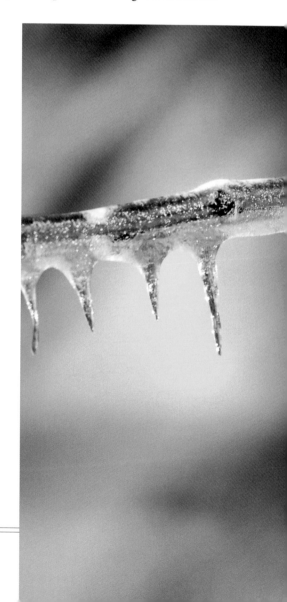

I don't care. My pace along the creek keeps me warm enough, and the only gear I really need is sunglasses. Everywhere are glistening diamonds too bright for unaided eyes. Through coated lenses, the world is simply magic. Ice and water droplets catch laser rays and break them into rainbow colors. For half a day, the woods are a kaleidoscope.

Is this the winter breaker? It could be, as time speeds toward spring. This late storm powered out of the southwest, a common

signature of winter's last invoice. But you never know. Such storms are sometimes double-barreled.

I hike the woods in winter's farewell tears and feel another wondrous moment in a Kansas year.

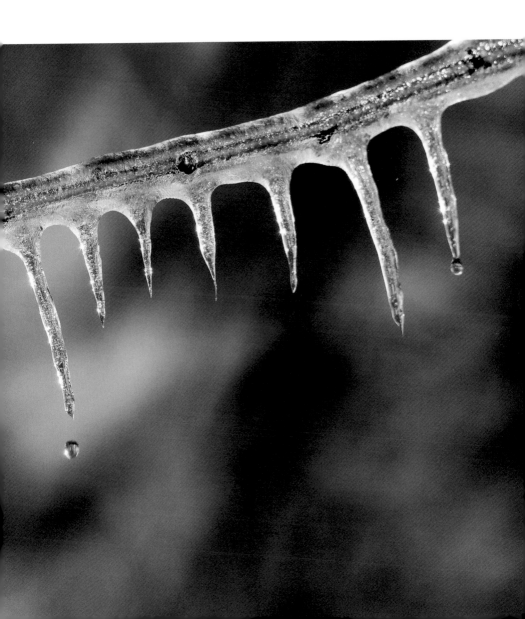

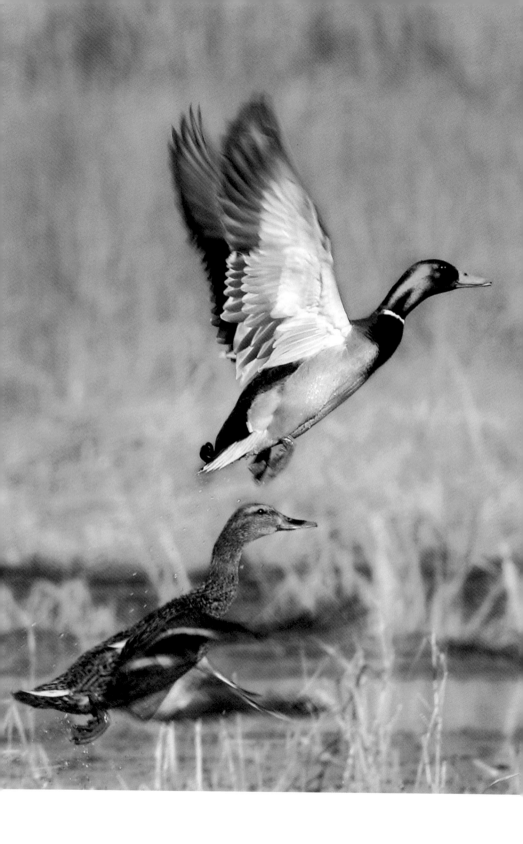

Mallards
March 6

I go each year to the marshlands. Mallards and pintails hurry north for a couple of weeks, and then they're gone. Green-winged teal come too, hardy and ready for the time of renewal. But none tarry in early March.

The later migration is more relaxed. Shovelers, gadwalls, and blue-winged teal arrive near April. Wood ducks appear. Resident mallards hang out. All dally and shop for homes. Some stay, and some move on. April lets you pick your days for observation.

But not early March. This is the whirlwind time for breeding ducks, when big, wild migrants reach for northern places. They come on a south breeze, and if you're lucky, they hit a wall of northern wind to set them down on a local water to wait for better travel weather. They eat and rest. They court. They bring a party atmosphere to the weary landscape. They grace the marsh with duck talk. The sky fills with skeins of flying ducks.

I'm there. I want to see their color. I want to watch them fly. I want to hear the ragged quacks of a mallard hen, suitors in pursuit. I want to feel the pulse of a changing season. I want to hear the heartbeat of March.

Lichens
March 10

A microcosm on a sandstone rock near Kanopolis Reservoir reminds me today that color is not bound by season. Vivid hues befitting an artist's palette adorn the boulder settled among prairie grasses on a canyon rim. The pattern and texture of its roughened surface are interesting enough, but the lavish colors draw instant attention in a tawny landscape. Earthen hues of mustard, rust, slate, and jade wander over the gray stone. As always, nature provides a gift of discovery.

The rock, facing southwest and tilted by random topography, is a perfect solar collector. Sunlight sinks deep to heat the porous stone for long hours on a winter day. Colorful life finds a way to exist on its bare, hard surface.

The color is borne by tiny plants called lichens. Strange growths, these hybrid life forms blend fungi and algae into plant bodies useful to both partners. The fungi, able to absorb trace moisture and minerals while stubbornly clinging to the rock, can't feed themselves on its barren surface. Algae, which can photosynthesize food in sunlight but which lack roots and stability, partner with the fungi to exist on the harsh sandstone. They intertwine in a complicated fashion.

Lichens can live where other plants can't. Their small size and slow growth allow them to occupy high mountain elevations, hot deserts, and frozen arctic conditions. They can survive extreme drought and radiation, shutting down their biochemical activity until favorable conditions return. Even the extremes of a Kansas rock can't kill them.

So here they are, thriving on stored solar warmth at a time when most plants are locked safely in protective buds. Their rich colors reflect different kinds of lichens—mainly crustose and foliose

varieties. Hidden from easy view, they form an important plant component on this difficult niche. Today, they take center stage in my late winter wanderings.

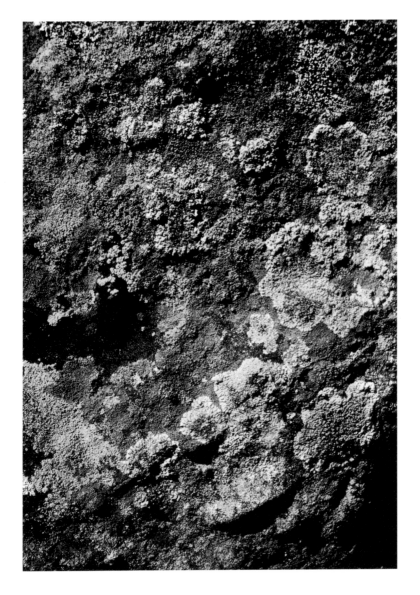

Blackbirds
March 15

Red-winged blackbirds are especially evident now, and they're causing problems at my photo blinds. Redwings and other blackbird species often form huge winter assemblies in cattail marshes—with nearly 4 million birds at some Kansas locations. Blackbirds make daily forays that cover many miles on their two-way travels. Feeding flights undulate across the winter skies like living rivers. The wintering blackbirds generally scatter out to feed, seldom forming congested masses in small areas except at the roost.

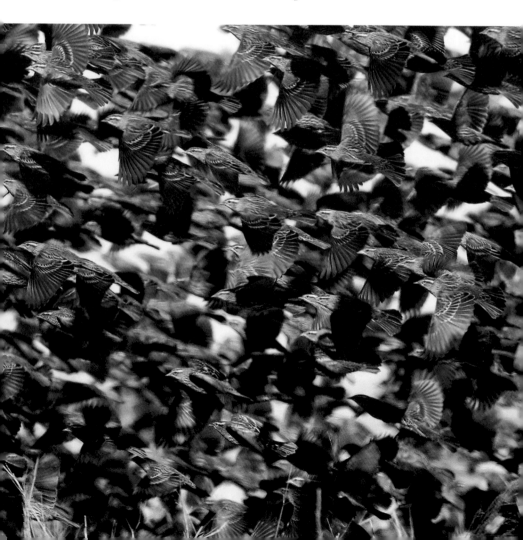

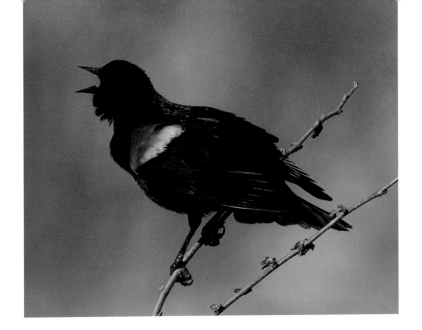

But now, the advent of breeding season brings the first male redwings to the marshes. And this, in turn, causes juvenile males and females to hang out in large congregations near the nesting areas. Huge flocks often form in mid-March. They're bothering my blinds at Texas Lake Wildlife Area now, eating corn and milo bait reserved for pheasants and ducks almost as fast as I can put it out. Worse, the blackbirds are congesting airspace so heavily that they're ruining photo opportunities when ducks drop in.

It's even more frustrating when a huge flock of blackbirds decides to sit in the tree above my blind. Then, a plastic rain suit is needed to keep dry—but I never have one.

Soon, the birds should start to disperse as breeding begins. Then, redwings will be preoccupied and out of the way.

I'm ready. Maybe things will return to normal. Meanwhile, these black clouds are raining on my party—except it's not rain.

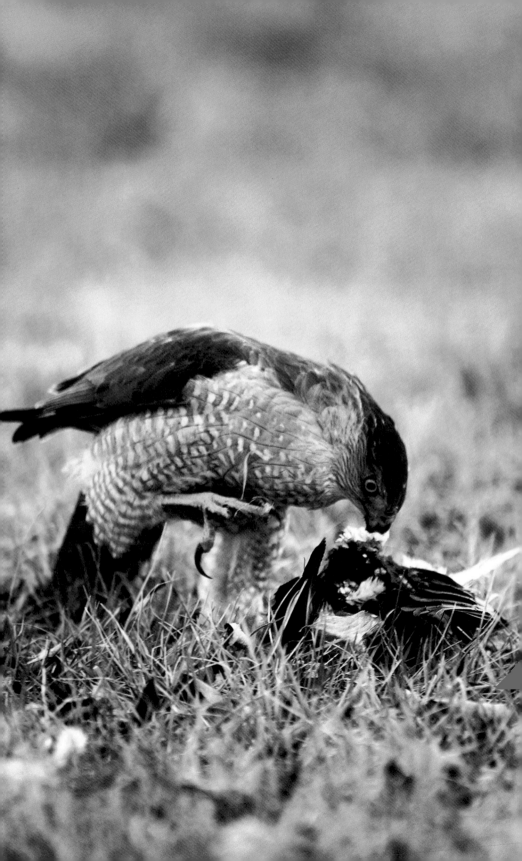

Cooper's Hawk
March 22

Spring began today, in the way that good news arrives about the coming of your first child. Visible signs are some time away, but now you're expecting. That changes everything.

The still-naked landscape was an open window to a March drama. The drab day brought a rare treat in the form of a Cooper's hawk eating a bird. These furtive hawks normally live in shadows, hiding in heavy cover and waiting to pounce on unsuspecting prey. Cooper's hawks are phantoms that seldom provide a glimpse.

If you feed birds, you may know the Cooper's hawk by reputation. Eighty-five percent of its diet is composed of birds. The hawk dashes through thick vegetation, relying on surprise to pick off a victim. Many birds are caught while preoccupied at feeders. A second of carelessness is often the difference between life and death for birds ranging in size from sparrows to pheasants. The aftermath—a litter pile of windblown feathers—is usually the only sign of this hawk's presence.

I admire these red-eyed hunters. Pursuit of sharp-eyed birds has to be among nature's greatest hunting challenges. Fear of sudden attack is why the slightest shadow puts feeding songbirds to instant flight.

So I watched this spring debut with keen interest. The large Cooper's hawk was clearly hungry, ignoring me as I drove close to watch it pluck and eat a pigeon. It was my best photo opportunity for the species in thirty years of wildlife observation. It fed for half an hour, and then carried a torn wing to a distant tree, disappearing once more into the fabric of a Kansas year.

Turkey Tails
March 25

City parks offer valuable local chances to learn about the Kansas
outdoors. Many parks have acres of water, woodlands, and trails.
A half-hour hike on a park path in early spring can do wonders to
shake off the winter blues.

Turkey tail fungi surprised me this afternoon on my trek in a
park. These wafer fruiting bodies covered a fallen log along the
trail. Most plants are understated at this time of year, only because
dormant buds are just now waking. But the handsome turkey tails
drew attention in the spring understory.

Color of this fungus varies by environment, with bands ranging
from blue, to orange, to maroon. A wood decomposer, turkey tail's

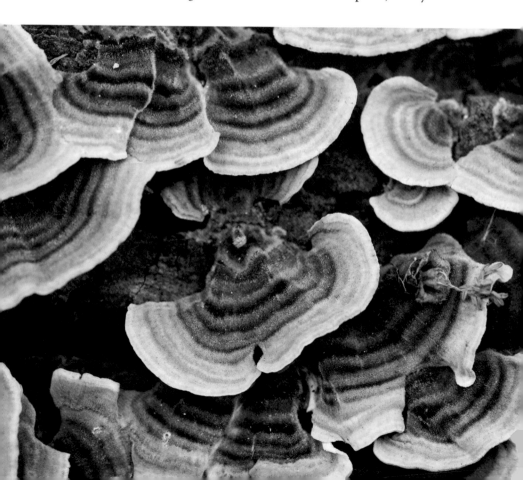

function in nature is to break down dead or dying trees. The fungus causes a white rot as it digests wood's lignin. It returns nutrients and minerals to the forest floor over long periods of time.

Undersides of turkey tail fungi are covered with tiny pores that increase the surface area for bearing spores. Spores, blown about during moist spring months, find other suitable trees on which to grow.

Turkey tails are among the most common woodland fungi. Even so, it's not often that a stump or log is covered with these beautiful plants. Years are needed to build such fungal densities, making this a special find.

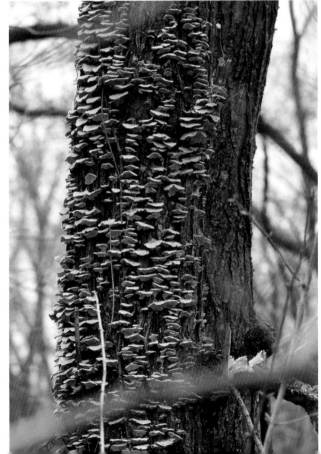

Spring Greening
March 28

One week into a Kansas spring, the woods are only yawning. I'd like them to jump up and shake off winter's drab coat, but they always take their time. I understand; it's hard to wake from a deep sleep.

The land greens from the bottom up. It starts at the forest floor, where soil absorbs increasing sunlight through naked trees overhead. Low, woody shrubs and vines must take advantage. They leaf early, gunning their engines to gather light and food for reproduction before the overhead canopy closes in. After that, they're banished to shade for the rest of the growing season.

It's a fast start in strong light. Leaves open quickly to soak in the energy—light is the catalyst for photosynthesis. Green chlorophyll builds rapidly in the leaves, and then, like magic, manufacturing begins. The simple components of water and carbon dioxide are converted to sugar. Flowering and seeding occur immediately on the flush of this new fuel. When these important functions are complete, the understory plants can idle in summer's shadows.

Today, a green haze clothes the basal forest and hints at spring's lush growth to come. A hike through Kansas timber sets my clock; I am ready for another season.

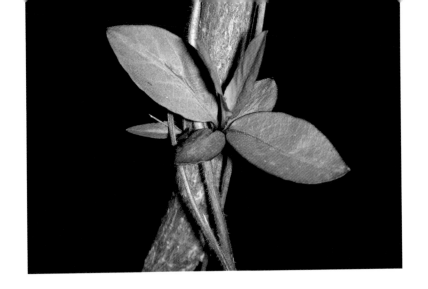

Maple Flowers
March 29

Excitement for spring builds with the first signs of this new season. Today, silver maple blooms along the river, turning treetops a soft coral. For us, it's a promise that green leaves are on the way. For maples, it's a hurry-up process to expand their kind.

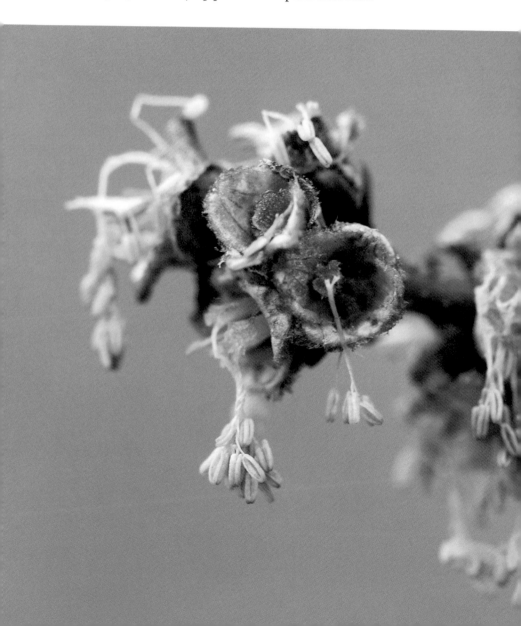

Maples are among the first plants to flower, and there's good reason. Seeds are large, as they must be for trees. Storing and producing reserves for woody seedlings takes extra time. The seeds germinate on bare, moist dirt. For the best chance to grow, they must ripen and land before herbaceous plants choke the soil. So silver maples need an early start.

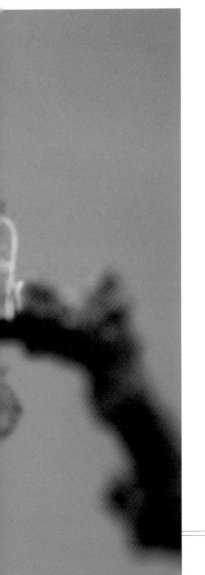

Tree flowers are often ignored, simply because they're *up there.* But they have the same familiar structures as garden species, and many are fragrant. I bend a limb and study the flowers. Small and colorful, they're still forming. Anthers dangle, producing pollen to fertilize ovules within the cups. Development is perfectly timed. When all is ready, male and female bonding will energize new life.

The flowers are best when new and fresh. Rain and wind, cohorts of spring, pound and tatter these fragile structures. Quickly, flower parts litter the ground beneath the trees. But safety is in numbers. Countless flowers ensure that some will seed. The species will live on—thanks to a timeless March production.

Wood Duck
March 31

I went to my wood duck blind today. A quiet hour passed, and then a pair of woodies dropped through the trees and landed with a splash. Suddenly I was looking at one of nature's most colorful birds. Few creatures are as beautiful as a woodie drake in spring breeding plumage.

Wood ducks sneak back into Kansas as March wanes. You won't see them on your local pond or city lake unless old-growth timber lines the water. These handsome birds are tree ducks. They nest in woody cavities they can wrestle away from squirrels. They prefer woody sloughs ruled by mud, muck, and mosquitoes. Their loud *whoo-eeks* at dawn and dusk may be the only signs that they live in boggy haunts nearby.

But they're fairly common if you go looking. A week ago at dusk, I found nine pairs of wood ducks on a small pool ringed by cottonwoods. The birds spend much time feeding and loafing at such places before nesting begins. I put up a small tent blind and waited for good evening light.

This was the day. Golden rays poured in. Wood ducks arrived, pair by pair, until the water was alive. And on the last day of March, I was a small but eager audience.

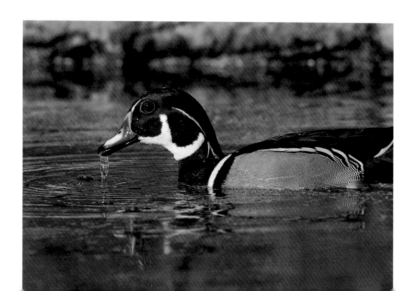

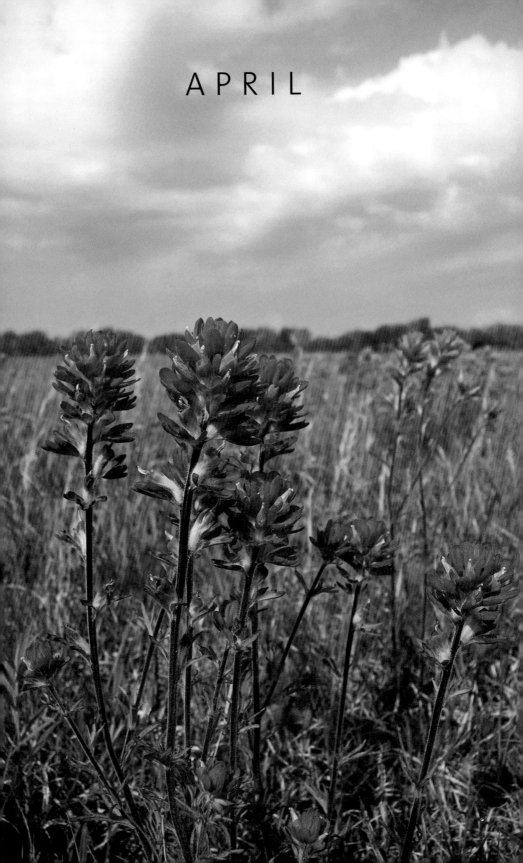

APRIL

Bobcat Crossing
April 1

Ha! Finally got him!

It took six weeks, but today the big bob triggered my remote camera in time to see the elusive creature. Again and again, I'd gotten a partial frame—just enough to identify the subject. Depending on travel direction, I got either a rump shot or a headless cat. Most frustrating was the March night when he crossed in giant, swirling snowflakes. His tracks were clearly visible on the snowy log, and the photo was spectacular—except his head was missing.

From the moment I spotted the natural bridge, I knew it was a perfect bobcat travel way. Bobcats don't like getting wet, and the clear stream was 2 feet deep and too wide to jump. It was a long way to the next crossing in either direction. So I set up a trail camera on an upright limb of the log bridge and recorded a parade of furbearers, wood ducks, and herons. Among them was the bobcat all right—but never the whole animal. The fast, infrared sensor that triggered the camera seldom failed to collect a full image. Raccoon, possum, and coyote pictures almost always came out fine. But the cat was a jinx.

It was a red male bobcat, always the same one. It lived on the creek's other side, crossing occasionally on a hunting foray. The sequence was always the same: cross, hunt for a few hours, and then head back home. Three to five days later, the cat would return. Seven foiled crossings finally convinced me to move the camera.

I set a wooden fence post on the creek bank to provide a sturdy camera support and aimed the sensor at the log's middle. Farther away, there was a better chance to catch the cat in frame. Then I armed the camera and left it for a week. The bobcat finally returned, and this time, the camera caught him perfectly. A month of work paid off, and the bobcat was revealed by the magic of high technology.

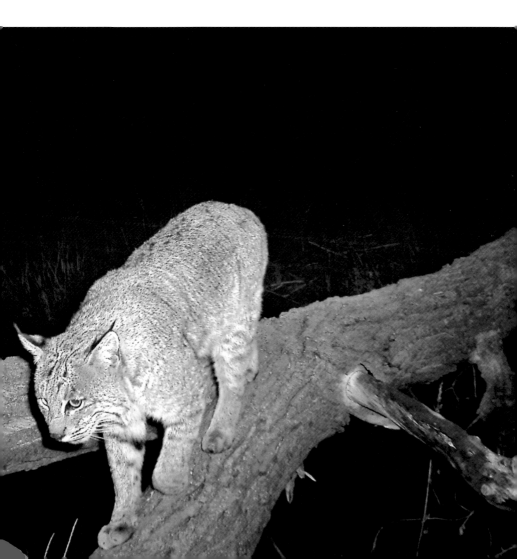

Crawdad
April 3

I hunt with my camera this warm spring night, searching through rain pools for chorus frogs. Breeding frogs and insects gather whenever it rains, racing the drying winds to produce their young.

I see fiery red eyes in the glow of the headlamp. A freshwater crayfish hunts in the shallows. The crawdad ignores my light as it crawls onto the grassy bank. I lie down and watch as it forages along the water's edge.

It is a strange-looking animal with stalked eyes, long antennae, and big pinchers. A hard shell covers the body, and jointed tail segments help it swim. No internal bones are present. Crayfish are more like insects than like higher animals.

The crawdad is big. Nearly 6 inches long, it is heavy and powerful. Snails, insect larvae, and tadpoles are on the menu in or out of water. Algae and some vegetation are eaten, too, but the crawdad prefers meat. An aquatic scavenger, it also eats dead animal matter.

Size suggests this one is several years old—about the full lifespan of Kansas crawdads. It has molted many times. During the first year of life, crawdads molt up to ten times to allow growth. After that, molting occurs less often. Molting is a dangerous time, since for several days, the crawdad is in a soft shell that gradually hardens. It is defenseless during this period.

Not that its defenses are that good anyway. This crawdad's large pinchers look dangerous, but they aren't. Such specimens have pinched me without harm. Fish, herons, wading birds, minks, and raccoons eat crawdads without fear. They may break the pinchers off to make the crawdad easier to swallow.

My close-up lens collects the image. I go my way, and the crawdad goes its own—I, the wiser for this spring encounter.

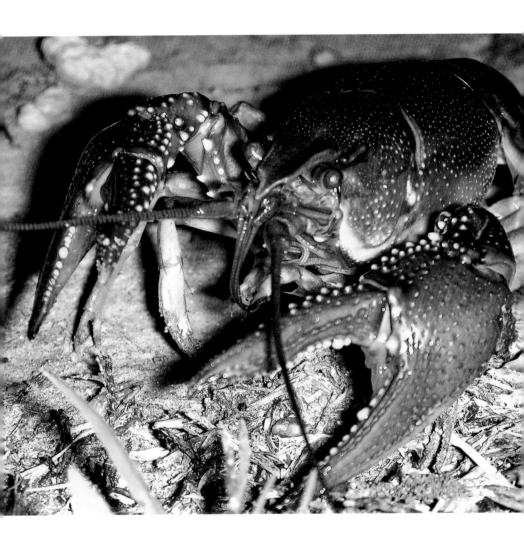

Whooping Cranes
April 9

Heavy fog shrouds the dawn playa. In dim light, I strain to see the large birds I left here at dusk last night. Like ghosts they appear, white phantoms in the misty distance. They wade closer.

Whooping cranes! This rare morning provides a close-up look at a species once nearly extinct. As I watch the adult pair, it's hard to believe that only 16 wild whoopers remained in 1942. Now, through extensive conservation efforts, the wild population

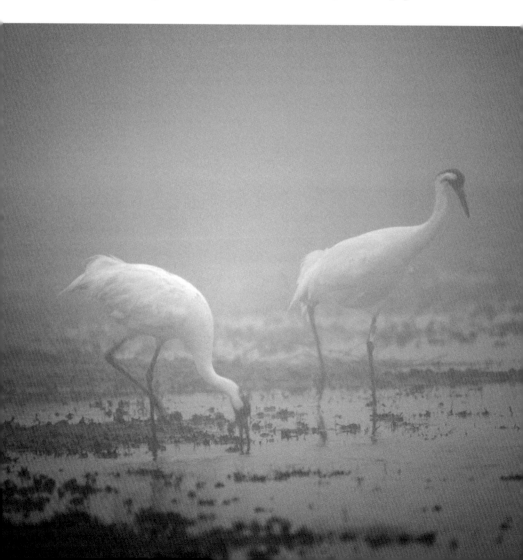

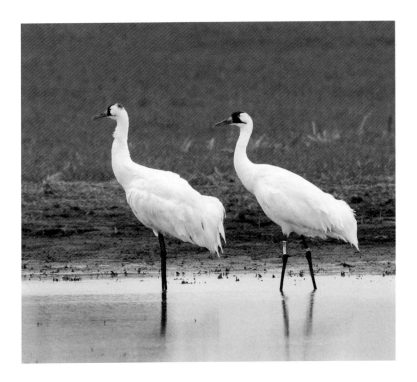

has rebounded to 266 birds. Even so, this close glimpse is the opportunity of a lifetime.

The female is more than twenty years old, according to the band on her leg. Records show she has landed in Kansas only twice during the past five years while migrating back and forth from Canada to Texas. Why the pair chose this small rain pool for a two-day stopover along a Kansas county road is anyone's guess. But it put them within easy reach of my camera. Often, views of migrating whoopers are limited to distant sightings at large marshes like Quivira National Wildlife Refuge or Cheyenne Bottoms Wildlife Area.

As daylight comes on, I film the pair in silver light. They wade and feed without a sound, coming as close as 50 yards. Then with a single guttural note, they lift off and are swallowed by clouds . . . leaving me with a thrilling April memory.

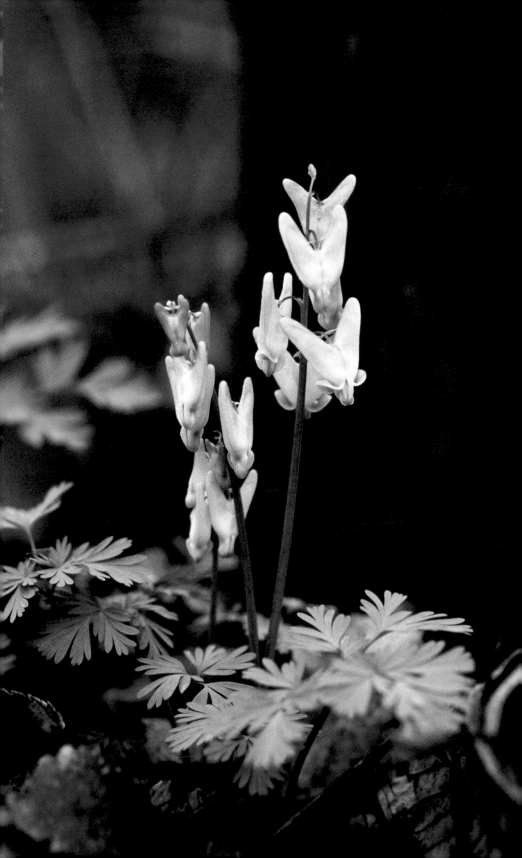

Dutchman's Breeches
April 10

Male birds call to prospective mates. The land is greening. Understory shrubs are clothed, and herbaceous plants push hard for sunlight. The first timid flowers appear in creek bottoms. Rich, moist soil absorbs spring warmth, paying back in color.

Old friends are in the woods. Blue-eyed Marys, trilliums, and anemones grace the trails. And then I see my favorite: Dutchman's breeches. This special plant arises each year from an underground bulb. Flowers are visible for a week or two, and then they disappear for another year.

The common name is easily derived. Flowers look like miniature pants or "breeches" hanging on a clothesline. They are white, or rarely, pink. Foliage is finely divided and soft to the touch. The plants are 6 to 12 inches tall.

Dutchman's breeches have a special symbiosis with ants. The flowers bear seeds with attached fleshy organs called elaiosomes. These organs, full of lipids and proteins, attract ants. Ants carry them to their nest and feed them to larvae. Leftover seeds are then discarded in the ant waste disposal area, where insect waste and dead ants provide fertilizer and protection for germination. New Dutchman's breeches arise.

This process, known as myrmecochory, occurs with a small group of plants worldwide. It helps both the ants and the flowers. The ants get food; the flowers get dispersal. The average distance seeds are carried by ants is less than six feet, so the effective process is slow.

I look for Dutchman's breeches in the eastern third of Kansas. The flowers are found in rich, debris-laden forest settings where moisture is adequate. They're a delightful harbinger of spring.

Redbuds
April 15

Redbuds bloom with the authority of a clock tower chiming twelve: you take note. More than any Kansas outdoor occurrence, blooming redbuds mark the start of the growing season. They're a benchmark on the living calendar.

Redbuds are small, rugged trees that can grow on a variety of soils. They belong to the legume family, and their podlike flowers produce flattened beans. They aren't trees for climbing—they're mostly too small for that—and throughout the year, they're largely inconspicuous. Heart-shaped leaves with smooth edges are their only easy identifier. Trunks are seldom over 12 inches thick. Trees branch low to the ground, forming crowns less than 20 feet tall.

Redbuds are known for their blossoms. Among Kansas' prettiest spring bloomers, redbuds are covered with magenta flowers before their leaves appear. Blooming early, trees appear as purple clouds on barren hillsides or in creekside timber. They're used in windbreak plantings, and they welcome spring to many shelterbelts across western Kansas. Their flowering makes them popular ornamental trees, too.

But more importantly, blooming redbuds are known for what they *mean*. They mean the soil is warm enough to find morels. They mean that white bass are moving up the creeks to spawn. They mean that crappies are moving onto underwater beds. They mean that wild turkeys are starting to nest.

When redbuds bloom, it means that the world is coming alive. No natural sign can be more welcome than that.

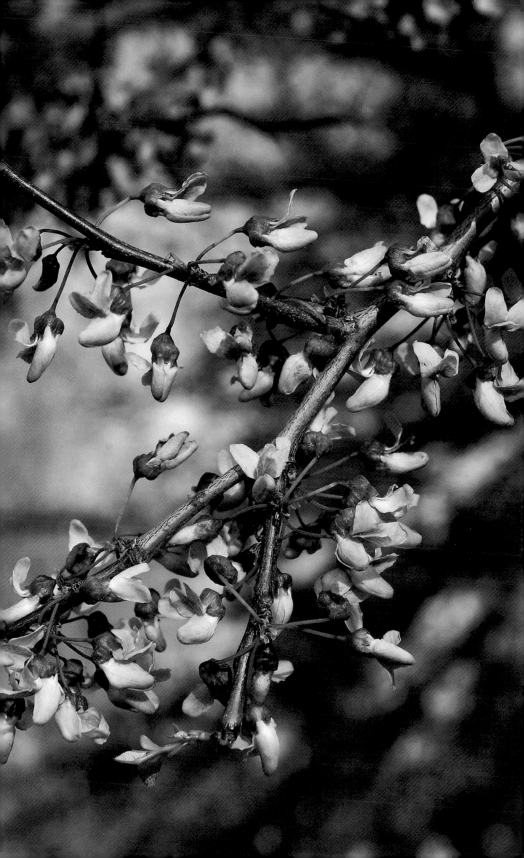

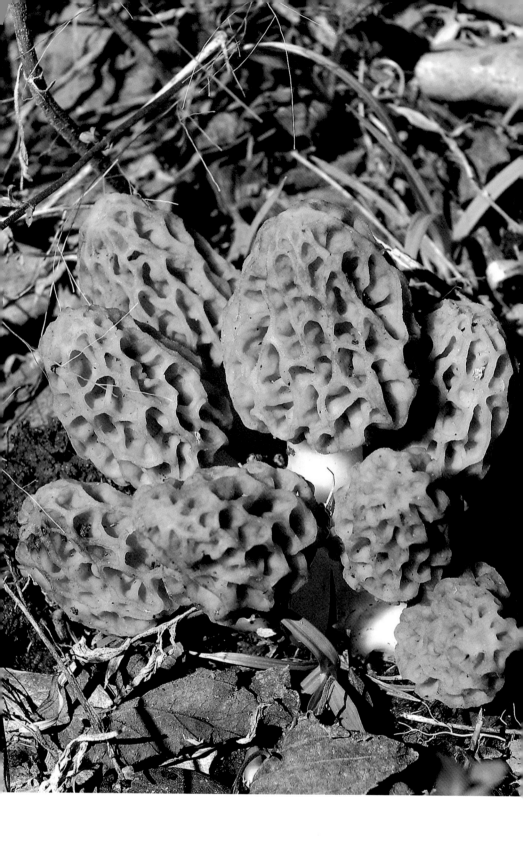

Morels
April 18

Some can't make it through a Kansas year without eating morels. These strange-looking mushrooms are known as "eminently edible" by most book descriptions and by those who hunt them. Trouble is, they're hard to find. They come up in different places and even at different times from year to year. Good morel spots are closely guarded secrets. Some hunters would sooner reveal a personal credit card number than a honey hole for morels.

Morels can often be found in the same general area each year, but not necessarily in the same spots. Hunting them is part of the fun. Warm soil temperature must combine with good rainfall to produce the fruiting heads. They spring up overnight and usually last only a few days before bugs and hot wind render them inedible. Some years, you might not find any. Others, you may cash in on a mother lode of delectable eating. Freezing can preserve excess morels for later use throughout the year.

Today, I got lucky and found a 5-gallon bucketful of these springtime treats. That makes it mid-April on the life-clock. Morels are an annual sign I can bring to the table. So tonight, it's good eating . . .

Willet
April 20

Shorebirds are fair-weather flyers, never in a hurry to crowd cold weather. They come along when temperatures range into the 70s and poke along the Kansas mudflats for days before moving on. Their sewing-machine feeding style makes them interesting to watch. When they first arrive, you can bet the calendar is pushing May.

I sat on a mudflat today and watched a dozen shorebird species feeding together. I sat in plain sight, but I didn't move. They paid me no attention as they fed close by. With binoculars, I watched in detail as dowitchers and sandpipers probed the mud for worms.

By late afternoon, a few willets appeared. These large gray fliers with black-and-white wings commanded attention because of their size. They probed for worms, too, but were capable of much bigger prey.

When a crawdad made the mistake of leaving the water, a willet sprinted over and picked it up. For the next couple of minutes, the bird methodically snapped off each crayfish appendage, starting with the claws. The defenseless crawdad,

finally stripped to a wriggling tube, was swallowed whole. This common but seldom-seen drama was the day's reward for searching out spring secrets in a Kansas year.

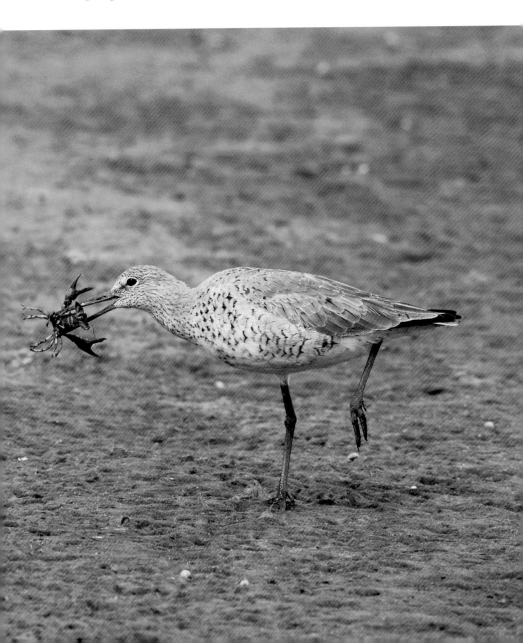

Foxes
April 26

There's a point in late April when the earth can no longer hold red fox kits. At six weeks old, the youngsters have far too much energy to hide underground all day. Now they must wrestle and chase in the sun.

The kits are often easy to view, since foxes tend to den in towns and high-traffic areas shunned by larger coyotes. Coyotes normally kill foxes that compete for food in their rural territories. So foxes move into cities, living along railroad tracks, dump sites, industrial areas, or even golf courses. Adult foxes are crafty, eating thrown-out food or pet food left outside in dishes. They are shy and seldom

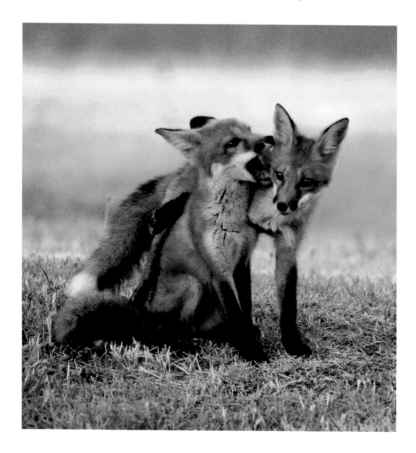

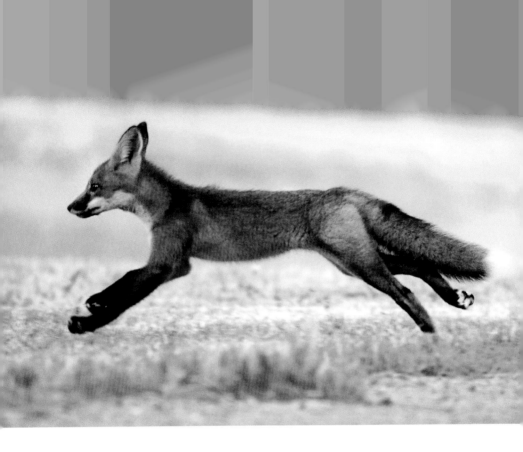

seen in daylight, even though common around human dwellings.

The exception is denning season. Then, parents stay busy feeding their young. Foxes average four to six kits per litter, but they may have up to ten. When kits become active at about five weeks old, they play outside the den several times each day. A bone or a bird wing may serve as a toy, occupying the youngsters for hours. Or they may play "King of the Mountain," rolling and tumbling on the mound or a high point near the den.

By seven weeks old, young foxes start learning to hunt with their parents at night. Gradually, they spend less time playing outside the den and more time resting inside by day. Parents may divide the litter now, splitting them between two den sites that may be a mile or more apart.

The spring outdoors is full of new life. Red foxes are always a special part of the wonder as May approaches.

Falling Blossoms
April 28

Drifts today—drifts of pale pink beneath the fading arms of the crabapples.

How quickly color soared and waned, exploding for a day when golden sunlight raised a conductor's baton after weeks of warm-ups preceded the concert! Perfume heightened the brilliant show of a million blossoms dressed in their finest. As always, it called me out to my yard's hidden lane.

I planted the crabapples twenty years ago. The woody sprigs at first seemed hopelessly small in their airy dimensions. Now, they fill the space and repay me each spring with a glorious display. On the right day, I visit to touch and smell and feel their tidings.

This year was no different. At the appointed time, I closed my eyes and breathed deeply beside the wall of vivid color, thanking God for his infinite imagination and the blessing of living art. As always, I wished the trees were in my daily view. But perhaps the short journey enhanced our special reunion.

Now it's ten days later, and cast-off petals are piled by wind and rain. They lie in drifts, testing my mower in the sparse grass beneath the trees' canopies. Chopped and dried, they return to earth and its endless cycles. I feel a twinge, and then plow through to finish my work and move on, leaving mulched soil, the onset of spring, and hope for the same wondrous color in another year.

Tree Swallows
April 29

Tree swallows arrive on spring migration when normal daytime highs and lows average 72 and 47 degrees. The birds generally reside near large bodies of water where mosquitoes and flies are plentiful. This time of year, insect swarms are common near warming marshes. But a late cold snap caught these swallows by surprise.

Air temperature this morning was 38 degrees in a soft drizzle. These juveniles, as indicated by brown plumage and faint breast streaks, were covered with water droplets and huddling for warmth. Such sights are not common in the bird world, but today's weather called for unusual action. The birds sat shivering together for at least an hour.

Making matters worse, the cold snap grounded any possible insects the birds might hunt. Without food, cold and damp conditions make it difficult to generate body heat. However, birds are resilient. They can usually stand about three days of such conditions before starving. Fortunately, the forecast called for quickly warming temperatures. Insect hatches would soon be in full swing again.

Not all days fit the normal seasonal pattern. But this tough day would be quickly forgotten. It's nature's way. And a Kansas day out of sync with the calendar? It's not so abnormal after all.

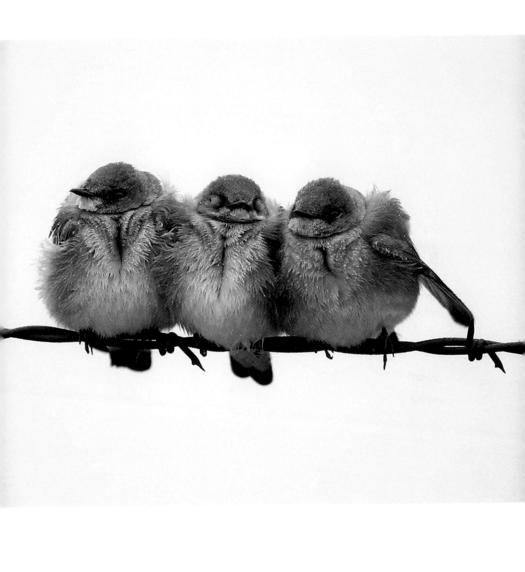

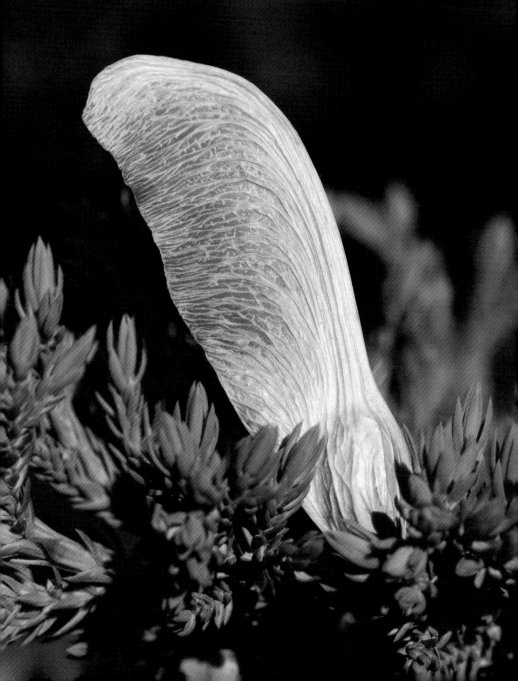

MAY

Ferns
May 1

Today I found a scattering of wild ferns. Rugged hills of Linn County harbored the plants in a forest cove that fell away to the north. Rich soil fed them, while trees and topography provided constant shade. Moisture was better than on harsh slopes facing south. Soil acidity, created by the limestone substrate, was just right.

Like all ferns, these were oddities in a world of higher plants. They had true leaves, but couldn't produce flowers or seeds. They were primitive compared to most midwestern herbs. They had a mysterious look, growing in low bunches with flattened fronds. Due to their lower nature, literature often links ferns to the world of magic and mystique. But I saw no elves or fairies . . .

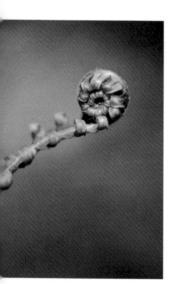

Fern roots are like those of other plants, fibrous and designed to take up moisture and minerals. Fungal attachments known as mycchorizae may be present. These increase the absorptive area of roots in shallow or rocky soils.

Ferns have a unique growth habit. Unlike leaves of higher plants that emerge from buds, fern leaves unroll in a process called circinate vernation. This creates interesting "fiddleheads" on the developing plant. Close up, these beautiful structures are secrets of a Kansas spring. Leaves produce sori on their undersurfaces that appear as ranks of double dots. Spores disperse from sori to create new ferns.

Folklore says that finding a mythical fern flower can lead to hidden treasure. For me, simply finding these rare Kansas plants is treasure enough.

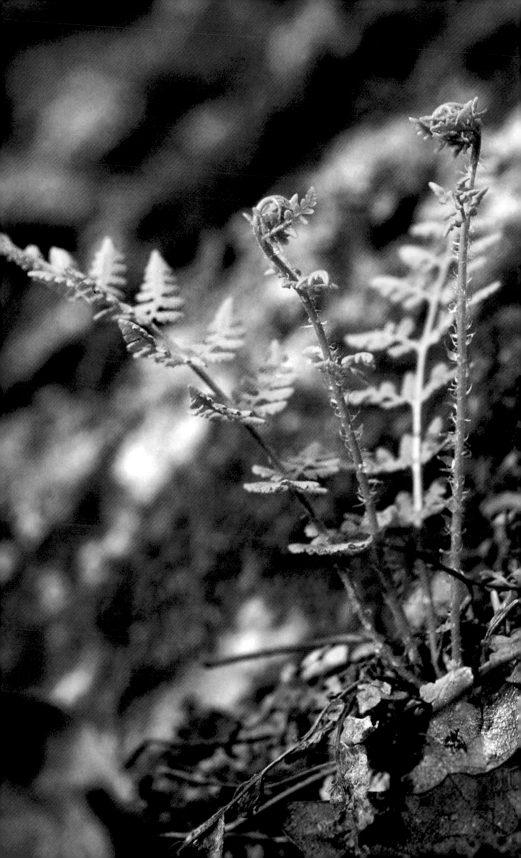

Killdeer Young
May 4

The evening sun shone on a grassy lot. A killdeer writhed as if caught by a snake, wing broken and crying loudly. It was a piteous performance as the bird dragged itself away. If only I had followed . . . but I didn't. The feigning bird finally stood, fluffed its feathers, and scooted away. Its mate approached from nearby, and the healthy pair dismissed the sudden intrusion of my car.

The odd behavior was a sure sign that hatchlings were nearby. Killdeer are famous for a broken-wing act that helps protect their young. Staying just out of harm's way, an adult bird leads potential predators on a merry chase. Then, the "crippled" bird flies lightly away, leaving the intruder confused and headed in the wrong direction. This time, the act backfired. It focused my attention on the small area where the youngsters had to be.

I rolled down the car window and readied a big telephoto lens. The killdeer sallied back and forth, gradually calming and feeding

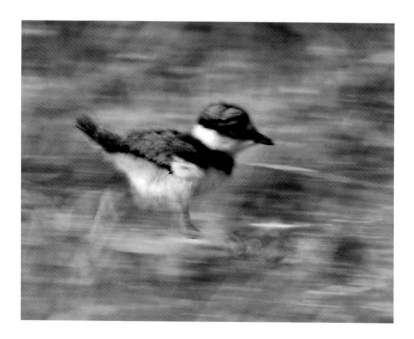

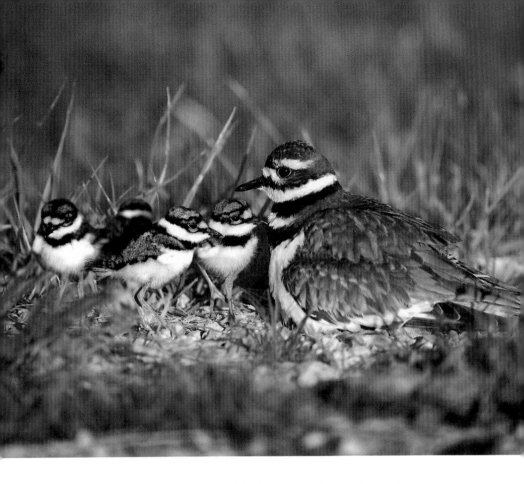

as they went. Tiny puffballs suddenly appeared, and the mother bird waggled her wings. The baby birds ran through grass and dandelions. They were surprisingly fast.

The air was cool in the late afternoon. Many kinds of young birds are confined to nests for several weeks while feathers emerge and they gain strength for flight. Not killdeer. These youngsters hatch and run, though they stay close to momma for warmth and protection.

Now they assembled for brooding. Mother spread her wings, and the four young birds crowded beneath. The parent snuggled down until all were tucked in—warm again, safe again . . . as all should be on the outdoor stage of early May.

Honeybees
May 5

The sound of honeybees once filled the outdoors. When I was a boy, it wasn't uncommon to locate wild hives in hollow trees simply by the hum of thousands of insects returning with nectar. This was an important natural process, since honeybees have always been nature's foremost agents of plant pollination. It's why bees are considered beneficial. They're instrumental in pollinating about 30 percent of all farm and domestic crops, as well as wildflowers, fruits, and plants.

But the sound of honeybees is almost gone. Sadly, mites that first appeared in the United States during the 1980s have exterminated nearly all wild honeybees and 60 percent of domestic hives. Further, a recent mysterious plague that surfaced in 2006, dubbed "colony collapse disorder," has worsened the honeybee decline. Beekeepers can scarcely protect their hives with intensive management; wild bees, having no such intervention, are mostly doomed.

That's why it's a big deal to find a honeybee brood searching for a new hive location. This small swarm rested on a cottonwood sprout at the edge of timbered hills near Independence. I found them swarming yesterday, and they settled and rested overnight. I took the photo in this morning's cool air, before the warm sun aroused flight.

Deep within the mass was a queen. The swarm would soon find a home, where the business of wild bees, however rare these days, would benefit many living things in an infant summer. It was a glimpse of a once-common sight—and a tiny ray of hope for May's flora.

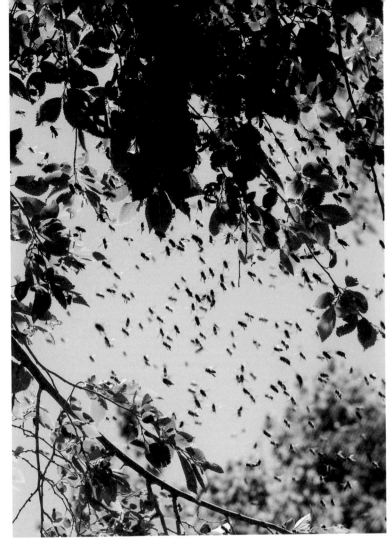
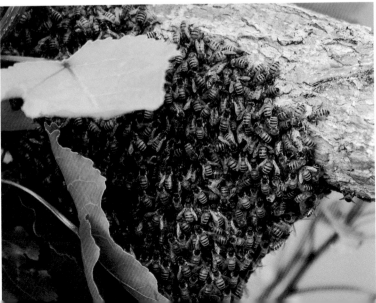

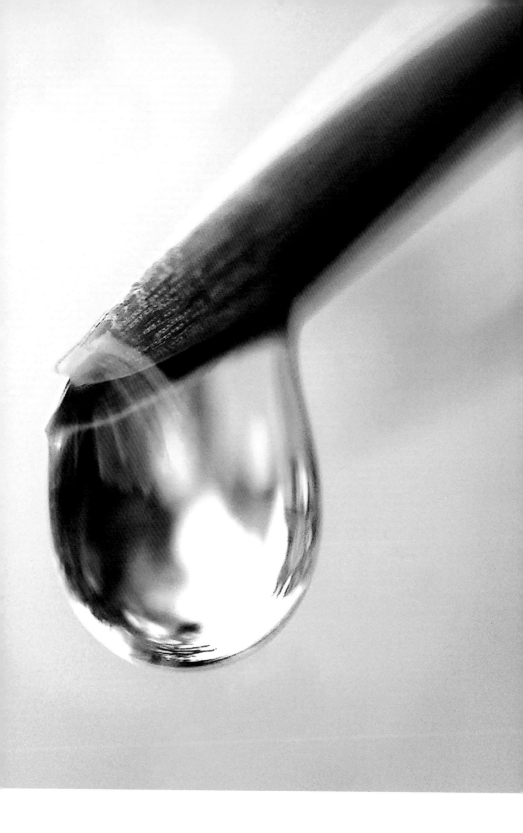

Raindrop
May 7

Rain doesn't come often on this mixed-grass prairie, and when it does, it's mostly with fury. Seldom do soft, prolonged rains come to drip and sigh the earth back to satisfaction. I awoke this morning to a gentle shower that continued through the day. The quiet, heavy air misted spring greenery and calmed all of life to contentment.

The soggy morning was a perfect time to explore the other world, the mirror-image place seen only through tiny lenses that cling to the tips of every wet plant. Hanging raindrops form a window to another universe that exists alongside us. But perspective is a must. The naked eye can barely perceive the other side through a glance at the dripping orbs. You must go closer, closer . . .

The micro-lens of my camera revealed a dimension where no two windows yield the same view. It's a place of green twigs, clouds, trees, and flowers. A place where rich, jumbled hues blend vast surroundings into tiny portholes—upside-down and backward.

You see it at the door of each crystal droplet. But only there. The fine point of focus reveals all. A fraction on either side, and the view is just a hazy blob. It takes patience and a gentle rain.

So I went exploring in my own backyard, looking through natural telescopes whose views were as eerie and exotic as distant worlds in space. I listened to the patter and felt the rain on my skin. A robin sang with ardor in spite of wet conditions, sang as if it also knew . . . there's more than meets the eye.

Night Chorus
May 8

The night was dark and stormy. Radar showed an approaching squall line that might add to pools already in the ditches. It was frog time: 10:30 p.m. Heavy air and lightning promised all-night serenades. I loaded the camera gear and headed into darkness.

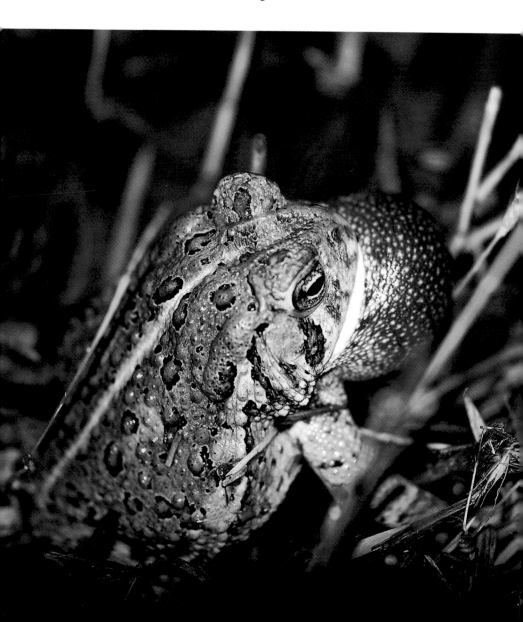

A nearby rain pool hopped with activity. The groans of Woodhouse's toads rang from the shallows, mixed with the creaky-door sounds of western chorus frogs. I powered up my headlamp and walked carefully along the edge. Chorusing frogs pay little attention to a flashlight, but my halogen spotlight was bright enough to stop the music. Heavy footfalls vibrating earth and grass didn't help either, so I sneaked as softly as possible. A few small frogs scissor-kicked into deeper water, burying themselves in bottom vegetation. They would be back.

I watched the males return to their posts. One in particular, a Woodhouse's toad, stood nearly upright in the flooded grass. But he remained silent under the light of my lamp. The light was necessary for sharp focus. I wanted a clear view of the toad's eye, and I wanted him singing with his throat sac inflated. I waited for a while. Nothing.

Punt that. I sang to the frog. Less than 3 feet away, I growled my best impression of his own voice, and it worked. The frog, not to be outdone by some dude with a light, laid it down. And there was my picture.

Just then, it started raining. That didn't bother him, but it did me. With more rain coming, many dry nights would permit other tries without risking expensive camera gear. So I went home and went to bed, happy for a half-hour of drama on this brooding spring night.

Shooting Stars
May 10

A prairie meadow near Fredonia caught my eye this sunny spring morning. It was covered with flowers, but at highway speed, I couldn't tell what they were. I turned around, parked on the shoulder, and walked to the edge of the field. Acres of pendulous blooms sprawled away. The flowers were shooting stars.

Few wildflowers are as beautiful as these. They were at the peak of blooming and unblemished by wind and weather. A scattering of wine-colored specimens flowed through the mostly white blossoms. Only rarely could one witness a living masterpiece like this field of pristine flowers on a cool morning.

I lay down for a snail's eye view of the hanging blooms, isolating them against the dark sky. From this perspective, their name made sense. Five anthers fuse into a single point, and five petals bend backward. The flowers look, in a fanciful way, like comets. The plants are a foot tall.

Shooting stars mature slowly, taking up to seven years before they flower. That made this field even more impressive, knowing that conditions were once just right for abundant sprouting, and the field, mowed for hay, had otherwise remained undisturbed for many years.

Perfection waited in the prairie meadow, and I was privileged to see it on a May day.

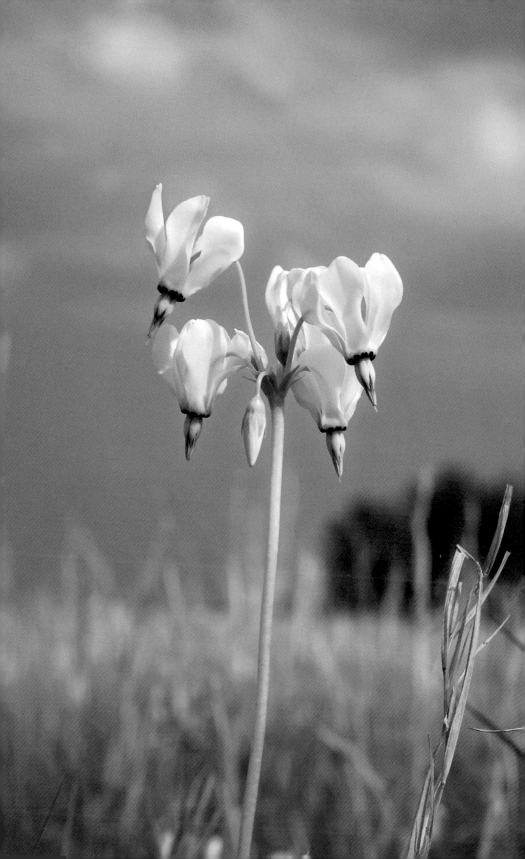

Orange Octopus
May 12

Last night's rain left an orange octopus in the cedar tree. Actually, it left hundreds of them. The odd, tentacled masses are seen briefly each spring when conditions are just right, proving that cedar-apple rust is active again. The colorful fungi, roughly the size of golf balls, are technically known as telial horns. Jellylike tentacles produce spores. These don't harm cedar trees, but the spores are wind-blown to apples and hawthorns where they infect leaves and blemish fruit.

The complex disease cycle took scientists years to figure out. The orange fruiting structures in cedars swell in the presence of

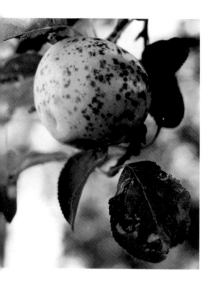

heat and moisture, appearing overnight as if by magic. Within a day or two, they dry and shrivel, releasing spores that fly to apple leaves to start a leaf spot disease. The apple phase develops through summer, forming "apple rust," whose spores then return by wind to the cedar trees where they overwinter. The disease requires both hosts within the same half-mile or so. Otherwise, it cannot survive.

Cedar-apple rust seldom causes serious harm to fruit trees, but it does result in small, unsightly fruits. That makes it a commercial pest. It is recognized on apple foliage as brilliant gold patches on the upper leaf surface, usually ringed by a dark margin. On cedars, the disease passes most of the year as an obscure brown gall hidden among the greenery. Only for a day or two each spring does the disease express itself in this odd and showy way.

Mimicry
May 14

Birds and animals seldom tangle with bumblebees. These bombers pack a powerful sting. Unlike honeybees, whose barbed, one-shot stingers stick in the skin, bumblebees have smooth stingers that can deliver rapid-fire, multiple injections. Potential predators quickly learn to stay away from these large and brightly colored insects.

Enter Batesian mimicry, a phenomenon where an insect without natural defenses is protected because it looks like another. Several examples are common. The viceroy butterfly looks very much like the monarch, which is bitter and toxic to birds. The viceroy is not bitter, but it gets a free pass by appearing to be a monarch. Likewise, several insects mimic the bumblebee's colored stripes and approximate size. Among these look-alikes are a robber fly, a carpenter bee, and a sphinx moth. None of these imposters can sting, but all enjoy the protection of Batesian mimicry.

This photo shows why predators avoid a snowberry clearwing moth. Its behavior is quite different from the bumblebee, though it feeds on the same flowers and lives in the same habitats. It is a sphinx moth and feeds on the wing, hovering in place and gathering nectar with a long tongue. Sphinx moths are sometimes known as hummingbird moths due to this flight behavior.

Though many kinds of sphinx moths feed at dusk or at night, the snowberry clearwing

feeds by day. This makes sense, as its coloration would do it no good in darkness. Its gaudy dress—a ruse—allows it safe passage wherever it goes. But you could catch and hold it in your hand without harm.

You could say that it's lucky for its looks. The secret, safe from many, is another absorbing footnote of the spring outdoors.

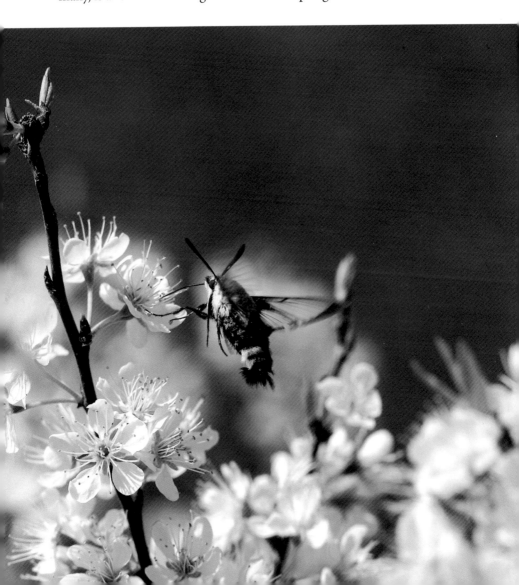

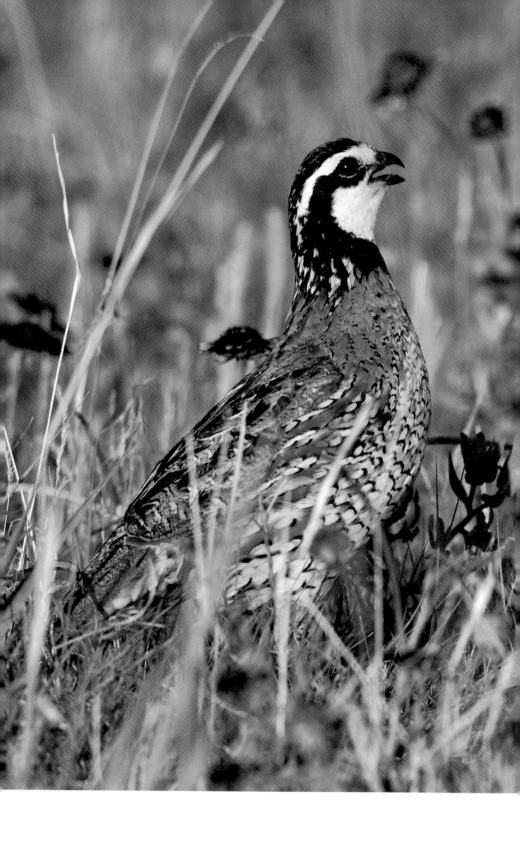

Bobwhite
May 25

The Red Hills landscape shimmers in spring heat. Wildflowers nod all around, and grasses still shine green before summer gets serious. Meadowlarks sing. It's a splendid prairie morning.

This time of year, bobwhites are on patrol. Hens are nesting, but males are quick to respond to a calling female. Male and female bobwhites are polygamous. A complex reproductive tangle may see a bonded male tending a first brood while his pair-bond female is incubating a second clutch. It's even more complicated when other males or females may mate with these same bonded birds and nest within the same territory. This creates something of a free-for-all in good habitat during late spring and early summer. Young, unpaired males constantly search for these mating opportunities.

I use this fact to try for a special bobwhite portrait in prairie wildflowers. Finding a colorful patch of rose-ring gaillardia, I set an electronic speaker in the grass and play the sounds of a calling female. Within minutes, several males fly in from distant cover. They chase each other, pausing to call their signature *bob-whoits* as they search for the hen. It's a comical show as the males fuss and hunt. One stops and poses. I get the photo and capture the essence of the great bobwhite renewal that's always a part of May.

Tree Brood
May 30

A black cat waits at the base of a tree in the park across the street. I spent half of yesterday morning doing the same thing, watching a small hole 20 feet high on a Chinese elm. I'd never seen the cavity until my wife happened to sit in the park and brush our dog. That's when a wood duck hen began a decoy act on the park lawn.

"There's a hurt duck over there," Chris said, as I crossed the street to join her. I saw the hen woodie and knew at once she was protecting a nest. I approached as the duck "crippled" her way across the park, took flight, and circled back to keep an eye on things. I soon spotted the nest hole.

I spent the next few hours waiting for the hen to return. When she did, I saw nothing of her brood. Her wary eye said, "Not a chance."

Normally, about a dozen wood duck hatchlings spend one day in the nest before bailing out. The hen utters a peculiar call, and the little fuzz balls jump to the ground. Immediately, the family moves to water.

Passage is dangerous. Broods may cross streets, parking lots, or open lawns. Cars, cats, dogs, raptors, and turtles are but a few of the perils that commonly pare the family. Safety relies on timing and wits of the hen.

Arising at first light this morning, I scouted the park's small creek and saw nothing. The cat, which seemed to know something about the nest as well, gave up after ninety minutes. The tree hole appeared deserted.

Clearly, these ducks gave us the slip. Even so, it was a secret learned. Woodies often nest in the same cavities each year, and next spring, I'll be watching.

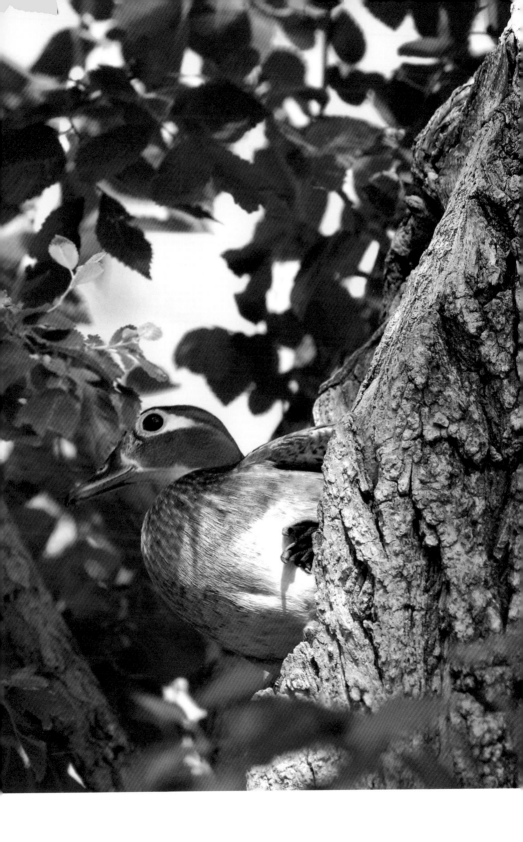

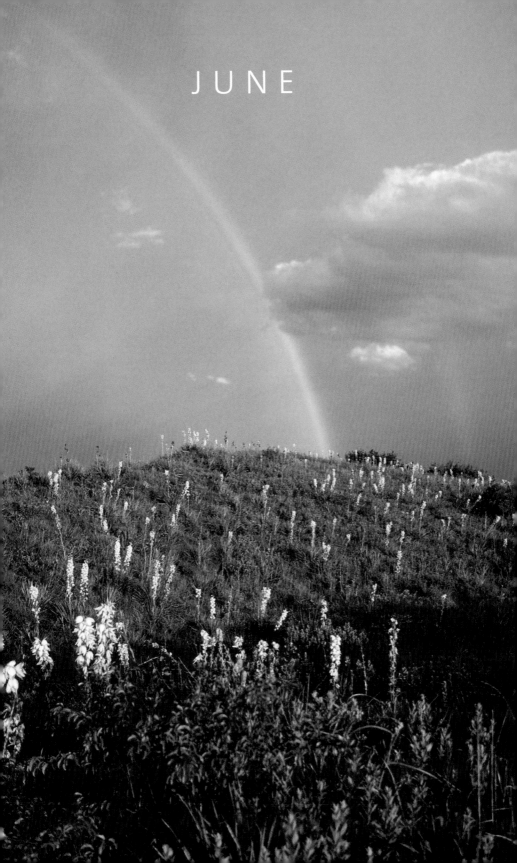

JUNE

Summer Drifts
June 2

White drifts are piling up today, and it's not snow. Cottonwood seeds are flying. Everywhere, the air is full of this annual springtime annoyance. Ragged clumps of cotton hang in the trees, releasing with every puff of wind.

This is the downside of the Kansas state tree, but then, it's probably the reason why plentiful cottonwoods earned this distinction to start with. Eastern cottonwood is a pioneer species. Fluffy seeds scatter by billions starting late May, ready to land and occupy any spot having moist, bare soil and sunlight. Cottonwood is often first to populate a disturbed site such as a scoured riverbank. But the puffy seeds must find a suitable landing zone quickly. They dry out and die in a day or two.

Cottonwoods are often cussed when their seeds clog radiators, air conditioners, and window screens. Some homeowners get so fed up that they remove offending lawn trees. But fortunately, not all cottonwoods produce seeds. This species is part of a small group having both male and female trees. Only female cottonwoods produce the green strings of pearls containing the silky seeds. Male trees have all the advantages of the species—fast growth, large size, and good shade—without the annoying seeds. These are the "cottonless" cottonwoods often sold for home plantings.

Seedtime continues for about six weeks. By then, new seedlings are growing, and the cottony mounds have weathered away. Today, I pick up a handful of fluff and blow it back into the sky, watching again the workings of an efficient natural dispersal system . . . and counting the days until summer drifting is over.

Turkey Nest
June 3

The few wild turkey nests I've found have usually been in deep shade. When hens left to feed, they covered the eggs with leaves and downy feathers, making the nests invisible.

But this nest? It's different. Its survival is amazing. The sitting hen is exposed to view, and just as bad, to the elements. She looks like a wet dishrag every time it rains. On clear days, direct sunlight burns into her dark feathers to make things miserable. Some days have been hotter than 100 degrees.

The nest is not a nest at all, but simply a depression in the sand beneath a barbed wire fence. Cars pass in open view less than 20 feet away. The nest is unlined except for a few stray feathers. When the hen steps away, she leaves her ten eggs exposed to passing crows and other hungry animals.

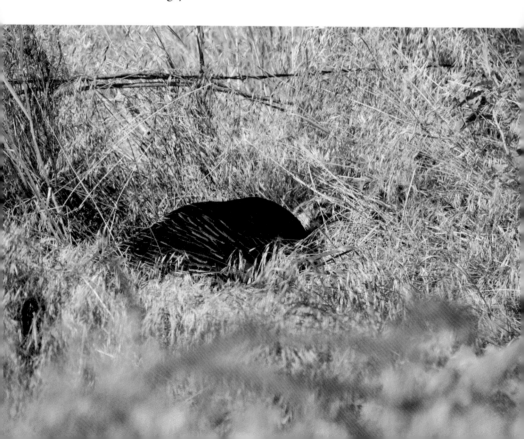

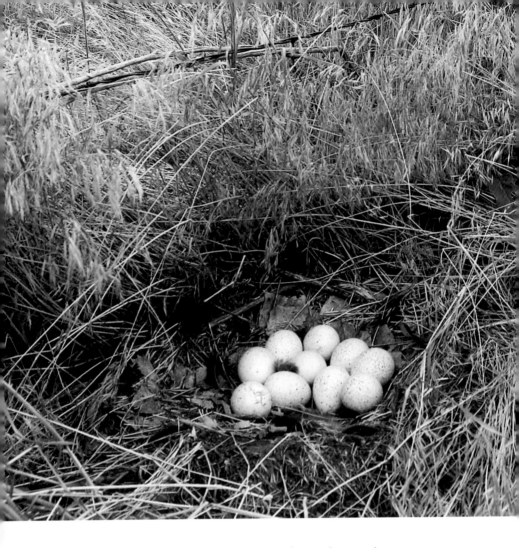

The fencerow is a natural hunting lane for predators. It's amazing that a skunk, raccoon, or coyote has not destroyed the nest. Research shows that about half of all turkey nests are ruined by predators, even when located in open expanses of grass and sage. A fencerow nest would seem sure to fail.

But this hen keeps beating the odds day after day.

I'm pulling for her. She deserves a medal or a dunce cap; I'm not sure which. She's just about to get away with the world's dumbest nest site—yet another outdoor surprise in the waning days of spring.

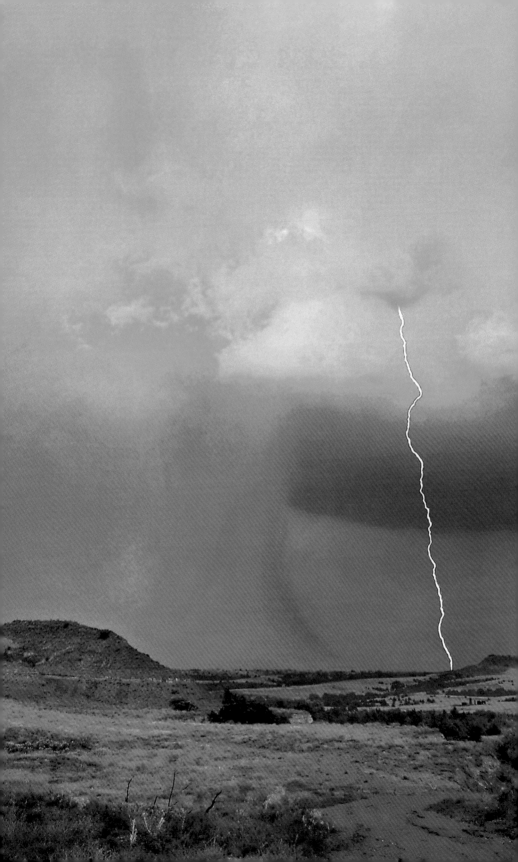

Summer Thunderstorm
June 4

Billowing clouds are common features of the Kansas June sky. It's bewitching to watch them tower and expand through violent forces masked by altitude and distance. From the ground, the burgeoning clouds appear to grow softly; but within, tremendous updrafts and condensation empower wind, hail, and lightning.

They're called thunderstorms. Rain, a precious commodity on the dry plains, is delivered in lashing blows. Seldom do summer rains gently water the Kansas land. South winds blow gulf moisture into the state, where thermals rising from heated earth carry it high into the cool, upper atmosphere. Condensation occurs, and clouds form and build. Rain falls.

Less violent than tornado-bearing supercells spawned when cold fronts collide with warm gulf air, summer thunderstorms can still produce severe weather in the form of gusty winds, downbursts, and large hail. And the rain comes hard. It pounds the ground in brief downpours and then moves on. Runoff is rapid, sometimes merely teasing the thirsty land.

Thunderstorms offer majestic beauty. Tonight, advancing clouds lured me southward as rain and lightning approached. The picturesque Gypsum Hills formed a craggy setting for the drama between earth and sky. Red dust colored the atmosphere, creating weird evening light as the sun lost its battle with cloudy curtains. Rain and lightning swept the land, offering a rare chance to film a massive electric bolt during daylight. The show was breathtaking—as it often is, when June advances a Kansas year.

Fawn Time
June 9

Few animals define wildlife like white-tailed deer. A graceful buck bounding over a fallen log is the stuff of dreams. The glimpse of deer feeding in a dusky field always quickens the pulse. The sight of a spotted fawn following its mother is an enduring memory. Whitetails are truly special.

Early June is the time for fawns. Though a few drop in May, most are born around the first of June and remain in heavy cover for several weeks. Their spotted coats help them blend with dappled grasses and woodland litter. When lying flat, they can be impossible to see. Hiding is a fawn's main defense for the first few weeks of life.

Does visit only to nurse their young, otherwise staying as much as several hundred yards away. This helps protect the scentless fawns by keeping the mother's scent out of the area. When finished nursing, a tiny fawn will wander away to choose its own bedding site, well away from the doe. The doe then exits by another direction, helping protect its offspring from discovery.

Fawns grow quickly. Play builds strength and endurance. Fawns run at top speed, bumping and tagging the doe or its siblings. When three weeks old, a fawn can outrun a coyote.

Soon, it will follow its mother everywhere, continuing this for a year or more.

I found this fawn today in short grass near a marsh. The doe wandered close, and the fawn nursed. They moved about 100 yards together before separating again. The fawn ran laps around the doe, burning off excess energy. Watching it was a special thrill—a dose of sheer exuberance on a late spring morning.

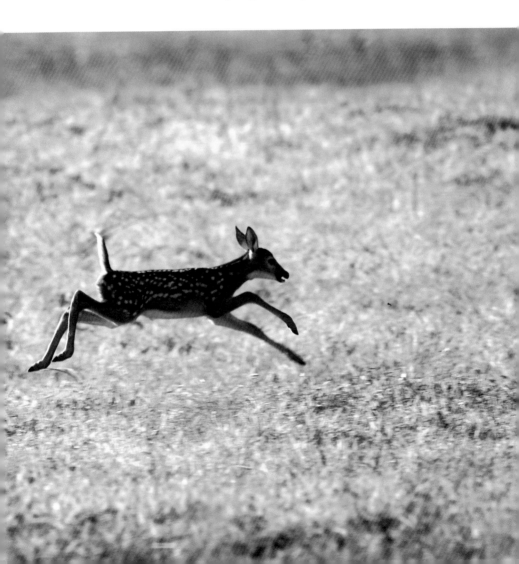

Summer Bats
June 12

I went to the bat cave tonight. Hot air shimmered on the June prairie as the sun went down. At first, clear air showed nothing unusual on the orange horizon. But twilight changed that.

A look into the cave's opening showed movement. Flying brown dots began to appear, orbiting the large chamber. Bats soon choked the congested airspace and waited for night. Leaving too soon could be a costly mistake. Agile Mississippi kites waited outside for a last-minute meal. Only darkness meant safety.

The first bats spilled out, flying up the slope for a night of feeding. I stood still as the exodus grew from a sparse stream to a flying river passing just overhead. The parade was nearly silent—little more than stirred air. But I knew that ultrasonic clicks filled the dusk as these mouse-sized mammals emitted squeaks and measured the return sounds with their huge ears. Echolocation helps bats navigate and find food. Swarms of bats always create a firestorm of high-frequency sound.

These were mostly Brazilian free-tailed bats, and it was whelping season. Bats have single pups in June. Pups nurse for about six weeks, after which they join adults on the nightly hunt. Estimates for late summer numbers at this cave ran as high as 100,000 bats. That many can consume nearly a ton of insects each night.

A large bat flight is one of the heartland's most impressive wildlife spectacles. Seeing it adds excitement to the middle of a Kansas year.

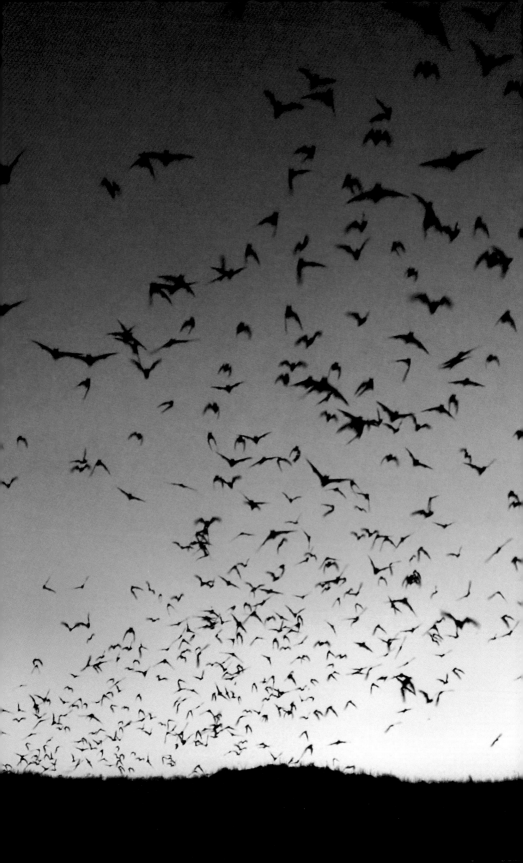

Roadrunner
June 15

Few birds are as entertaining as roadrunners. These long-tailed sprinters can run nearly 20 miles per hour. They prefer running to flight. Their short wings are not built for sustained air travel but serve them well in gymnastic escapes and dashes to capture food.

Roadrunners eat lizards and snakes, tarantulas, small birds— anything they can swallow. They catch most of their food in fast attacks that may snatch escaping victims from the air.

Personalities vary greatly. Some roadrunners are curious and tame, allowing humans to approach closely. Roadrunners sometimes enter houses through open doors, or sit on a vehicle and watch while a farmer works nearby.

But the ones I've filmed lately were spooky as all get-out. Drive down a country road they were hunting, and they dived right into the brush. They were also shy around blinds or vehicles parked

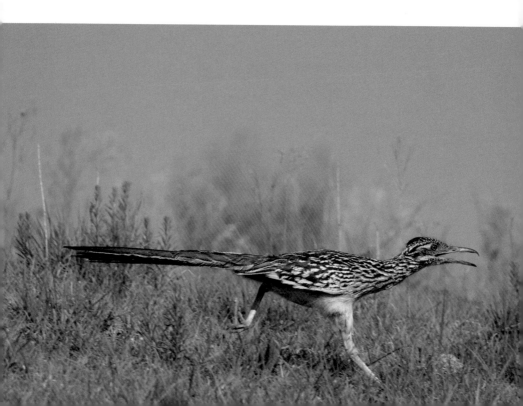

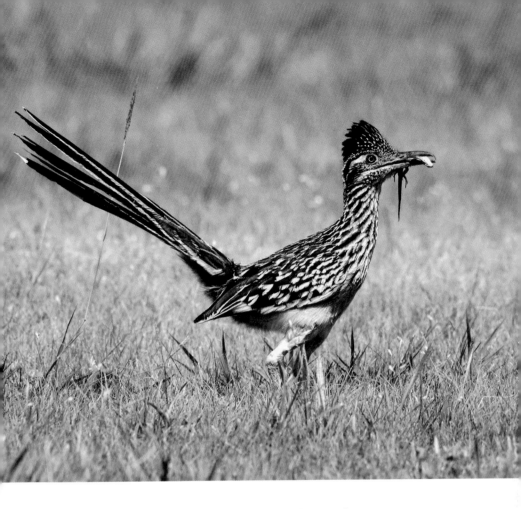

within sight of their nest, even when located some distance away. This required patience and trickery to get the photos.

Summer is the best time for roadrunners, since animals make up 90 percent of their diets. Even in winter, roadrunners scratch through duff to find insects and other arthropods, though they will eat grains and seeds to sustain them. Of all prey species, though, snakes and lizards are most impressive. Summer lizards are fast, not unmatched by the keen-eyed roadrunner. Watch a chase through clumps of sandsage, and you'll see a spectacular display of predation—usually ending with a limp lizard in the beak of its hunter.

Fireflies
June 17

My truck was stuck in the Red Hills sand at dusk. The nearest help was 4 miles away. Since I knew the area well, I cut cross-country over the rugged terrain. On the way, I saw one of the most amazing sights I've witnessed in Kansas. A remote, grassy valley was literally filled with fireflies—seemingly millions of them. Without a camera, I took only memories of the astonishing display. I've never seen another like it.

Everyone is familiar with "lightning bugs." These common insects are as much a part of a June evening as sundown. The beetles produce greenish-yellow flashes through special organs. Their chemical light is highly efficient compared to manmade lights. An incandescent bulb returns only about 10 percent light and 90 percent heat for a given energy input. With fireflies, about 90 percent of the energy input returns as "cool" light.

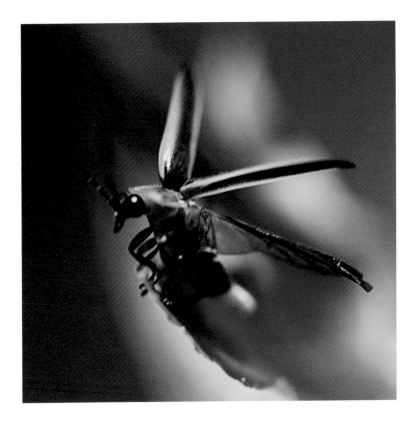

Fireflies are most noticeable when they mate in mid-June. Male fireflies flash in a unique courtship pattern answered by females. This flash code helps them find each other in darkness, according to species. But some predatory female fireflies send false signals to attract and eat searching males of other kinds.

It's common to see fireflies in lawns and city parks on summer evenings. But the most impressive displays are usually in wild situations where habitat and timing are just right. I've rarely observed such displays and photographed only a few. But none have matched the spectacle in the Red Hills—an unmatched sighting of spring's last days to balance out a night of trouble.

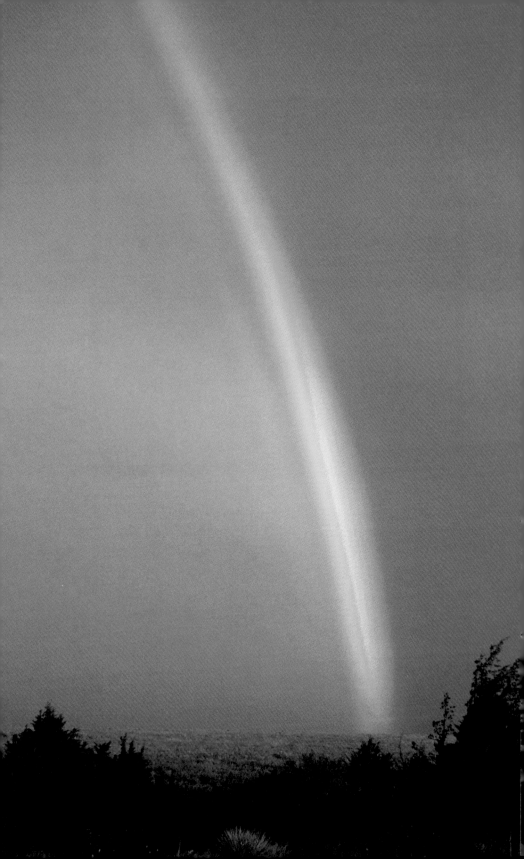

Rainbow
June 19

Heavy rain ebbs away as the sky lightens in the west. I grab my cameras and head for the hills. A rainbow is possible, and only a natural scene can do it justice. I race for the country.

Sure enough, weak rays start to shine as the storm moves away. At first, a pale wand of color arches overhead. Then the sunlight strengthens. The rainbow intensifies to a dazzling brightness, lighting the sky with banded color that crosses the visible spectrum. It's a wondrous display that never grows old. I film the vibrant band until it starts to fade. Rainbows never last long.

This familiar sky show is well known, but seldom seen. Rainbows belong to the growing season, when late spring and summer storms rake across the land with showers in tow. Only when sunlight shines through a downpour are the spectral colors separated. Monsoon rains of other seasons exit far too slowly for rainbows to form.

This fast storm leaves a glorious mark. As summer nears, it reminds me in a special way that the changeless outdoors is always changing.

Under Attack
June 24

A great egret, white and stately, strikes an elegant pose wherever it wades. Making any scene beautiful, this bird is nonetheless a dangerous predator. With lightning-fast reflexes, the bird uses its long neck and spearlike bill to strike in a surprisingly long arc. Its normal diet includes aquatic insects, crayfish, minnows, and snakes. However, it will routinely snap up mice, birds, and ducklings that pass near. Most marshland creatures fear it.

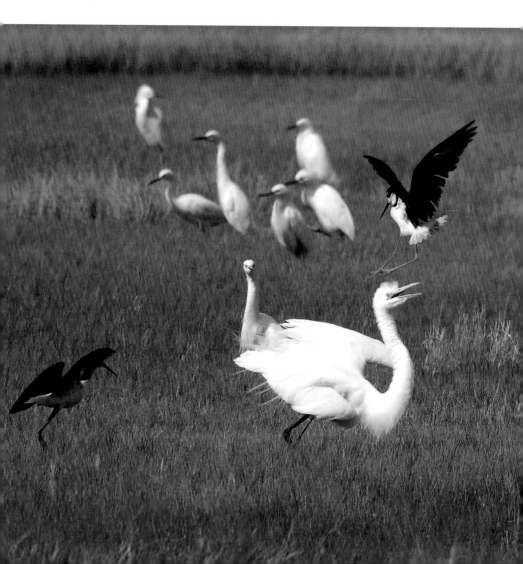

Black-necked stilts are smaller birds that nest on salt flats. For minor threats, stilts may attempt to decoy predators away from their nest. They do this by feigning injury, flapping wings and dragging themselves away from their young. They might fool a raccoon or other nest predator into trying to catch them, thereby sparing their chicks.

But none such tomfoolery occurs when a flock of egrets lands nearby, as it did today. The egrets chose to hunt where stilt families foraged. Puffball stilts were potential morsels in the short grass, and at once the stilts attacked the egret closest to their young.

Aggressive cries drew other stilts from half a mile as the parents assaulted the big bird. Within seconds, a handful of the black-and-white fighters descended on the offending egret, forcing it momentarily to the ground as it warded off the aerial attack. The noisy episode lasted nearly half a minute until it found a short lull by which to escape. With it, the whole egret flock lifted off for more peaceful environs.

Gradually, the marsh settled down, and the stilts resumed feeding. Sometimes you fake; sometimes you fight. Today, it was a slugfest.

Tree Poults
June 28

Something was odd about the tree. At 30 miles per hour, I saw . . . *what?* . . . from the corner of my eye. Often, such feelings are false alarms, but I've learned to always check. Backing up, I raised my

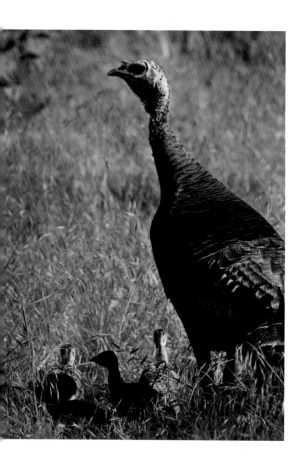

binoculars and saw a wild turkey hen roosting with a brood of young poults.

This was a rare moment. In all my time outdoors, I'd never observed young turkeys roosting until now. I'd seen and filmed lots of adult turkeys in trees, but this was a first. The family was 15 feet high on a horizontal limb. It was an hour before normal roosting time, but the youngsters were probably coaxed up early on what may have been their first fly-up. The hen positioned her wings to gather her brood as night descended. She would probably envelop them for warmth.

I guessed the poults at ten days old. Turkey hatchlings can't fly, but they leave the nest immediately to follow the hen. Darkness poses danger. At night, the hen pushes young turkeys into brush

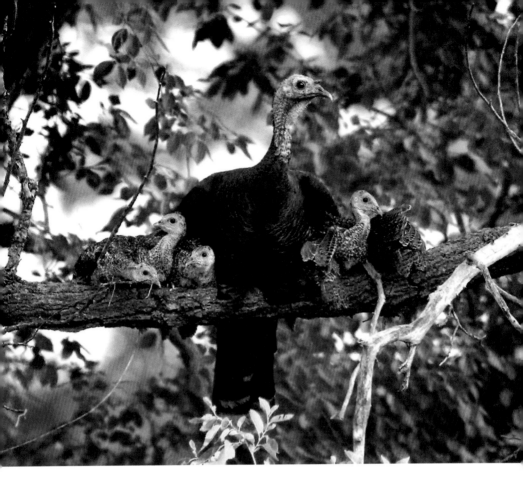

piles or low vegetation where they can hop upward for protection from ground predators. When strong enough, poults join the older birds in trees. That was happening here.

Some scrunching was evident as the turkeys balanced together. None seemed uncomfortable. I watched for at least ten minutes, and there was little attempt to shift positions.

Such events aren't rare—they're common in the summer woods. Wildlife generations grow and learn on a schedule that varies little from June to June. The difference? I was there to see it. And that's what keeps me searching for new vignettes in a Kansas year.

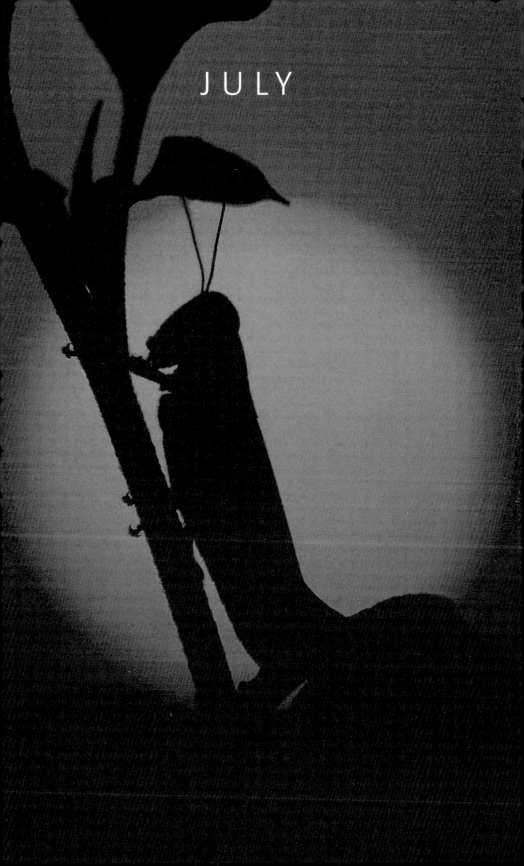

JULY

Lightning
July 1

I seldom miss the opportunity to watch lightning in summer storms. Not all lightning is created equal. Every storm has its own characteristics, and the light show is sometimes little more than muted flashes. But some storms create amazing webs of fire.

Just after dusk tonight, a monster storm dumped five inches of rain in less than an hour near my home. Though the system rained itself out before arriving, cloud dynamics were impressive. Lightning was frequent and spectacular, creating double bursts and long trailers. The show was spellbinding.

Lightning formation is mysterious and fascinating. The process starts when strong updrafts carry raindrops high into the cloud

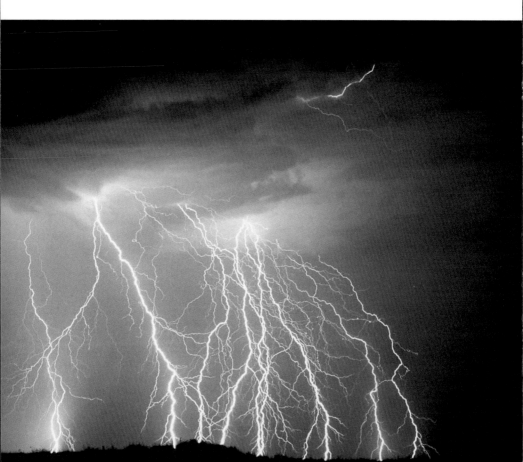

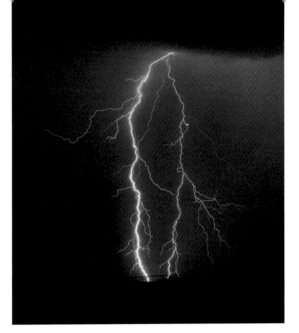

tops, usually 20,000 feet or higher. The droplets freeze, and ice crystals interact with other supercooled droplets still in liquid form. An electrical charge results, building downward in 50-yard increments called step leaders. These steps continue, producing a channel that holds the charge. Reaching a tall object on the ground, the circuit is completed and the charge released. The bright strike is actually a return of the charge back *into* the cloud. The visible lightning travels upward.

Channel air heats to 50,000 degrees in a few millionths of a second. This develops tremendous pressure and creates a shock wave expanding outward from the channel. The shock wave converts to a sound wave, creating thunder.

Some lightning bolts travel more than 100 miles, and 60-mile strikes are not uncommon. Lightning often runs from the storm's leading edge into its trailing portion. Usually, lightning will strike no farther than 10 miles in front of an approaching storm.

To see lightning is to realize its awesome power. Watch the fire in a nighttime storm, and you glimpse a fraction of the planet's summer energy.

Little Deer
July 9

Every year about this time, I start watching deer. Summer heat puts wildlife into lazy patterns. Does with fawns begin to rejoin other maternal groups at feed fields. Big bucks, long since calmed from hunting season, venture out in bachelor groups to feed and grow their antlers. They move in evening sunlight now, more visible than at other times of year.

But I have to admit, I can't resist the little guys either. Spotted fawns are from six to ten weeks old now and fast enough to give predators a run for their money. Young deer are often on their feet, exploring the small world surrounding their birthplaces. Especially when part of a sibling group, as they often are, fawns move and play together when momma is not around. This provides opportunity for some of nature's most endearing photos.

Today, I saw triplet fawns crossing a county road in late afternoon. The lead fawn had already scampered by when these two heard me and stopped to watch. I grabbed my camera and filmed the pair from 50 yards away. A moment later, they raised their tails and dived into the undergrowth, no doubt feeling they had outfoxed the metal monster rolling down the road.

And all of us were tickled.

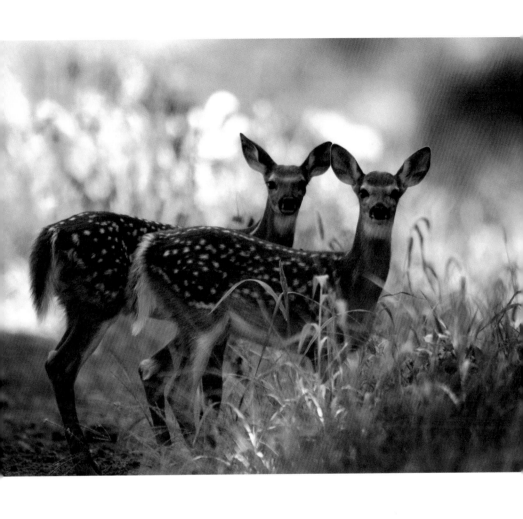

Giant Swallowtail
July 14

Teasel's lavender flowers were alive with butterflies today as I drove down highway 152 near LaCygne. These butterflies were the big, showy swallowtails—pipevines, tigers, giants—even a few zebras. Flowers and insects were at peak perfection, as if prepped for a photo shoot. The next ninety minutes were a study of the handsome fliers as they fed.

The patch of teasel covered a quarter acre in a weedy pasture bounded by timber. I detected little fragrance, but apparently, the butterflies did. Something clearly drew them from every direction. Judging from their conditions, most were newly hatched. They clambered over the blooms, probing and moving constantly in search of the sweetest nectar. Their wings quivered steadily, ready for instant flight.

Swallowtails are normally skittish, and today was no exception. I stayed back 10 feet, moving often to isolate each subject. The butterflies were never still, making sharp focus difficult. But many opportunities helped to get things right.

Giant swallowtails have always been my favorite. Not common in Kansas, these big charcoal-and-yellow butterflies develop on such unusual plants as prickly ash. The larvae are large and exotic, and the adults are fast fliers. They are creatures of the wild country, often seen along shady creeks in woodlands. They feed on wildflowers in backwoods hayfields . . . and teasel along the highway.

Today, I spent time with the butterflies, paying for the encounter with sweat and chigger bites while watching the show on a July stage. A giant swallowtail made it all worthwhile.

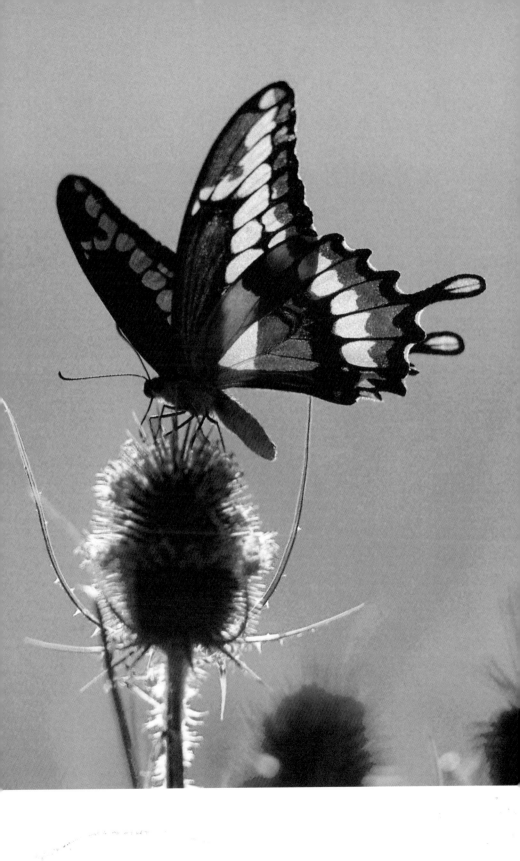

Sunflowers
July 17

Only tough customers can stand all day in a blazing sun. Choosing light without shade, seldom taking a drink, some can thrive in conditions a few degrees short of fire. That's how it is with July sunflowers.

These hardy plants always show up in time to announce summer. They decorate the outdoors through the hottest months. Their yellow flowers stand in bright congregations, and everyone knows them. They're the perfect state flower for a land of grass and sunny skies. That describes Kansas.

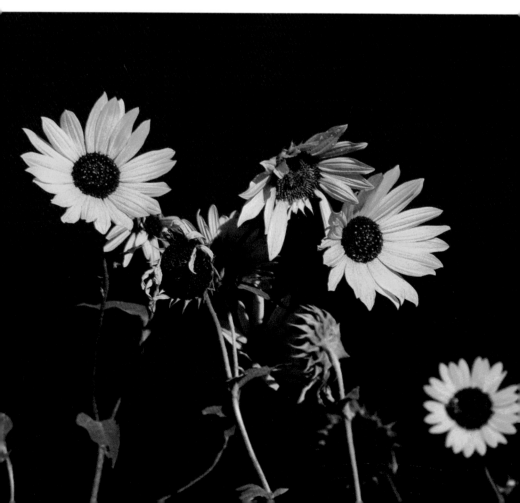

Sunflower is an honest namesake, since its blossom resembles the sun. Petals spread like golden rays from a darker center. Hundreds of tiny florets make up each flower head. Strangely, these follow a pattern of interconnecting spirals. Mathematicians relate this pattern to Fibonacci numbers. A high degree of order exists in this natural blueprint.

Sunflowers paint the July fields. Few plants bloom as boldly. Other flowers may retreat, opening and closing for brief respite. But sunflowers never rest. They shine throughout the season as living summer icons.

Besides color, sunflowers offer food. Birds and small mammals eat their oily seeds. Summer's oven produces untold seed volumes through these common annual plants.

Summer flags—that's the way I see them. They bridge the softer seasons with joyous accents. I look across a sunflower riot, and suddenly, the hot sun seems a friend.

Minks
July 18

Minks are the stuff of legend and lore. They're the fur-trapper's equivalent of gold, and a familiar element in the history of American settlement. Living at the seams of wet and dry, they prey on fish and small animals with deadly efficiency. Though abundant throughout Kansas, they're seldom seen. Minks stay close to water and are mostly nocturnal.

That's why this pair surprised me as I photographed in intense, midday heat along a shallow waterway. I was filming birds when a large swirl appeared on the surface. These young minks suddenly emerged and bounded onto the rocks. They frolicked like kids, chasing and teasing one another. They posed for a moment before plunging back in—a cool encounter in the 100-degree heat.

Their wet fur glistened in the sunlight. Though no longer as important to industry, it's easy to see how fashion once coveted their beautiful pelts. The mink's typical white chin patch was clearly evident as both animals paused to check their surroundings.

A sniff and a quick look settled their curiosity. Then they were off again, swimming and doing whatever minks do when they wind up working on the wrong side of their normal business hours.

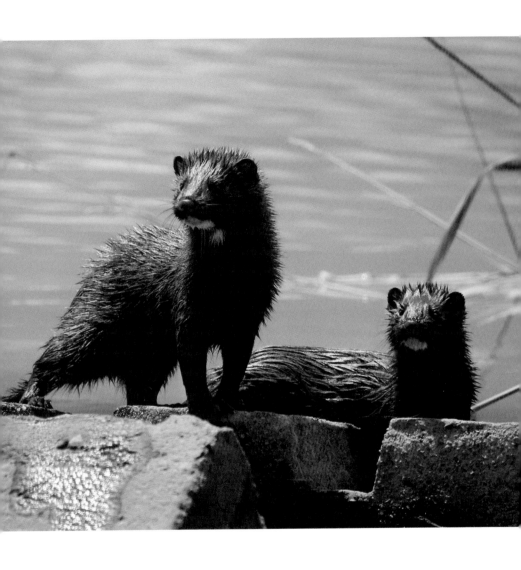

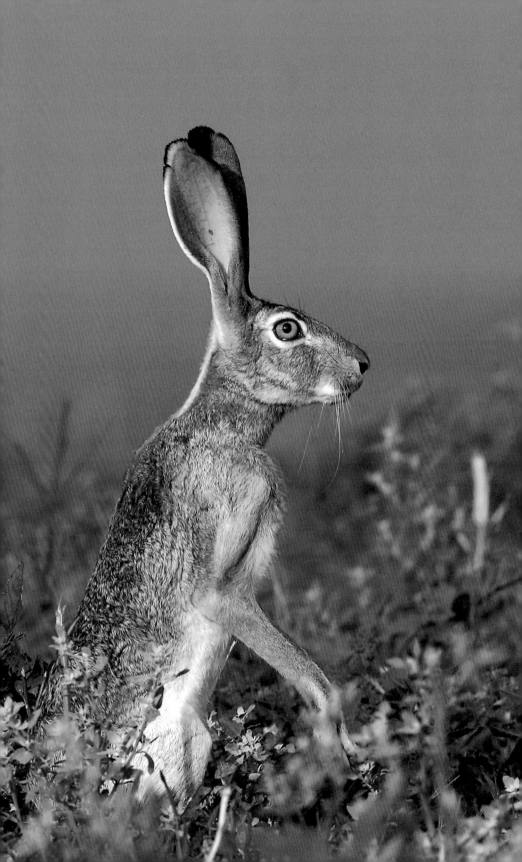

Jackrabbit
July 19

The jackrabbit stood upright for a better look as I eased along in my pickup. It was three hours before sundown—a surprising time to see a hare in hot summer. This time of year, jacks feed mainly at night. But succulent plants along an old cattle lot provided both food and water. The animal was probably thirsty in the triple-digit heat. I stopped, and it eyed me suspiciously before moving away.

Chances are, it was a female with young nearby. Nursing requires extra water, and since jackrabbits seldom drink, they must eat large amounts of moist food. This was a big hare, and females usually outweigh males by several pounds.

The huge ears were striking. Jackrabbits can hear well, but the ears serve double duty. Blood flow is adjusted at will through the thin ear membranes to regulate body heat. That's definitely useful on the hot summer prairie.

Living in open country, jackrabbits rely on sight to warn them of approaching danger. They normally hide to avoid detection. If surprised, they can run at speeds of more than 40 miles per hour. Coyotes are their most important predators, but a single coyote can seldom catch these big hares in a chase. Golden eagles, ferruginous hawks, and great horned owls are also enemies, using speed and aerial advantage for surprise.

Jackrabbits eat a variety of plants, including sagebrush and cactus. To conserve water in dry habitats, they sometimes eat their feces to reabsorb any remaining water in digested materials. Strange as that seems, it's an efficient strategy.

The summer prairie can be a brutal place. Going eye-to-eye with a jackrabbit on a hot afternoon, I met one of its toughest critters.

Bug on a String
July 20

I was hanging clothes on the line when something big and buzzy hit me on the back. I looked down to see a green June bug trying to right itself from the collision. Suddenly, I thought of my mom. She told stories of tethering June bugs and flying them like kites when she was a girl. So I reached down and captured the bulky insect and put it in a jar.

Later, I tied a sewing thread to the beetle's rear leg where it joined the body, creating an effective leash that would not interfere with flight. Green June beetles are strong, but I wondered if the line weight and aerodynamic drag would prevent flight—surely the heavy insect had enough trouble lifting itself on short wings.

Not to worry. At once it powered away, buzzing easily and circling against the leash. The beetle flew so well that I uncoiled

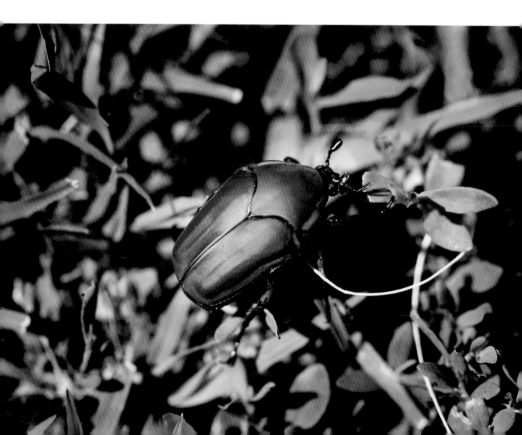

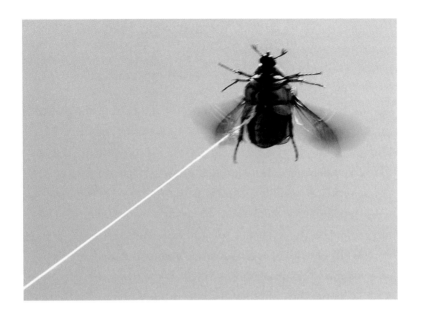

more line from the bobbin. Walking into an open park area, I
launched the bug and watched it fly to the end of the line. It went
50 feet and then circled as if on a merry-go-round. The insect made
three laps on its long tether, flying high, flying low, pulling against
the thread. With someone to help manage the line, it was obvious
the June bug could have flown much farther. Flying the bug again
and again, I watched it climb to the power lines and then try to land
on the nose of my dog. It was a show.

I felt like a kid. It was fun flying a living bomber, and the insect
displayed amazing strength and power. Imagine a light airplane tied
to a mile of heavy cable: that's probably not a bad analogy.

Green June bugs are destructive pests of gardens, lawns, and
golf courses. Normally, you might want to step on one to help
protect your plants. But I've got to admit, this experiment provided
an interesting discovery about the strength of a June bug. It was
summer fun, and reminded me of the time when youngsters did
things besides play video games.

Wild Plums
July 25

Many of nature's mile markers are intangible—things you observe, learn from, and leave behind. They remain as knowledge for another seasonal journey. Wild plums are different. They're functional. They leave a vast, wild harvest that begs usage. Tons of these colorful fruits may be found in a few acres, more than enough for regeneration, wildlife . . . and you.

I stopped to pick them today, gathering a bucketful in less than thirty minutes. The red fruits, soft and ripe, were pleasantly tart. Many kinds of wildlife eagerly feed on plums, and my Labrador retriever grazed them steadily as I picked. The fruits aren't as sweet as apples or peaches, but their high pectin content makes them perfect for natural jelly. That was my goal: plum preserves to eat on pancakes on chilly fall mornings.

These were sandhill plums, the kind that grow on pasture bushes seldom more than head tall. Kansas has other wild varieties, too, among the best being wild goose plums that grow on 10-foot trees. Those are fruitier and not quite as tart. But where I live, sandhill plums rule.

When pastures turn red, you know it's summer. Wade in. You'll revel in the bounty of a Kansas July and taste a seasonal marker that's as real as a calendar page.

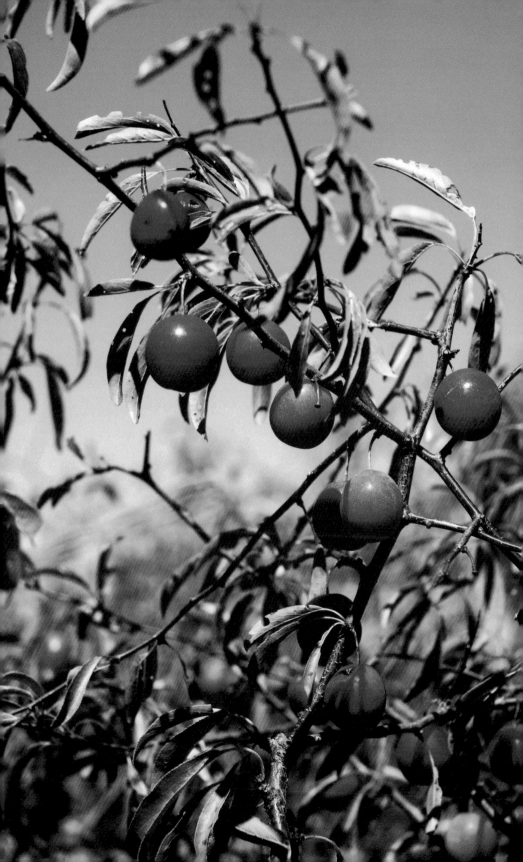

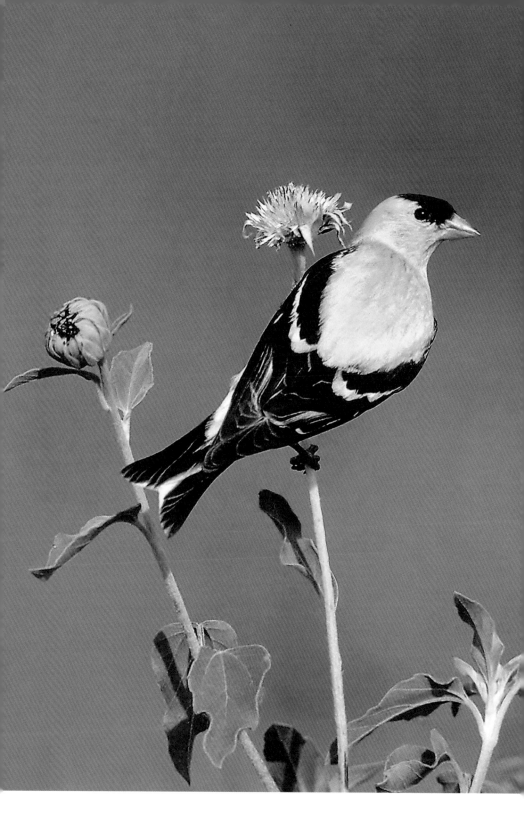

Goldfinch
July 27

I was idling along under a burning sun at Maxwell Wildlife Refuge near McPherson when a spot of bright yellow caught my eye. Goldfinch! The male was dressed in his finest breeding plumage, and he stood out handsomely against the summer greenery. Goldfinches look especially good in July, since they undergo a second complete molt in spring. Most birds molt only once, in fall.

Early afternoon heat and brightness didn't bother the male as he flew among thistles and sunflowers. Nesting season was under way, and goldfinches are among the latest nesters of all birds. This is due to their dependence on plants like thistles that produce seeds and down for use as nest linings. These plants don't mature until other birds have already finished at least one nesting cycle.

The male was feeding alone, indicating that his mate was probably occupied. Goldfinches are social at all times of year, and it's not uncommon to see pairs or loose flocks feeding together. But things get busy in the nesting season when goldfinches often produce two broods. Males usually take responsibility for fledglings of the first, while females follow up with a second clutch.

I stayed close, filming the lone bird as he picked dry seeds from sunflowers. Busy, he paid me little attention. I got some nice portraits of one of Kansas' most colorful species. His activities gave notice that the year was already in the downswing . . .

Tachinid Attack
July 30

If you're country enough to grow your own tomatoes, you probably know about tomato hornworms. These finger-sized caterpillars can chew through lots of foliage. They affect growth and crop quality when present in numbers. Gardeners may spray to prevent damage.

Hornworms can catch you by surprise. They're perfectly camouflaged and hide during daylight. I didn't know my plants were affected until I noticed a vine tip dancing unnaturally this afternoon. There, I discovered a gruesome case of biological control in the garden.

A Tachinid fly was attacking a large caterpillar. This fly species, which looks like a hairy housefly, is a parasite of tomato hornworms. The female, sporting a stinger-like ovipositor and eager to lay eggs, flew repeatedly at the large host. The caterpillar, virtually defenseless, writhed violently to discourage its attacker from landing.

It was a slow, futile effort. Again and again, the hornworm tired and the fly landed, piercing through the skin and leaving an egg inside the caterpillar's body. I watched for ten minutes until the hornworm finally grew still and allowed the fly to finish its work.

When I returned later, the fly was gone and the larva was wet and bleeding from stab wounds. But it wouldn't die yet. Instead, it would continue to live as the fly eggs hatched inside it. Voracious maggots would then eat it from inside out. End of problem.

That's a tough way to go, but hey, it's nature. The good-bug, bad-bug routine is constantly at work, and in this case, it saved me a chemical application. Along the way, it heightened my appreciation of a Kansas year.

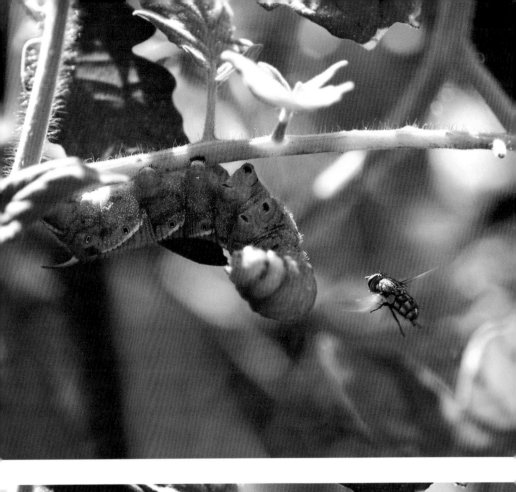
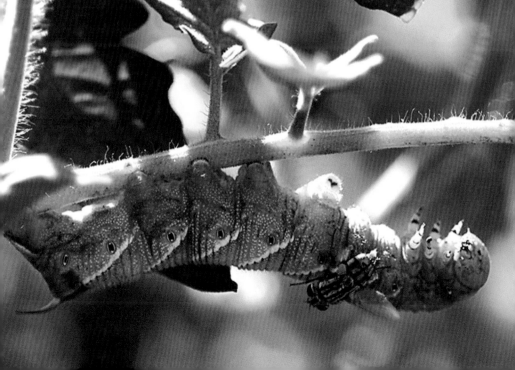

AUGUST

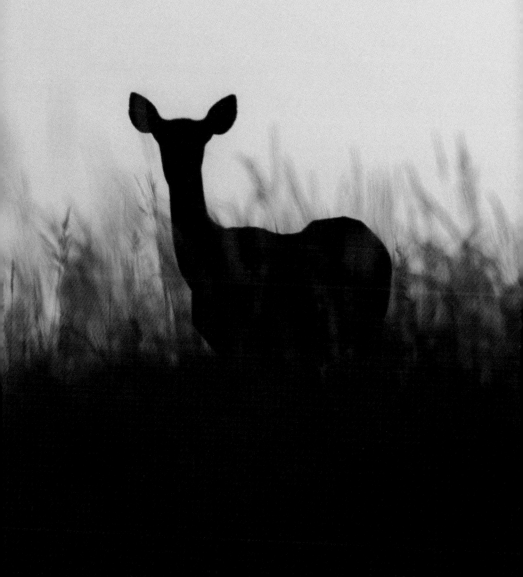

Vine Tendrils
August 1

It's a jungle out there. Deep in the growing season, young plants fight their way through the greenery. Vines are especially interesting. They grow fast and often outrun their competition by growing right over it. Vines use special growing points called tendrils to help them climb. The tendrils wrap around leaves and stems. In some cases, they actually strangle their competition.

Today I saw an army of new wild grapevines clambering over other plants. The young grapes bristled with tendrils waiting to grasp any object that could help them climb higher.

Vines are highly touch-sensitive, in some cases ten times more so than human skin. Tiny hairs on the vine stems "feel" the surroundings and cause tendrils to reach and wrap. When they touch a twig or leaf, unusual growth occurs. The tendril's plant cells on the side opposite the touch rapidly lengthen, while those on the side touched may actually compress. This growth difference causes the tendril to bend around the object. Often, the tendril encircles its host for a firm grip.

At each new anchor point, the vine grows toward the strongest light. Mature wild grapevines reach high into trees and may eventually be as thick as a man's leg. They live for decades.

Every growing season is about youth and vigor. These hungry vines identified the season as midsummer. The curled, waiting feelers showed another subtle detail of the vast life and energy marking the Kansas landscape.

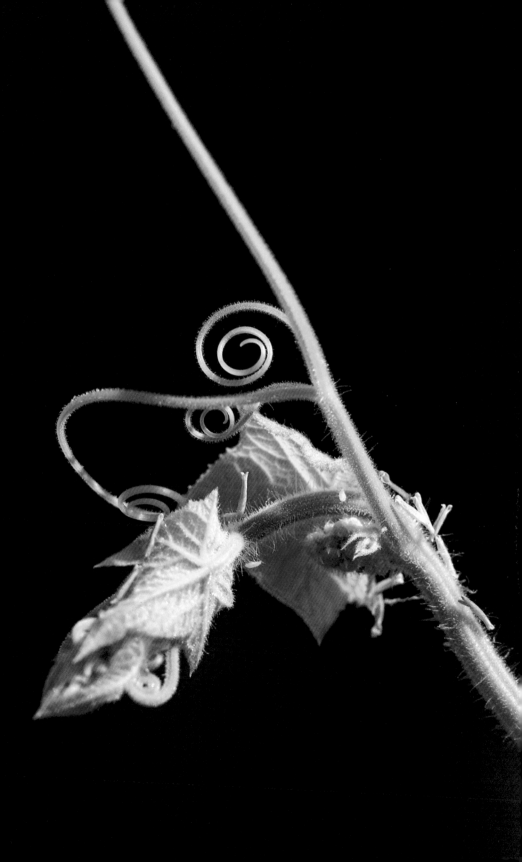

Poison Ivy Mites
August 3

Poetic justice lives in the outdoors: Poison ivy gets a rash of its own.

Too bad this doesn't kill the itchy booger. If you've endured the red welts or weeping blisters caused from contact with this plant, you know what I mean. It's only right that the vine can get a dose of its own medicine.

A nearly invisible mite causes the bumps on poison ivy. Eriophyiid mites are colorless and difficult to see, even with a 10X hand lens. They attack the ground form of poison ivy at bud break in spring. Their feeding causes the poison ivy leaves to produce abnormal galls as they develop. The galls are warty and gradually turn brilliant red—not so different in appearance than a poison ivy rash on human skin. Though damaged, the plants survive.

Mites live and reproduce inside the galls. If drought makes the ivy leaves too dry, the mites emerge, stand up on their sucker pads, and let the wind carry them to more suitable hosts. If they can't find new moist ivy within two days, they die.

Let's hope they get lucky.

The batch of infected ivy I found today is typical. Affected plants usually show their worst rash each year just as August rolls around. Actually, galls are present earlier in a green or yellow form, but they don't turn red until now.

I say, the redder, the better. I hope they itch like crazy.

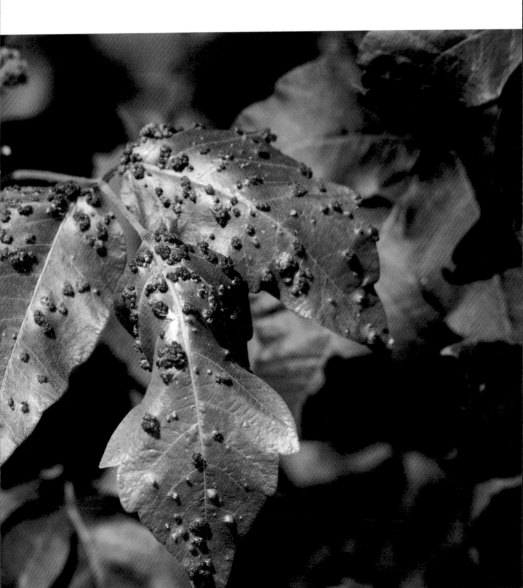

Shrike
August 5

Grab a strand of barbed wire on an August afternoon, and you might burn your hand. A scorching sun heats the wire to near-untouchable levels. That's why I winced when I saw a dung beetle impaled and paddling helplessly on a wire barb.

The stout, shiny beetle was no doubt cooking on the hot skewer even as it helplessly tried to escape. I don't know how long it had struggled, but I knew how it got there. A shrike had caught the insect and employed its classic trick of hanging the victim for a later meal.

Northern shrikes, also known as butcherbirds, are predatory

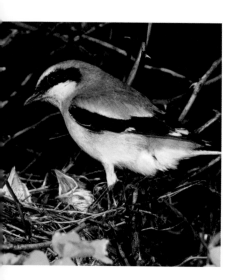

songbirds just larger than a robin. They are gray with black face masks. They have hooked beaks, and they eat insects, mice, small snakes—any food they can kill. They hunt when the chance presents itself; if the bird isn't hungry, it impales the victim on a handy snag. If the prey lives in this trapped condition, so much the better. Then, it's still fresh when the bird returns.

I've seen mice and small lizards impaled on honey locust thorns, and shrews and insects on wire barbs. Most were dead. This shiny beetle was lively in spite of being pierced through the body by a hot wire. It moved endlessly in a futile effort to escape. I returned hours later, and the live insect was still struggling.

Not all of nature is pretty. This grisly August scene is a common event in Kansas shrike country—a natural, macabre barbecue.

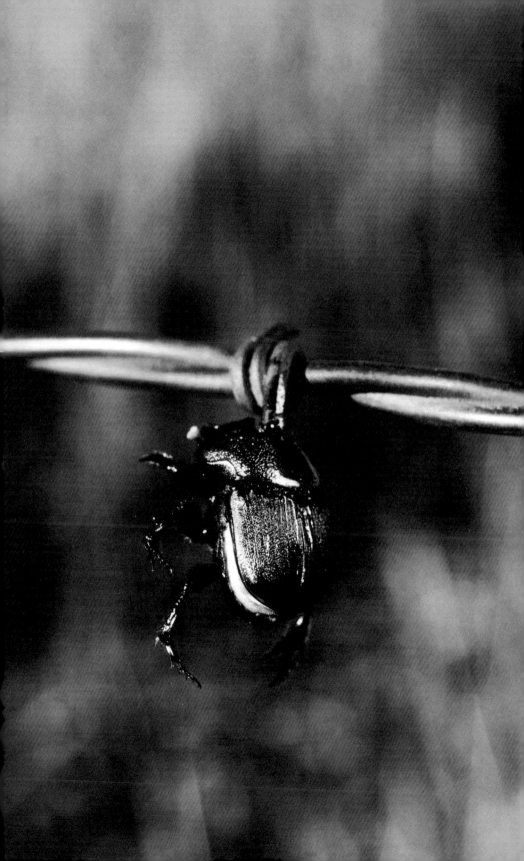

Ninnescah Morning
August 7

I sat by the river this morning. A red sun peeked through the trees while the Kansas breeze rested. Sounds of the day were still quiet. It was peaceful.

 Cool air offered a gentle nod to the morning shift. By ten o'clock, the clouds would be gone and the sun would burn. But for now, the morning mood matched its beauty.

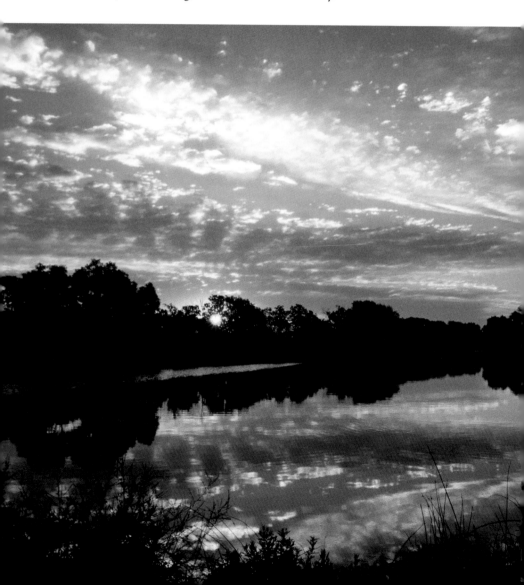

Summer. This was part of it, rising early to contemplate before another day set in. Blast furnace hours would come later, when sweat and toil were familiar cronies. The day might have its usual problems, but this gentle head start would offer balance. No need for coffee here. The outdoors was salve enough.

Mosquitoes were long since gone. Maybe the river boiled each day—I don't know. Or the current carried larvae away. But the brackish swamps and puddles that bred these flying vampires were tinder-dry, and that meant freedom. The moment was serene.

I watched the Ninnescah. Its water flowed, and fish broke the surface. Drifting currents showed time in a different way. I understood life in a different way.

Then the sky brightened, and it was time to go. When I left, I, too, was different.

Dodder
August 11

No, that's not spaghetti in the grass—it's dodder. This strange and unwelcome plant is a parasite on many kinds of native, broad-leaved vegetation. Dodder spreads tentacles wherever it can steal food. It's a common sight in August fields and meadows.

Dodder is yellow due to a lack of chlorophyll, the essential green pigment involved in making plant food. Chlorophyll helps leaves produce sugars. Dodder has no way to make food and must attach and draw nutrients from other plants. It forms dense, twining masses on an unfortunate victim. Like internal worms in animals, dodder does not kill, but simply weakens the host. This plant thief can be a costly pest in crops like alfalfa and clover.

Dodder was accidentally introduced into the United States from Europe. It's an annual plant spread by tiny seeds. At germination, a simple, rootlike system grows a primitive shoot. This "vine" attaches to a green plant and starts absorbing nutrients while its roots wither away. Dodder becomes aerial and detaches from the soil, relying fully on the host plant for survival. The thin, yellow shoots grow into tangled masses.

Dodder produces tiny white or pink flower clusters. Seeds fall to the soil and await favorable growing conditions. They can survive for long periods, and dodder can re-infest areas where suitable hosts have not grown for years.

Nothing in nature is free of enemies. Dodder, an odd parasite of the plant world, is a bandit that pulls its biggest jobs in August.

Tenpetal Mentzelia
August 12

Drive through a western Kansas pasture on a mid-August morning, and you'll see little but sunbaked grass. Return in the afternoon, and the flowers of tenpetal mentzelia transform the scene. This tall, showy flower is an August staple on chalky soils. It thrives in hot, sunny habitats with little rainfall.

Blooms hold their beauty for a month or more. Flowers are closed for much of each day. They open in late afternoon and glow in the low angle sunlight. By midnight, they close again. Their beauty is measured in small doses.

Blooming mentzelia adds a near-magical quality to the landscape. Bright stamens decorate the elaborate flowers. The creamy blossoms are profuse. Mentzelia transforms a tired prairie that seems bent on becoming dry desert into a state of hope and beauty. It keeps this pact through late summer—but you have to take the evening train.

I filmed this tenpetal flowerscape today in southwestern Kansas, and its sunny disposition makes a vibrant scene. To me, mentzelia is a visual lifesaver in the burn-down days of August.

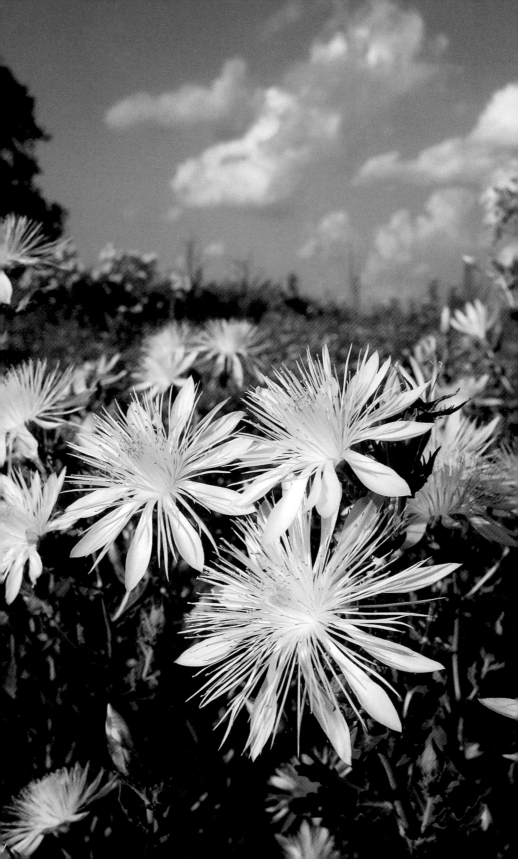

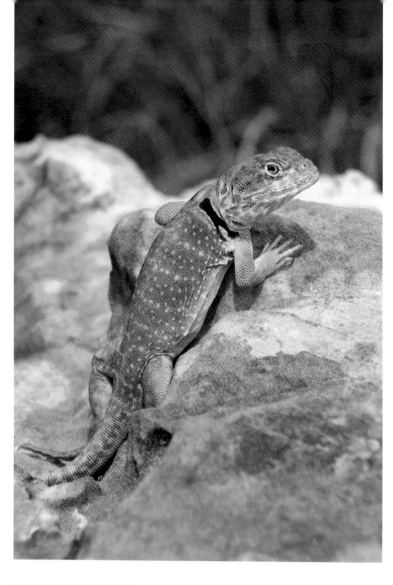

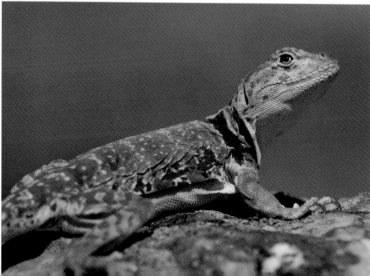

Collared Lizard
August 15

Most wild animals seek water and shade on August afternoons. But
I can usually count on one colorful species to sun on rocks when
nothing else is out. Collared lizards like it hot, and sitting atop an
outcropping while tasty insects buzz about is fine with them. I have
a favorite spot in Barber County where these big lizards lounge on
summer days.

Collared lizards are the biggest lizards in Kansas, growing up
to 12 inches long. They are also brightly colored. Males are often
turquoise and yellow; females tend toward olive, though when
pregnant, they develop orange bars and spots.

Collared lizards eat anything they can catch and get into their
mouths, including small snakes and other lizards. They are fast and
agile, sprinting from lookouts to catch a beetle or snatch a moth
from the air. They sometimes stand upright and run on their hind
legs, though I've never seen this.

The lizards have excellent eyesight, and they are skittish. I use
binoculars and approach them carefully. I usually carry several
lenses for my camera. Starting with long telephotos, I move
closer and shorten up. On rare occasions, a lizard will tolerate an
approach to just a few feet away.

Today, I visited the rocky outcropping where collared lizards
live. Sure enough, half a dozen basked on the sandstone rocks
scattered across several acres. Some were females ready for a second
clutch of eggs. Others were big males defending territories.

The stalk was hot and slow, but worth it. Close encounters
with these tiny dinosaurs made a worthwhile game under a hot
August sun.

Cicada Killer
August 19

Droning cicadas are an August hallmark. These thumb-sized insects fly among treetops and sing lazy serenades just right for long, hot afternoons. Occasionally, the rhythm is marred by a drawn-out cicada screech. This means that giant wasps are on the hunt.

Cicada killers are nearly 2 inches long and among the largest wasps. Their size and bright colors warn enemies to stay away. They sting and subdue annual cicadas, hard-bodied insects that appear armor-plated. But membranous segments on cicada abdomens are vulnerable, and this is where cicada killers attack. Using sight and scent, the big wasps search tree limbs to find a victim. Then, they swoop in and grasp the cicada, slipping their stingers deep to inject a measured dose of venom.

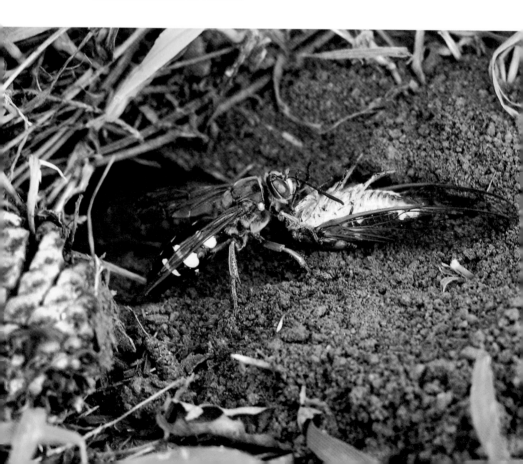

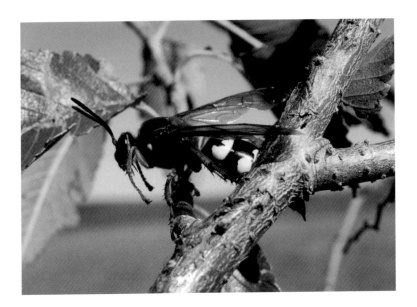

The doomed cicada faces a nasty future. Paralyzed but still alive, it is flown to a waiting burrow dug by the wasp. Deep in a nursery chamber, the cicada killer lays an egg on its body. Hatching wasp larvae are thus ensured a fresh, live meal.

Unfertilized eggs produce smaller male wasps that develop on one cicada per egg. Fertilized eggs produce larger female wasps. These must be fed two hosts per egg. Cicada killer larvae hatch in about three days and require several weeks to finish feeding. After that, they spin cocoons and remain underground until the following July, when adults emerge to repeat the cycle.

You'd expect this striped hunter to be fierce. Strangely, though, adult cicada killers are docile and eat flower nectar. Since females must conserve their venom for hunting, they are not aggressive to humans and will sting only if handled. Male wasps cannot sting. Adult cicada killers live for about three weeks.

For that period, the big females are always on the hunt. When you spot this giant wasp on low patrol, you can be sure it's middle summer.

Coyote Pup
August 25

Summertime . . . and the living is easy—or so they say. This coyote pup is a reality check. Even the season of plenty is no picnic for youngsters on their own.

I spotted the puppy in a pasture. Now about fourteen weeks old, the young coyote was independent. But the look in its eye showed neither pride nor confidence. The animal was reasonably well fed, thanks to abundant grasshoppers and sandhill plums. But a haggard condition spoke of normal problems living in the wild.

Thin rump and tail hair showed a touch of mange. This common, mite-borne problem is often contracted at the coyote birth den. Mange can cause complete hair loss that is life threatening in colder months. Otherwise, the bristly pelt showed symptoms of internal worms. Most coyotes are riddled with internal parasites picked up by scavenging or eating infected prey.

The juvenile looked scared. It was navigating alone in bobcat and golden eagle country. More pressing, it crowded into a coyote society where mild tolerance is as good as it gets. Older coyotes wouldn't attack the pup, but there would be no favors, either.

Dog-eat-dog was the new order of life, and this youngster ranked low in the pecking order until size and better skills developed.

The hay bale was probably home for now, offering shade, cover, and a landmark easily found in the open prairie. Chances are, the young coyote will mature and fit into the neighborhood. On the way lie many lessons of a Kansas year.

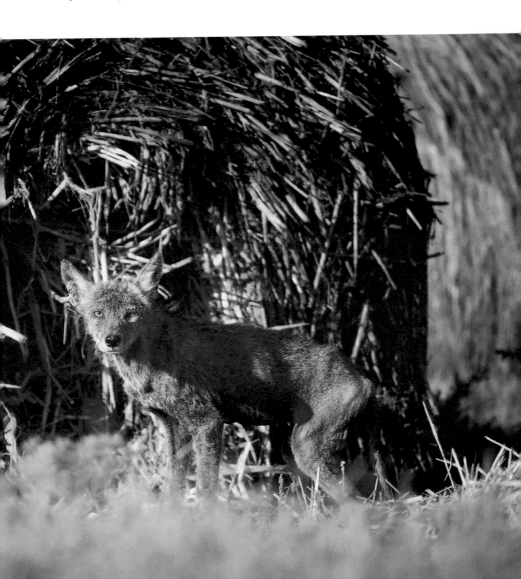

Velvet Shedding
August 29

Long shadows from a late sun stretched across the alfalfa. I hoped to see Splitter, a big white-tailed buck that fed here all summer. His rack with double split brow tines was extra large and covered with fuzzy velvet. But tonight promised something new. It was velvet-shedding time, and I wanted a first look at the buck in hard antler.

This period of whitetail development is a sure waypoint in the Kansas late summer. Velvet covers a male deer's soft, pulpy rack while it grows from May through August. Antlers are among the fastest tissue growth in the animal kingdom. They can lengthen by as much as a half-inch per day. By late summer, the tissue hardens into bone. Then, velvet that once protected the blood-rich tissue is no longer needed. Bucks rub it off on tree bark or bushes to polish their fighting weapons.

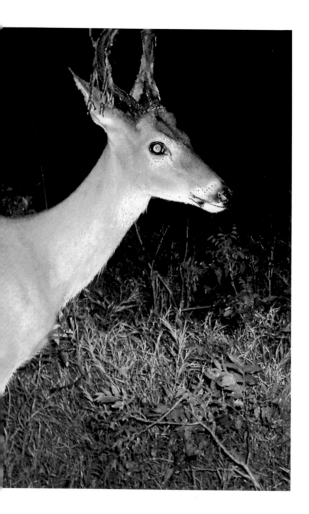

The shedding process is fast and seldom observed. One day a buck has velvet; the next, he doesn't. In between, the deer aggressively works to strip off the unwanted covering. Not uncommonly, it's

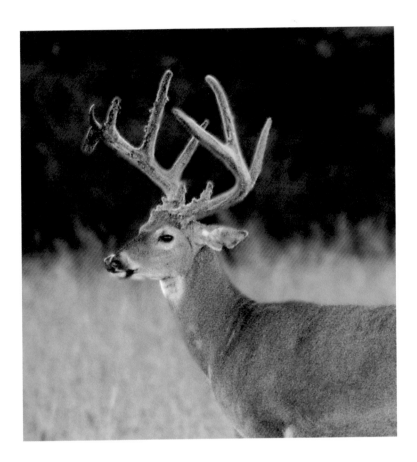

a bloody process, since a few straggling veins between bone and velvet might still be active. In that case, the antlers stain bright red. Velvet hangs in tattered strips until rubbed off. Seeing a buck in the stripping phase is rare.

Plenty of whitetails showed up tonight, but Splitter didn't appear. That's another change at this time of year—bucks adopt different movement patterns. But he'll be back sooner or later, no doubt polished and handsome in his fall breeding gear.

Meanwhile, my trail camera caught a young buck that illustrates the shedding process perfectly. Next time with any luck, I'll film Splitter.

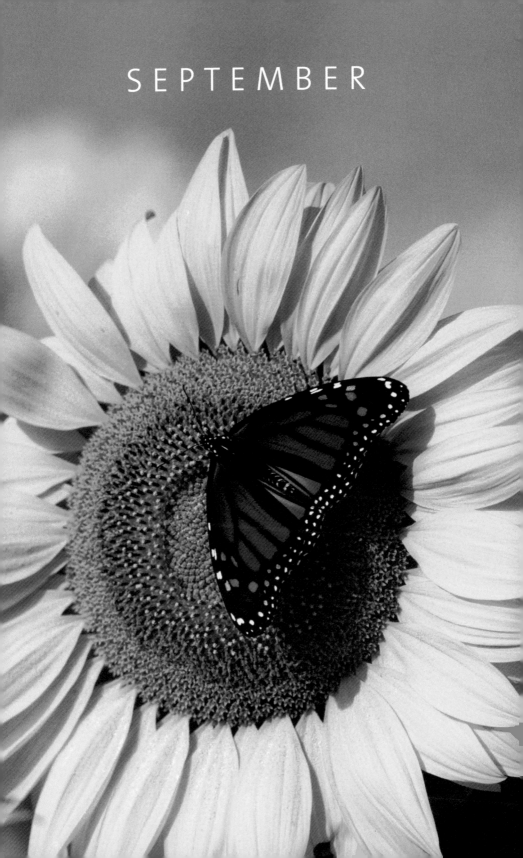

SEPTEMBER

Mississippi Kites
September 1

Mississippi kites often fill the skies of a late Kansas summer. These buoyant raptors soar so high that they can sometimes barely be seen. Their prey fly at treetop level, so you have to wonder if these vertical wanderings are conducted for the pure joy of it.

Kites are late nesters, tending young into middle July. They are famous for aggressive defense of nest sites. In Kansas, kites often nest in urban areas such as parks and golf courses. Kites perceive human activity as a nest threat, and this leads to trouble. Adult kites attack golfers and hikers, usually swooping them from behind. Attacks seldom make physical contact, though minor injuries sometimes occur. Mostly, it's just scary when a big bird swoops close to your head. Kites will rarely bluff if you keep direct eye contact. I freely try to provoke such dives for flight photos. I am seldom successful, unless I can dupe an attacker by looking preoccupied.

Kites are agile hunters, winging at high speed to pick off flying June bugs, dragonflies, or cicadas. Occasionally, they eat small mammals, lizards, and birds. These raptors are most impressive in open air where maneuvers are easy. They also dart among tree limbs in short chases.

By September, juveniles join the adults in high, lazy flight. Squadrons of kites etch the high blue, preparing for early migration. They will travel far, to central South America. Most kites leave Kansas by late September.

Today, though, they're up there, wheeling and inviting the envy of earthbound man. I watch and wish, noting the busy sky as a pre-autumn sign.

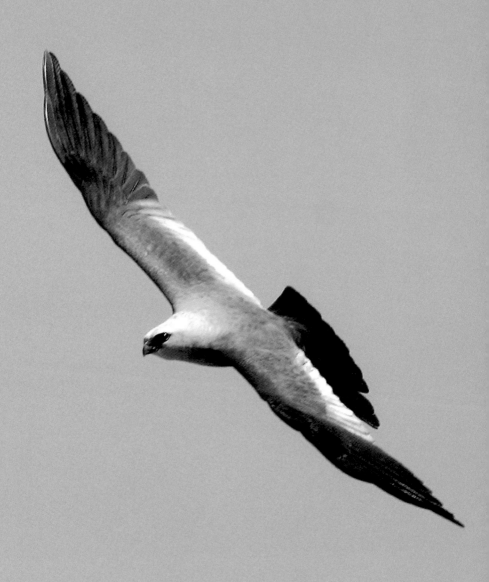

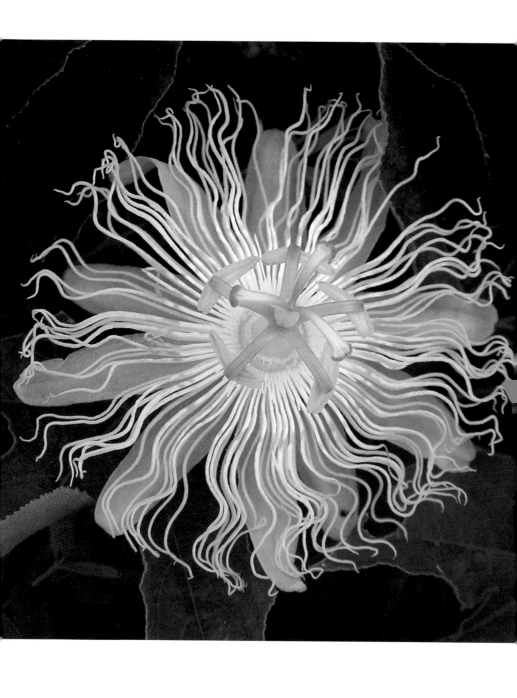

Maypop
September 3

I found a wondrous flower in the coal dumps near Pittsburg. So elegant was its structure that words were not enough. Only eyes could fully understand its beauty.

It was purple passionflower, or Maypop. This subtropical vine is rarely seen in Kansas, and only then in the southeastern corner. It grows in wild, sprawling places.

Maypop has large and intricate flowers with prominent styles and stamens. It's prettiest when purple or lavender and marked with greens and yellows. This one was nearly white. Still, it was exquisite.

The flowers normally bloom late June through August, so it was later than expected. Maypop grows on long, perennial vines in open pastures, right-of-ways, and thickets that receive adequate sunlight. Farther south, it's a common weed. It cannot grow in heavy shade. The flowers are self-sterile and require insect pollination. They are fragrant and especially attractive to bumblebees. The fruit, which resembles a yellowish hen egg, is edible but seedy. The dried plant is often used as an herbal remedy for insomnia and anxiety.

That's OK where plants are abundant. Here, I'd leave it for a seed source. Weed or not, Maypop brought a sudden, shining star to my pathway. An odd time to bloom, an odd flower to see—it was a special Kansas discovery on a late summer day.

Garden Spiders
September 8

Orb webs decorate the morning landscape now. Robust spiders hang head down in the centers of their silken homes. Webs are marked with heavy bands of zigzagged silk. The time has come for black-and-yellow argiopes: garden spiders.

The webs are strong, their makers, powerful. Prey include large insects like butterflies, moths, and dragonflies. When victims crash the web, the spider quickly bites and swathes them in silk. Bundled this way, escape is impossible. Then the spider can feed at its leisure for several days.

Argiopes build webs as large as several feet across. In warm weather, these spiders sometimes eat their webs at night and construct new ones the next day. But on cool nights, they hang in torpid suspension, subjects of dew-drenched art at daybreak. At such times, spiders in their open webs are easy targets for birds.

If you pass close by, garden spiders may "dance" and bounce the web. This is meant to warn, but it's actually an idle threat. Garden spiders are harmless to humans.

This female argiope feeds on a tiger swallowtail butterfly. A meal this size can sustain her for more than a week. Soon, she will lay as many as a thousand eggs and bundle them in a silken egg sac. She'll guard this until she dies, usually at the first hard frost. Spiderlings hatch in fall, but remain inside the protective egg sac through winter. Development will be completed next spring.

Mature garden spiders are a sure sign that fall is coming. Like many natural elements, they blaze and pass with the season. They add their color and their purpose—and help define September.

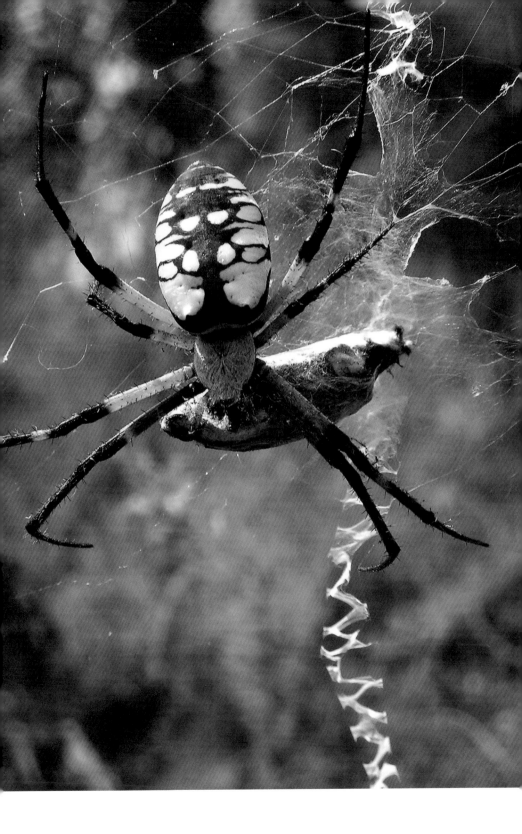

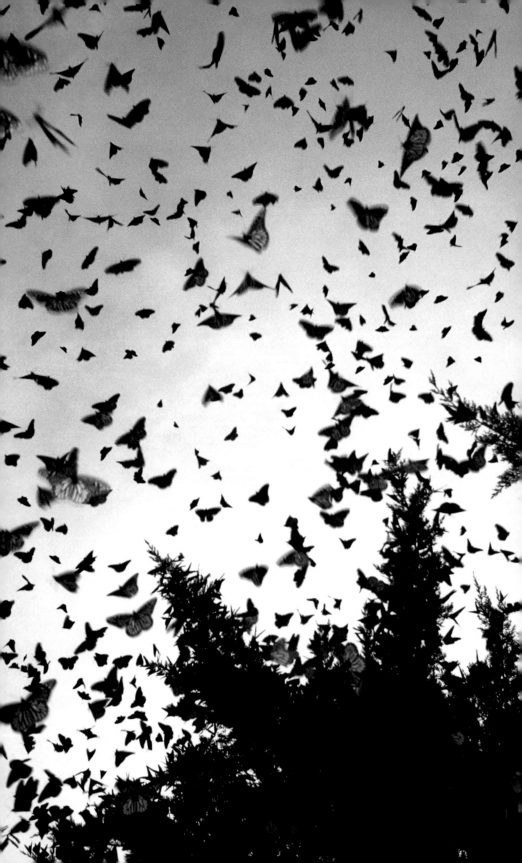

Monarch Migration
September 12

The annual monarch butterfly migration to Mexico may span nearly 2,000 miles. This passage is both amazing and unique in the insect world. Monarchs fly unerringly to a small region in the Mexican mountains, where hundreds of millions overwinter en masse. They mate and die, leaving new monarch generations to hopscotch northward into Canada through the summer. Then, adult monarchs from across the continent fly back south as fall approaches.

In a normal year, monarchs pass through Kansas in numbers prompting only vague awareness: *Oh, they're back again.* . . . But some years, the passage is impressive. They fly alone, but their concentrations can sometimes suggest loose flocks. When many are present, they roost together at night. Scent signals emitted by gathering monarchs invite others to land. Sometimes, these build-ups can be impressive—like the rare event I saw near Larned.

I was told of the gathering, and I arrived on a clear dawn to see it. The butterflies would not leave until a new sun warmed them to flight temperature. Monarchs covered a sunflower field and nearby cedar windbreak. Every hardwood tree appeared to be foliated with orange leaves.

I moved quietly and recorded the assembly. Acres of resting monarchs were simply astonishing. As they lifted off, butterfly clouds filled the air. I stayed for hours, watching as they headed south.

I'll probably never see such a gathering again. The day remains one of my all-time greatest wildlife encounters, and a sign to watch for in September's fleeting weeks.

Hawk Migration
September 16

Swainson's hawks are the most visible migrants of the hawk world. These large raptors are familiar hunters in both farm and prairie country. They commonly hover above tractors working Kansas fields, and even in the smoky air above springtime prairie burns. Both places, they pounce on prey trying to escape the disturbance below.

Swainson's hawks eat a variety of small animals, but unlike other large hawks, they commonly eat grasshoppers and moths as well. Because of this, they spend time on the ground in mown hay meadows or harvested grain fields where they chase down insects on foot.

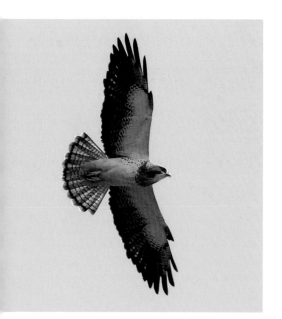

Swainson's hawks gather for migration in mid-September. They fly tremendous distances, often wintering as far south as Argentina. Large numbers of the soaring birds indicate a passage. Such migrating flocks are known as "kettles."

Migrating Swainson's hawks roost together each night on poles, posts, or trees. I once counted 130 on fence posts along a large field at sunrise.

Today, the sky was full of Swainson's hawks spiraling south. A camera didn't do the passage justice, since many flying birds were out of frame. Even so, the migration punched a card on the Kansas time clock.

And winter was coming.

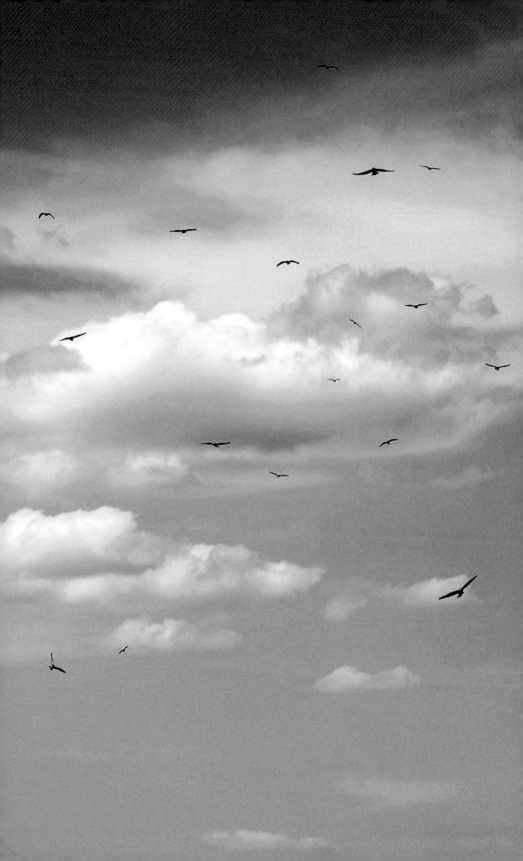

Teal
September 18

About the time summer's dog days convince you that the last heat wave will never break, cool air spills down from Canada to set a new tone for the rest of the year. Teal ride this wave, showing up in Kansas in large numbers. It's whimsy to believe these small ducks bring cool weather with them, but I like to look at it that way.

What really happens is, ducks catch a tailwind to ease their long flights. They don't bring cool weather—they simply move with it. Blue-winged teal are fair-weather ducks, disliking temperatures much below 50 degrees. Greenwings, their hardier cousins, consort with mallards and tolerate much colder temperatures. Even so, in the interest of family relations, some greenwings travel early with

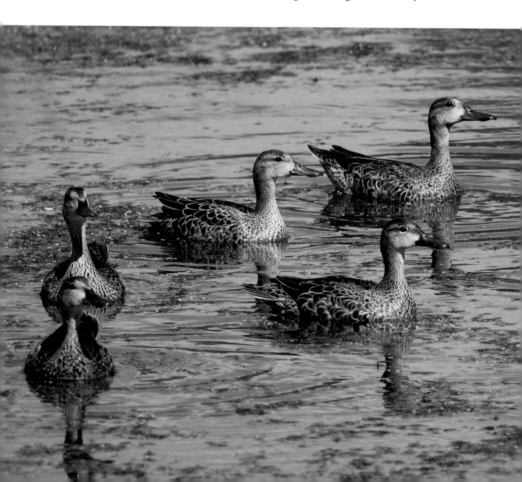

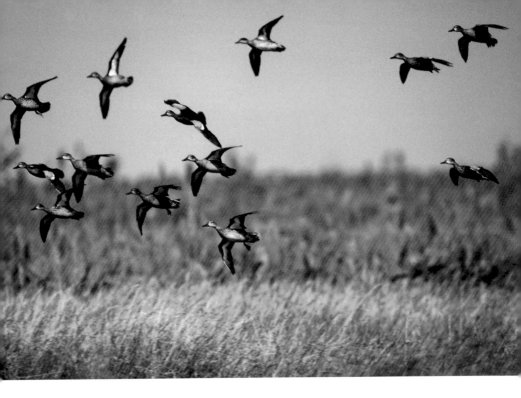

their brethren. I like to meet them on marshes when slate blue clouds promise rain and fall weather.

Fall teal season coincides with ripening milo. Find a flooded pothole in red grain, and hungry teal brush themselves into a living masterpiece. Flocks of fighter-fast ducks bank with the sound of tearing fabric and then splash and tip in the shallows. The water comes alive with their boisterous, small-duck doings.

Mosquitoes? Yes, but what the heck. I'll watch a teal show any day. This September gift is welcome proof that seasons are finally changing.

Valley Fog
September 19

Signs of autumn are here, though the season is not yet official. Morning fog in low areas is a function of recent cool weather, adding beauty to the late summer landscape.

This morning, ridges near Konza Prairie at Manhattan illustrate valley fog, a type formed when a cool substrate loses heat to still, stable air above it. Hilly terrain is especially prone to this condition, since cool, heavy air spills down slopes to pool in the lowest places at night, leaving warmer air above. Just before sunrise, thick clouds condense in the valleys, leaving tall trees and hills to protrude above the white blanket.

From Konza hilltops, I enjoy the misty scene. Fog decorates the uneven terrain for an hour after sunrise. Then, a warming sun lifts the clouds, and a heavy overcast rules for an hour before moisture evaporates and the sky clears. The day turns golden.

Valley fog is a favor of the state's rougher topography. It's most often seen in

spring and fall when temperatures are favorable. When viewed at a distance from above, the white cloak makes an unforgettable sight.

Yellow-gold trees? Fog in the valley? They're cards enough. With them, you can bet on September.

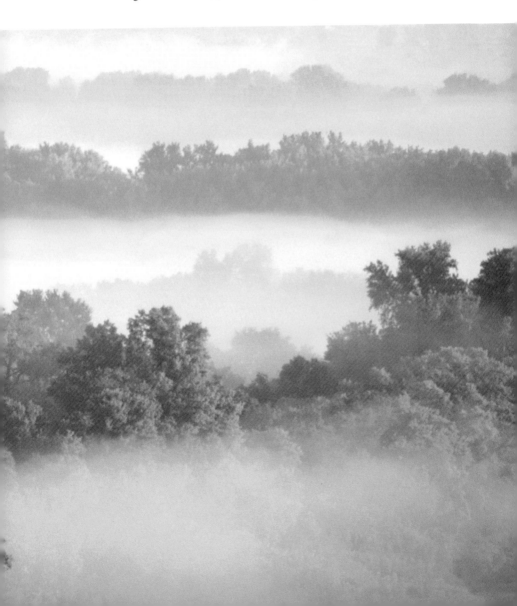

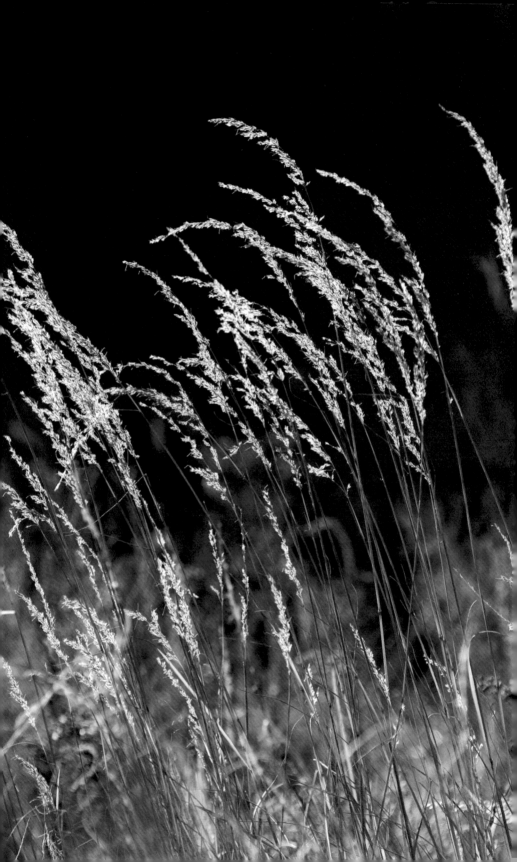

Indiangrass
September 20

If you want to *feel* the onset of fall, take an evening hike through a flowing stand of Indiangrass. Spread your arms, palms down, and brush the tawny plumes of this golden plant. Feel the soft seed heads, and see the light trapped in its vegetative webs. Hear the sigh as it nods in the wind. No grassland plant sets autumn's stage like this one.

Indiangrass belongs to the tallgrass prairie. It grows from 3 to 8 feet tall across much of the Kansas sod. This warm-season grass starts easily and develops quickly, reasons for use in most conservation reserve plantings statewide. Growth is best in well-drained soils but possible on other sites as well. The grass is hardy and drought-tolerant.

Indiangrass is dormant for much of each year. Growth occurs when soil temperature is 50 degrees or above—mostly during summer. Golden seed heads form on green stalks in August. That's pretty, but it's still several months before Indiangrass sees its finest hour. By October, the grass is gilded.

Tawny Indiangrass tells me when the land turns prime. In the dew of an autumn morning or the rays of a dazzling afternoon, Indiangrass dresses the landscape for fall.

I look for it each year, a harbinger of my favorite season.

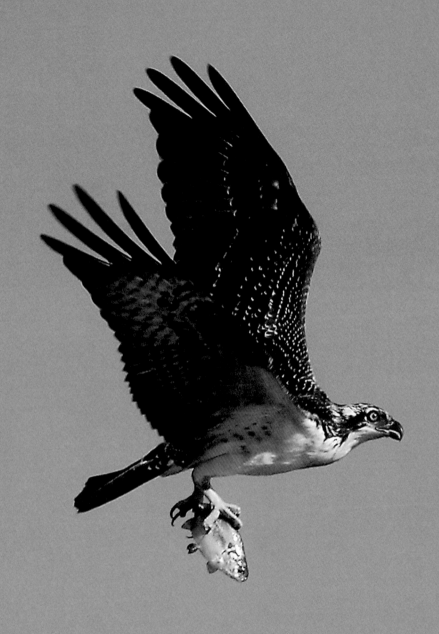

Osprey Strike
September 24

Ospreys are back in Kansas during this last week of September. These fish eagles put on spectacular fishing shows several times each day. Ospreys circle over water, using their keen eyes to spot fish cruising near the surface. Then they dive, hitting the water with a tremendous splash and often disappearing entirely before popping up and flapping away—usually with a fish.

The stoop is spectacular. An osprey wheels, tucks its wings, and dives nearly straight down to its target. Though the final 20 feet is just a blur, stop-action photography reveals perfect aerodynamics. Talons stretch out front in line with the eyes, the wings are back, and the bird knifes through the air with tremendous speed. Impact with the surface leaves the bird unfazed, and it easily takes flight again. Usually within a few seconds, the airborne hunter waggles and shakes its feathers to dry off.

Today offered a spectacular show when five ospreys gathered on our local lake and hunted through the afternoon. West winds forced the birds to dive toward the sunlight, allowing the finest view of their hunting techniques. Intensity is evident in the moment before a strike—an outdoor secret that is no longer secret.

Mushrooms
September 28

Beauty appears in many forms as summer gives way to fall. Today's version was a mushroom cluster in a hidden glen. The handsome specimens grew from a rotting log and were at the peak of growth. The discovery was lucky, since just the right combination of moisture and temperature is necessary to spawn the fruiting bodies. They arose from fungal mycelia in the rotting wood.

The new caps smelled strongly of fungi. The white flesh was clean and unmarred by feeding bugs. Pronounced gills added rich detail. Multiple heads formed a fine composition worthy of a painter's eye. In forest shadows, the mushrooms were a delicate find.

These were a species often called trooping funnel. This kind of mushroom grows in autumn and forms small bunches on rotting logs. Trooping funnel is said to be good to eat. But eating wild mushrooms is risky business, and I left the primitive plants undisturbed.

Shadows are getting longer now, and the smell of fall is in the air. Trooping funnel lights the "check fuel" warning on the dashboard of another growing season. It reminds me that the tank is running out for this Kansas year.

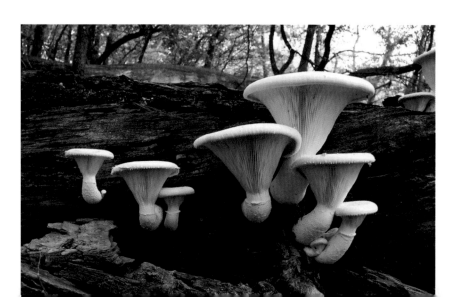

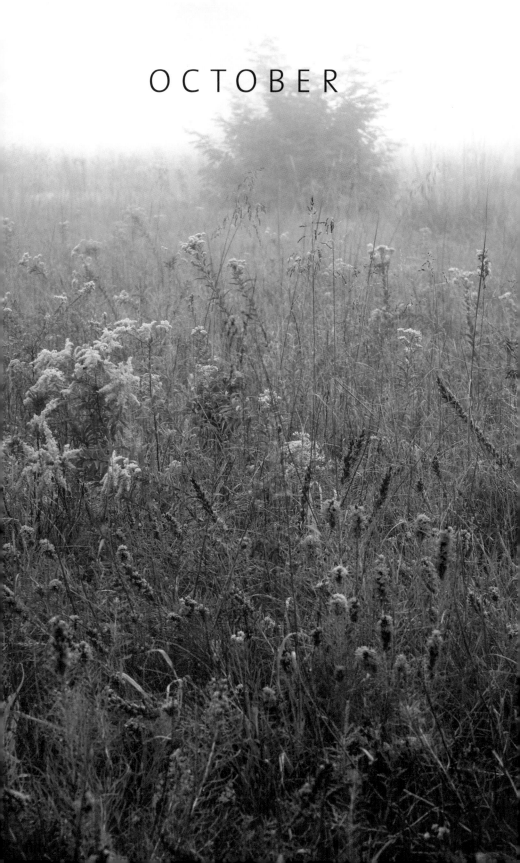

OCTOBER

Mast
October 1

I sit high in the canopy of an oak forest as splashing sounds break the silence. It's raining acorns. Chinkapin nuts let loose as the morning breeze freshens. They fall through leafy branches, sounding like pebbles hitting water. They build a feast on the woodland floor for deer and other wildlife.

There was a time when men knew their mast. Back before urban living, before the time when food was something you got at the grocery store, the mast crop was a topic of fall discussion. Each year, the woodlands produced nuts in varying amounts. In good

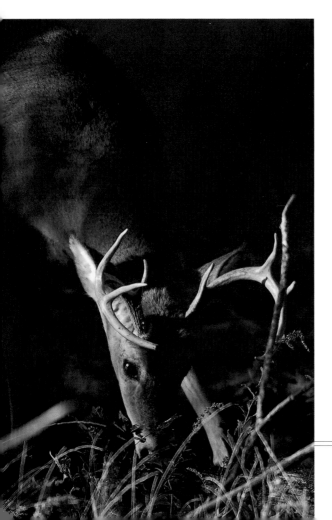

acorn years, squirrel and deer hunting were easy. Animals fed in predictable fashion in or under the best trees, wolfing down nutritious acorns. Poor mast years made hunting tougher as wildlife ranged widely to find other foods.

Not all mast was considered equal. White oak nuts—bur, post, or chinkapin, among others— were the favored smorgasbords.

These nuts fell earlier and had less tannin than red oak acorns. Tannin was bitter. Animals preferred the milder white oak mast when available. Squirrels on a diet of white oak nuts tasted better when eaten as food. So hunters always watched the white oak crop with special interest. Even so, all acorns were an important food source, and any oak species made a favorite hunting destination when mast was good.

Now, it's another world, and few pay attention to the old things. But nothing has changed from that early woods lore. I walk the path that came from this heritage, and I understand, too. So today, splashings in the oaks are calling, and I wait for a deer and a wild autumn harvest . . .

Cardinal Flower
October 3

The autumn woods held a rich surprise as I walked along a pin oak flat at Marais des Cygnes Wildlife Area. Cardinal flowers! Dozens of the plants enflamed the shadows with their scarlet spikes. Some call them America's favorite wildflower because of their intense, glowing color. They're common garden plantings, but seeing wild ones in the Kansas woods is always a special treat.

These were scattered along a forest edge where western light offered favorable growing conditions. Cardinal flower grows best in dappled light on stream banks, sand bars, and marshes where protected from all-day sun. But neither does it like heavy shade. The plant depends on soils that are well watered most of the time.

The scarlet flowers are impressive when muted yellows and oranges just start to show in the landscape. Their fiery red is a precursor to fall's flaming hues yet to come. Cardinal flowers can grow up to 5 feet tall, though the ones I saw were half that size. Even so, their showy blossoms drew instant attention. The red flowers are special beacons for migrating hummingbirds. Hummers help pollinate the flowers when drawn to their favorite nectar source.

It's easy to see why Native Americans used the cardinal flower as a love charm. Few natural elements are more colorful—even in the most glorious part of a Kansas year.

Purple Dye
October 5

Here and there across Kansas, you run into prickly pear cactus. Or hope you don't. Spines capable of flattening street tires or penetrating hiking shoes cover this small, dryland plant. Just as bad, it has soft tufts of fuzzy hairs that seem harmless but penetrate skin almost invisibly. These usually cause festering bumps that heal and stay with you the rest of your life—all because you can never find the little sons-of-guns to dig them out.

The daring may scrape and eat the flesh of prickly pear. The fruit, a handsome pink nodule about half the size of your thumb, can be used for jellies and relishes. Try this at home, and you're sure to learn the hard way about the soft tufts of fuzzy hairs.

Prickly pear has problems of its own. Scale insects may colonize the plants, resulting in masses of white fuzz that protect the feeding insects. These look like bird droppings on the cactus leaves.

Crush a fuzzy mass, and you find one of nature's most vivid natural dyes. The color is a beautiful deep wine, and you immediately learn its permanence. Once your fingers are dyed, the stains must wear off: Washing is not enough. The dye is useful for those who need natural pigments for art or fabric projects. Obviously, source is a limiting factor, unlike purple dyes such as pokeberry that are also colorfast and produce higher volumes of dye material. Even so, the color is subtly unique and worth knowing about.

The scales may be noticeable all summer, but it's early fall when I usually see them. Outings then reveal the dense, cottony vessels of rich dye. Nature has many such hidden treasures for all who step to natural rhythms—and what better time than fall to find them.

Gray Squirrel
October 6

Nothing says *busy* like squirrels in the fall woods. Kansas has two kinds: the fox squirrel—large, red, and familiar statewide; and the gray—a small, sneaky animal sometimes called a cat squirrel because of its habits. I'm partial to the gray. Fox squirrels can live in open country with windbreaks or a few trees. Gray squirrels live only in true forest situations.

Grays do things their own way. They usually live and nest in tree cavities. Because of their small size, they can squeeze into woodpecker nest holes. They are most active at first and last light. They are wary and difficult to approach. When alarmed, they alert the whole woodland community with wheezing squeals—much different than the sharp, staccato barks of fox squirrels—but maybe more efficient, because they never quit until danger is gone.

Fall is this animal's busiest time, since it stores food for the winter. Gray squirrels bury walnuts, hickory nuts, pecans, and acorns individually, scattering them over their 10-acre homes. Nuts are usually tamped into an inch or more of soil, placing them in a perfect growing situation if unused. Interestingly, the nuts are often buried in openings where extra light is conducive to seedling growth. Gray squirrels are important tree planters.

In poor nut years or extended droughts, gray squirrel reproduction is limited. However, populations rebound quickly through large or double litters during good years. Major population swings can occur in a several-year period.

The gray squirrel is a symbol of the October woods. Watching it work tirelessly to prepare for winter is a lesson in life.

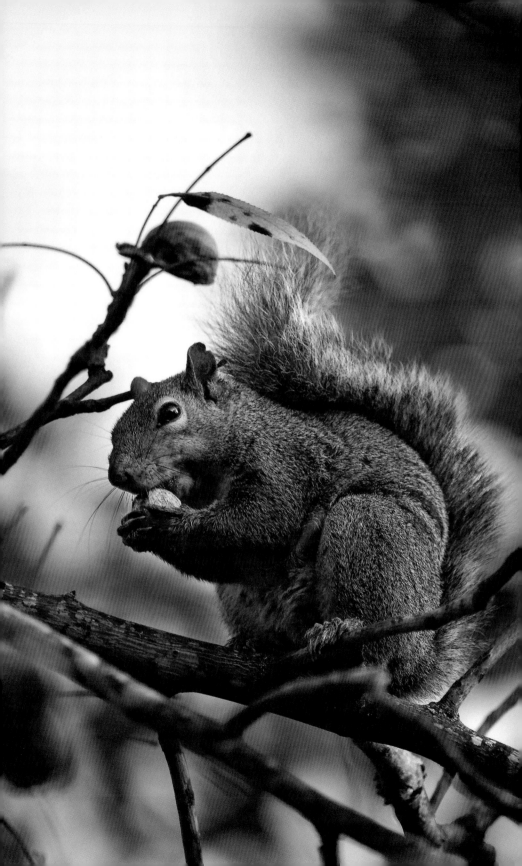

Norther Arriving
October 11

On a rare day, a fine day, you can sometimes watch the seasons change before your eyes. Today was such a day.

The calendar and meteorologist say that fall has officially started, but all of that's just talk when temperatures in the 90s stay way past their welcome. In a normal year, cool relief appears by the equinox, and fall advances on a slow and gentle schedule. But this summer was a bully; it threatened to stay and simply scorch the leaves off the trees. I thought that might happen, too—until today.

I sat in parched timber, waiting for wild turkeys to feed along the creek. Through ragged windows in the thinning canopy, I saw a hard line in the far northern sky. It was a serious front, riding six white horses and advancing with purpose. The hot, southern breeze was oblivious, and the sun seemed indifferent. For an hour or so, summer hung on.

But you could tell what was coming. Life in the woods began to dance. Birds and squirrels got active, and deer started moving along beaten runways. The wind grew calm, the air, questioning. A massive dark blanket was pulling itself across the sky. You could see it moving now, marching southward. And you knew its air was cool.

It was a feel-good moment when things were suddenly right again. The sun winked out. Breezes stirred from the other direction. In the sudden shade of Canadian clouds, fall appeared, just like that. And this time, it was the real deal.

October
October 13

Now . . . the days are rich with beauty. Poison ivy and Virginia creeper wrap tree trunks in crimson spirals, while gold and orange canopies glow against a blue sky. The first sandhill cranes voiced their buglings yesterday, calling down from high rivers of southbound air.

Whitefronts joined the chorus at dusk, a sure sign that fall is here for real.

Stars twinkled in this morning's cold dawn, and the season's first frost was on the grass. The day warmed to a glorious 65 degrees, with sunshine so bright that clouds dared not appear. Squirrels hurried to work, storing fat for now and food for later. Snowy tree crickets trilled in the autumn fields, and a coyote let loose as the sun touched the horizon.

Sugar maples splashed the hills with red. The sun set early, south of west.

Life is joyous. Life is urgent. Life is dazzling.

It's October.

Food Fight
October 16

Wild animals feed heavily in mid-October to stock up for lean months ahead. Many species may share good food sources at the same time. Wildlife neighbors usually get along at a community feeding site, but disputes can arise.

Take deer and raccoons, for instance. The normally mild-mannered deer tower over aggressive raccoons, and a deer's sharp hooves could split a furbearer wide open with a well-placed kick. On the other hand, a snarling raccoon known for its fighting skills could deliver a painful bite to a deer.

Physical contact probably seldom takes place, but trail cameras prove that bluffs are common when these two animals decide to take the same bite of food. I bait the woods with grain where

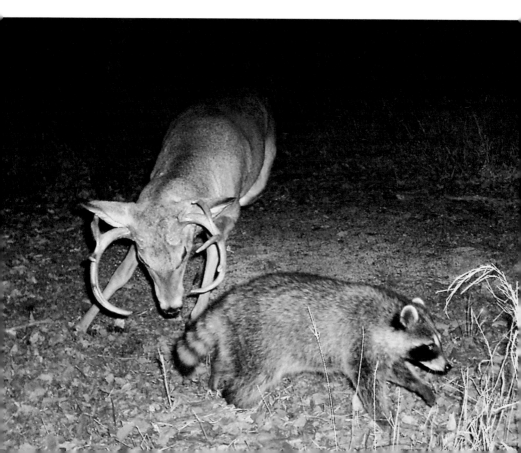

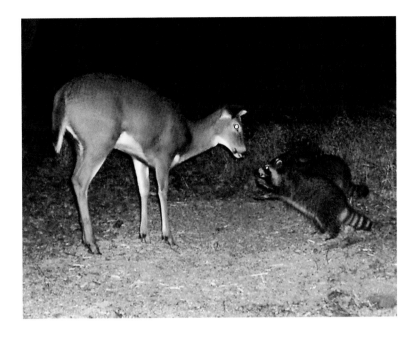

animals feed and compete each night. Half a dozen raccoons and the same number of deer often feed peacefully within a step of each other. But sometimes, one of them gets cross, and the animals bluster. As expected, the coons usually yield to their much-larger opponents, but it's not without comment. And that results in surprising photos.

Fawns, at the bottom of the deer pecking order, enjoy bullying the smaller diners. Chases are common. Antlered bucks, charged with testosterone for the coming rut, are irritable and intolerant of any challenge. Sometimes a buck lunges. Sometimes a raccoon leaps at a deer.

But ill will is fleeting. Soon, all return to their meals, and peace is restored. After all, plenty of free food keeps everything in order in the fall outdoors.

Fall Color
October 24

Color is spectacular right now where eastern Kansas maples grow wild on the autumn ridges. That country is home to me, and I visit each fall. Vibrant color explodes in a grand finale that lasts mere days. It renews me to see it again.

The process of autumn color is intriguing. Yellow and orange pigments are always present in the leaves of most trees. After bud

break in spring, green chlorophyll builds quickly to hide these colors. As days grow shorter in fall, some of the chlorophyll breaks down. Secondary leaf colors then become visible. Microvariations in temperature, moisture, and sunlight account for an infinite mixture of greens, yellows, and oranges. Color variation depends partly on tree species.

But the season's real magic—red hues of sumac and sugar maple—forms another way. A cell layer develops at each leaf base to stop flow between the leaves and roots. Leaves continue

to produce sugars in certain species, but these are now trapped. Red pigments called anthocyanins build up in the leaf. These cause the brilliant scarlet hues. Best color occurs when warm days are followed by cold nights. The process can vary at different locations on the same hillside, creating vivid pockets of color.

Gradually, autumn paints the woodlands. The kaleidoscope builds to a crescendo and then fades before we're ready. But for a week, the very light of day is tinted by fall's magnificence. It is the outdoors' finest hour.

October 24. I wish I could slow down time. But I can't, and that's why this wondrous week is my favorite of the fifty-two that mark a Kansas year.

Fall Ducks
October 26

The marsh is all business now. Sure, there'll be loafing in the noontime heat, and for the naïve observer, ordinary will seem to rule the day. Dragonflies will patrol the shores, and turtles will sun on logs. Five-legged crickets may hint that the summer show is over, but you won't know that by watching a heron spear a frog.

The ducks tell you. They wouldn't be here, if it weren't for the Grim Reaper stretching cold fingers up north. Death waited there. The ducks know, and they're on schedule. They're restless, even while tipping and dabbling in midwestern pools that still teem with summer's seeds and larvae. They're in no great hurry—but they're watching the weather for the best flight times south.

Strong and exercised, wearing new sets of fall plumage, they're always ready to move. In fact, it's a sign of the season: ducks taking off for no good reason, making a pass, and settling back in. They fly from pool to pool, just to stay limber for continued migration.

There is power in the sound of duck wings now. You can hear in them the thunder of distant winds. You can feel in their draft a stirring of distant cold. And you know that one day soon, ducks will be gone . . . taking fall with them.

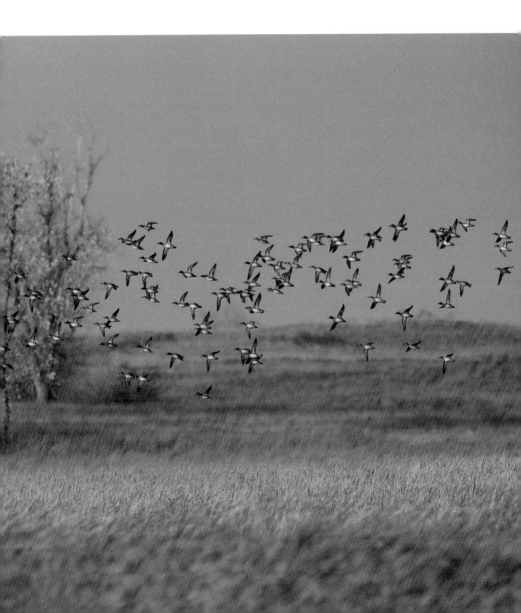

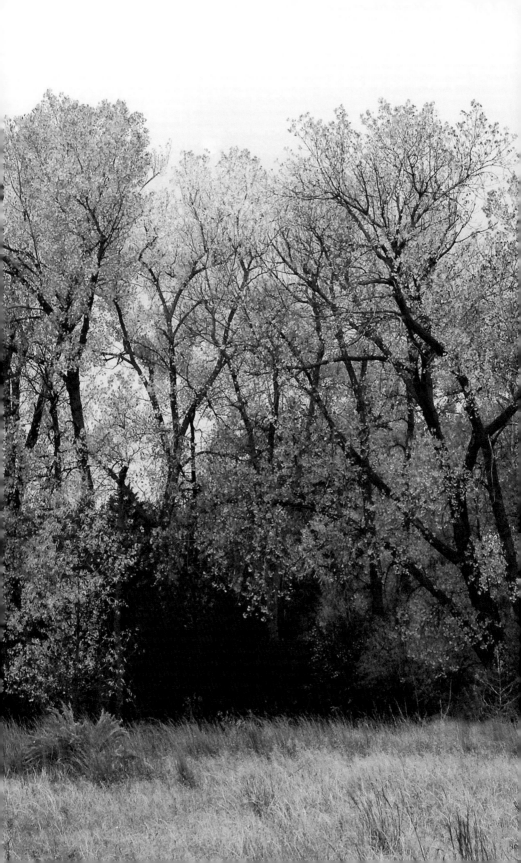

Thinnings
October 28

I love the sound of fall cottonwoods. They applaud the arrival of October's fresh winds. Their sound reminds me of our old country house. Cottonwoods overhung our bedroom, and each night through open windows, their rattling leaves measured the wind and sang us to sleep.

I heard them again today. A north breeze stirred the cottonwoods as I walked along a two-rut road. The trees were tired now. Some years, their crowns are golden starbursts as late as mid-November. But this dry fall, they succumbed to heat. Their leaves, overworked by drought, were brown and spotted as they hung on the trees.

They fluttered as always, twisting on flattened leaf stalks that make them unique among Kansas trees. But the wind that fueled their fall concert sent them scuttling early to the ground. Already, before October ended, they were thinning rapidly. This year, their color would be disappointing.

The sound of the leaves was softer, too. Only when they quake together is the symphony full, and too many leaves were missing. But even so, I listened and enjoyed, knowing the lesser gift was all this Kansas year could afford.

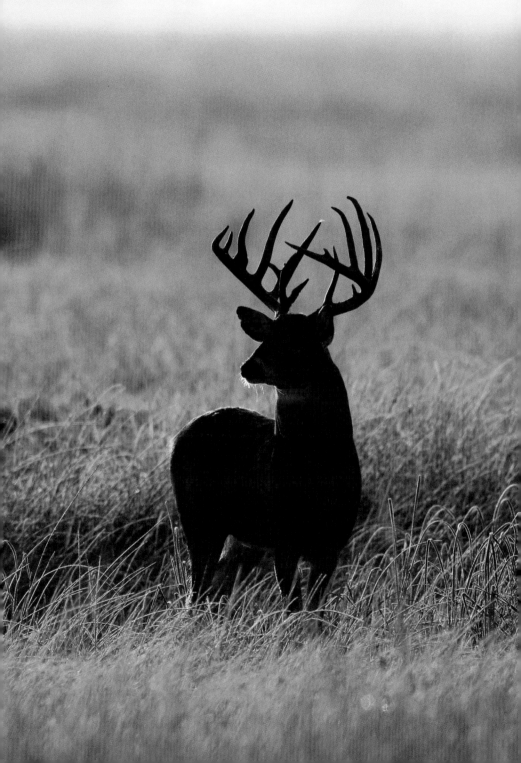

NOVEMBER

Reflections
November 1

You must see the waters on a November day.

Earth's natural mirrors are made for beauty, and there's no finer view than an autumn wood seen double in reflected glory. Granted, November foliage is sparse some years, but the color that remains is refined and brilliant. Fall reflections are among nature's best showings in a trip around the sun.

The water must be right—clear and settled, as it often is this time of year. Muddy water from heavy rains? It's not worthy of fall splendor. The water must lie in state, unperturbed by wind or current, flat as marble, bright as gold. Only then is it autumn's looking glass.

There's distance and angle, of course. A mathematician could calculate such things, but why? Simply go to a lake, a pond, or a stream, and look. You'll see the beauty as you explore, and you'll naturally go where the views are best. Find an open shore where water can be seen from a low vantage, and hillside color will reverse itself in a magic way. A leaf, a tree, a ridge . . . the best of fall awaits in mirror image.

You must see the waters on a November day. It's a sight you won't forget.

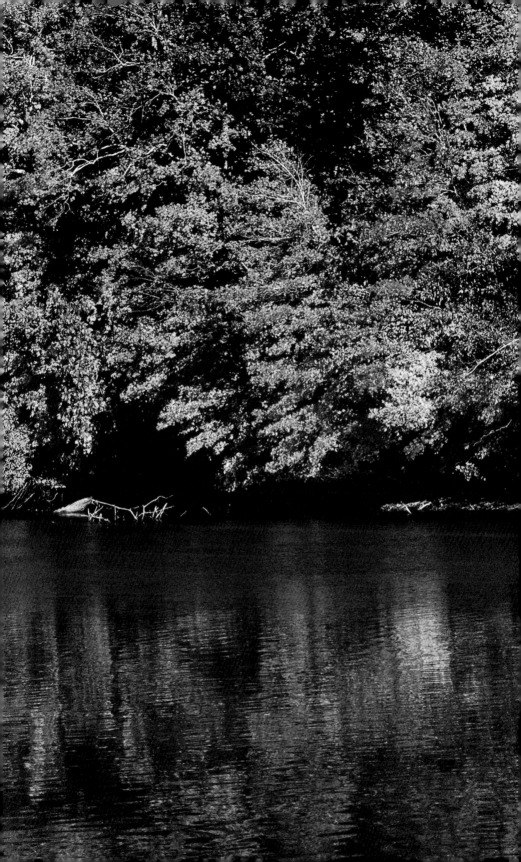

Ballooning
November 3

This time of year, silken strands seem to decorate every fence post and twig in sight. Look toward the sun in late afternoon, and silver threads are evident where light shines through. Spiders cause this when they travel to new habitats by "ballooning." Spiders less than one-quarter inch long are light enough to be lifted by average breezes or thermal currents. They throw out strands of silk and then fly away when the wind picks them up. In this way, they can move vast distances, sometimes hundreds of miles, to inhabit even remote islands. More commonly in Kansas, ballooning spiders quickly inhabit a disturbed area, such as a prairie after a fire.

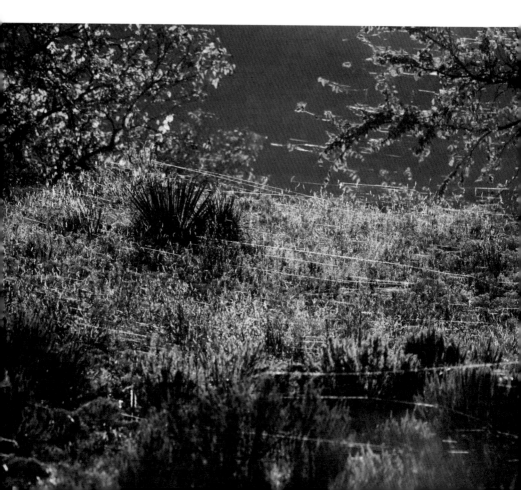

Ballooning is most common in fall, when young spiderlings hatch and disperse to new areas before overwintering in dense grass or leaf litter. Ballooning spiders may number in the tens of millions per volume of air above one square mile. And you wondered where spiders came from . . .

Ballooning is easy to observe, once you know what to look for. Sometimes, you can see strands of silk flying overhead, but most often, the silk is noticed where it seems to stitch plants together across the vast landscape. Ballooning announces that fall has arrived, another natural marker on a Kansas journey.

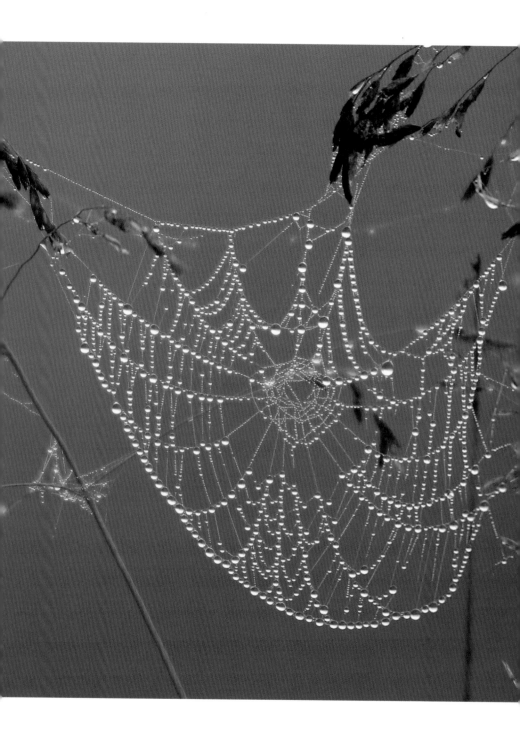

Fall Rain
November 5

Rain came today. It was the soft kind that often marks November, a steady patter on thinning vegetation. The gray sky never brightened. Leaves glistened in the gloomy light. It would seem that full sun might make autumn's brightest showing, but its glare is a thief. Colors glowed in the soft and muted light of rain.

Free from wind, raindrops clung to every twig and leaf. Steady rain soaked the soil. The dry duff, crispy as cornflakes before today, softened and settled. Now you could walk in silence.

Wildlife welcomed the respite. I moved quietly in camouflage clothing, careful as any animal. I saw the red-bellied woodpecker, disheveled but happy, quietly probing a trunk for grubs. A bushytail hopped through the wet ground litter, looking for fallen walnuts. A young white-tailed buck moved steadily down the creek, hoping to find a doe as the rut began. An older buck followed a minute behind, using the young deer as a scout for danger.

I was wet but not cold. The fall shower brought odd comfort. Things were as they should be. The long, fall rain was bittersweet— on one hand, the farewell tears for another growing season; on the other, a freshening as the year's natural decline continued.

This long drink would revive the woodlands. In the coming month before hard weather, life would be grand. I felt it all and was part of it. I anticipated it. November rain washed my spirit.

Carolina Wren
November 7

Nothing cheers a fall morning like a Carolina wren. The woods are dressed up, and the air is crisp. Birds and animals are busy storing food. When the wren starts up, it's like oldies playing at the drive-in restaurant on a summer night: it just wouldn't be the same if things were quiet.

This wren is common in the eastern half of Kansas, and it's gradually moving westward. It's a handsome little bird, rusty red on the back and buff-colored below. Its most notable feature is a white eye-stripe. It's a curious bird, and may hop close if it sees you sitting against a tree, as I did today. Then, you can study its pert behavior up close—just don't move.

Most often, this wren is heard, rather than seen. In the fall timber this morning, I listened to its melodic tones ringing through the woods. Carolina wrens have a distinctive call with individual variations. This one had a catchy, slightly unusual cadence: *On Sunday and Monday, I'll sing for you . . . On Sunday and Monday, I'll sing for you . . .*

On and on it went. The wren paused only to listen for the return calls of its kindred farther down the creek. I heard at least three answers with my failing ears; I'm sure there were more.

The bird was clearly happy. It sang with verve for several hours, burning another image into memories that I see when I close my eyes and think of November.

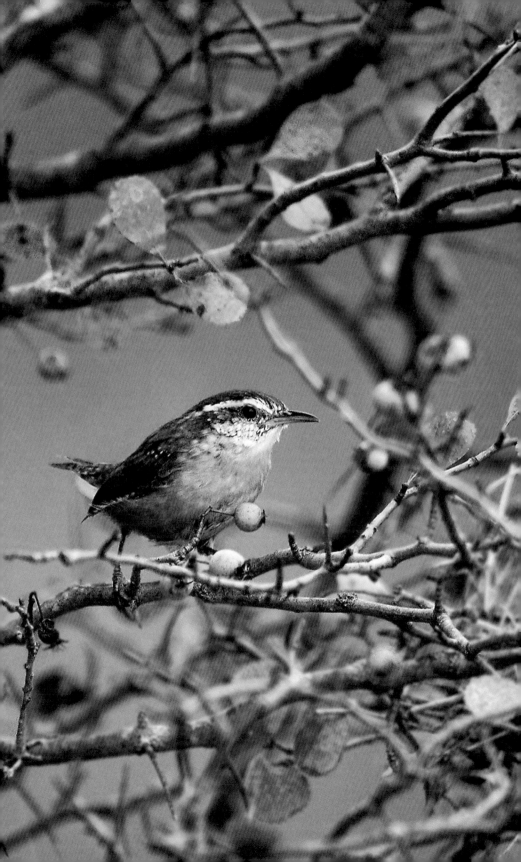

Persimmons
November 10

Bright orange persimmons are a feast for the eyes. When tingeing purple, they're a feast for the tongue. Then it's time to gather these natural candies.

Persimmons were everywhere along my eastern Kansas pathway today, and sign showed that wildlife considered them the tastiest treats in the woods. Scats of raccoons, possums, and coyotes— many imbedded with the fruit's flattened seeds—littered the ground near persimmon trees.

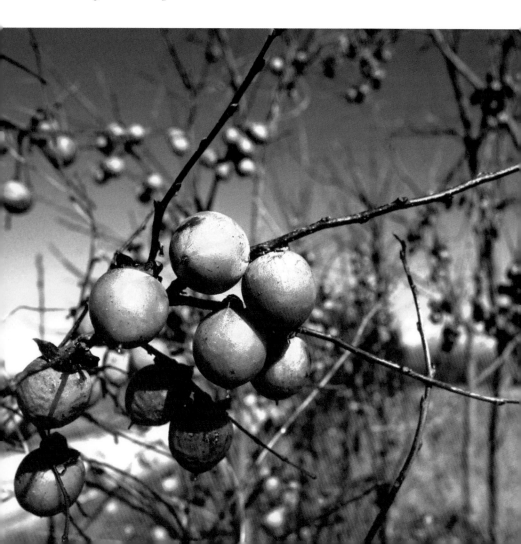

I tried a few of the wild goodies. Persimmons are a fickle treasure, and timing is always the key. Frost and aging are necessary to produce the expected sweet and luscious flavor. Before they're ready, persimmons are filled with tannins that cause a bizarre, astringent taste. Frankly, it's an experience that everyone should try, since nothing else is like it. Green persimmons are the kings of pucker.

But freezing breaks down the tannins, and when the fruits are soft and dentable, they're delicious. Mostly, they are eaten raw, but sometimes they're used in pies or puddings.

Wild persimmon trees are small and shrubby. They're found in fencerows and grown-over fields on Kansas' eastern margin. They grow slowly, especially in dry soils, but can live for more than a century. Their blocky bark looks like alligator hide. Heartwood is black ebony, but it doesn't develop for decades and is seldom commercial.

Instead, the persimmon's jobs are to feed wildlife and provide fall beauty: missions accomplished. Walking through fields on November 10, I eat my share, enjoy the sweetness, and watch another year packing for retirement.

Rut
November 11

I heard the sounds of chasing even before it got light. Deer splashed through the river, and everywhere, bucks ran does through the timber. The rut had kicked in during darkness. Up until yesterday, I'd seen bucks moving steadily and sniffing along trails. But overnight, the deer mating season had begun in earnest.

If I could pick one day to watch white-tailed deer, I'd choose November 11. In thirty years of personal observation and journaling, this day emerges as the most explosive time to see big bucks in daylight. Most trophy deer lead secretive lives. They feed and travel mostly at night. They stay close to heavy cover, and it's rare to see a giant whitetail in hard antler.

Except during the rut.

Now, bucks move with abandon, following does anywhere at any time. Storybook-sized deer may pass through your front yard. You can stop along a country road, and a huge buck with a doe in a ditch may ignore you at high noon. Because of this, deer-vehicle collisions are common when the chase is on.

In a day or two, things settle. Breeding begins, and paired deer melt away into isolated thickets where they tend to stay put. But now, during the chase phase, the bucks run hard to check every doe they find. It's an autumn ritual of a waning year. But it primes life's engine for another season.

I wouldn't miss it. This is the time when classic, outdoor paintings come to life. You can see for yourself one of nature's finest shows, and feel the pulse of November . . .

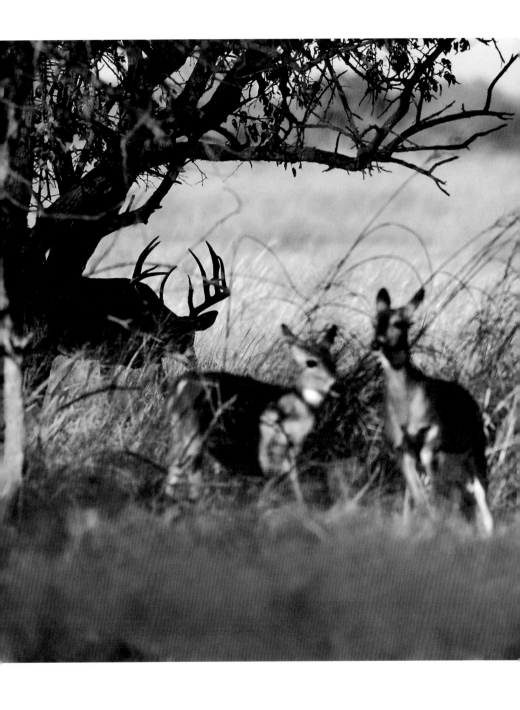

Bittersweet
November 15

Orange berries caught my eye in the drab November woods today. Freshly weaned from the riot of colors now gone, I welcomed the sight for two reasons: surprise beauty, and the chance to make holiday wreaths.

Few plants are as attractive as American bittersweet. At its fall best, bright yellow leaves play among berries in a stunning display. The fruits are scarlet red, enframed by orange husks that remain into winter. When the leaves fall, berry clusters show as fiery beacons in a graying landscape—often high in the trees.

Bittersweet vines are aggressive climbers and often found on trees or fences along a woodland edge. Berries don't last long when hungry birds visit. Many species eat them, leaving only the hollow orange husks.

Collected berries dry naturally and hold their color for months. Woven into grapevine wreaths, they make beautiful and natural home decorations. I make fresh wreaths almost every year. They last indoors from one fall to the next.

The catch? Bittersweet vines must be taken along with the berries, and careless collection can destroy the plant. I leave bittersweet alone where it's uncommon. When I do collect, I take only the outermost parts. This way, it remains strong and replaces terminal portions with berries again next year.

Eventually, bittersweet wreaths lose their luster. Still, they brighten my home year round. They help keep the outdoors indoors through the seasons, reminding me to watch for another November, when a fresh batch of berries will open again.

November Geese
November 16

A glowing sunrise showed endless streams of flying birds. This was Quivira at its finest hour, when nearly a million waterfowl called it home before moving on. Quivira National Wildlife Refuge, located in the heart of Kansas and the Central Flyway, is an autumn wildlife mecca. The dawn refuge promised spectacular viewing.

A mild fall left late color in the dying marshland. I drove slowly around Wildlife Loop, listening and watching thousands of trumpeting sandhill cranes. Many had lifted off already; now, the remainder voiced interest in flying out for breakfast. Nearby, huge rafts of snow geese also waited. Suddenly, the air went white as the geese took wing.

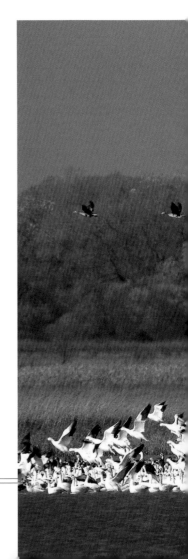

Snow geese were rarely seen at Quivira before the early 1990s. Up until then, Squaw Creek Refuge in northwestern Missouri traditionally held most snows during fall migration. But by 1995, large fall flights began to appear at Quivira, while Squaw Creek numbers declined.

No one is sure why. Some speculate that a single odd weather system caused a paradigm shift. Migrating birds swung west one year, allowing them to find suitable stopover habitat in central Kansas. Then the birds continued to go that way. Others believe that a growing continental snow goose population simply expanded into more westerly niches.

Whatever the reason, snow geese are now a normal part of the Kansas fall outdoors.

White geese rising in this morning's November sunlight were spectacular in sight and sound. Goose music blended with the voices of cranes to create an unforgettable symphony on the flat marshland. The experience left an indelible mark as this public land took center stage in the glory days of fall.

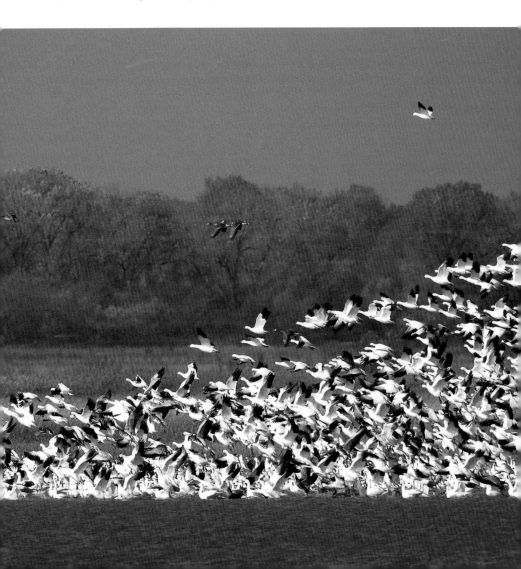

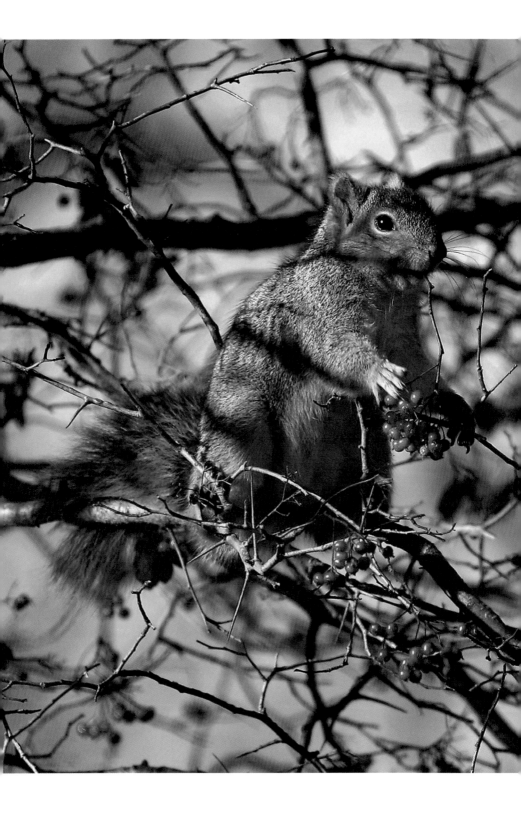

Fall Feast
November 26

I look forward each year to Thanksgiving. It kicks off the holiday season and wraps up another year of production. Everything is settled, and the harvest is in. Food and celebration abound.

Thanksgiving is a natural holiday for all of life. Late November is a bounteous handout. Growing season is over, and there's time to rest. Lush growth lies behind, with hardship ahead. But for now, this stretch is often filled with gentle days.

Leaves are gone, but berries and mast are plentiful. Food is easy to find. Temperatures are mild, and animals are strong and fat entering December. A party atmosphere pervades the land.

Color is gone, but a third of fall remains. Winter is still hidden by wispy cirrus overhead: The final season can be sensed by those with an outdoor eye, but it's still too early to pay it heed. Soon enough, the door will close on another vibrant year.

No worries. Now is the time to revel in the goodness that remains. Now is the time for Thanksgiving.

Coyotes
November 30

I heard them in late afternoon. They sounded like an old-time radio straining to find a station, yowling across the musical scale until zeroed in. Then a chorus of *yii-yiis* bounced from group to group across the distant horizon. Coyotes were on the hunt.

No Kansas animal stirs me like the coyote. These shifty dogs are the smartest, wariest, most highly strung animals in the state. I've filmed them, called them, and hunted them for decades. I raised several coyote pups when I was a kid. I still remember their ability to outwit squirrels that sneaked across the yard to drink from a watering dish. My dog would chase a squirrel and always lose the race. But the coyotes would dash directly for the tree, cutting off and catching a squirrel as it tried to escape.

I admire a coyote's understanding. The biggest buck in the woods might look you right in the face, shrug, and then move on. Not a coyote. This animal identifies you instantly and runs for its life. Anything amiss? The coyote asks no questions. It simply heads for safety. You could never outwit a coyote if it weren't hungry all the time.

And that's where my electronic caller came in. I spent a few minutes and set up against a small cedar, hiding my camera's big lens with a camouflage tarp. Popping a cassette tape into the caller, I hid and turned it on. The sounds of an injured rabbit wailed across the flat. Minutes later, I caught movement.

The coyote raced in, looking for a meal. I panned the focus, struggling to follow the fast action. When I fired the motor-driven shutter, the sounds spooked the animal and it darted away. But one of the frames was just right—a perfect study of the top Kansas predator racing toward potential food in the waning days of a Kansas year.

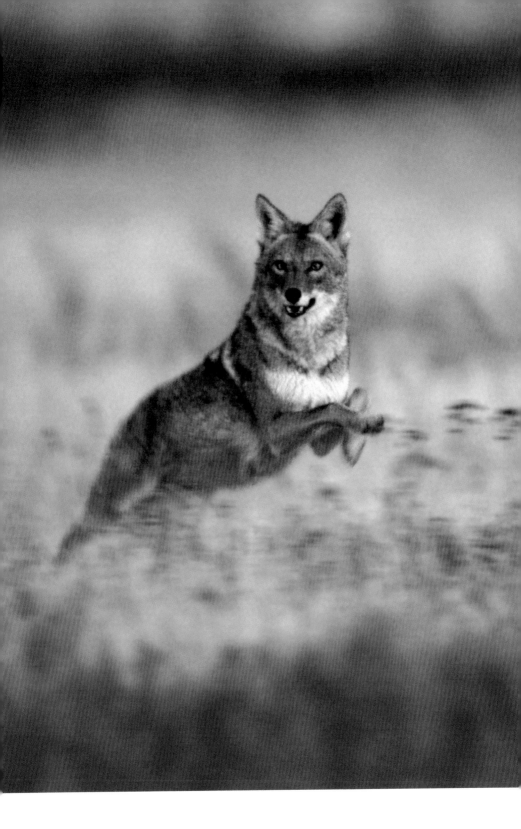

DECEMBER

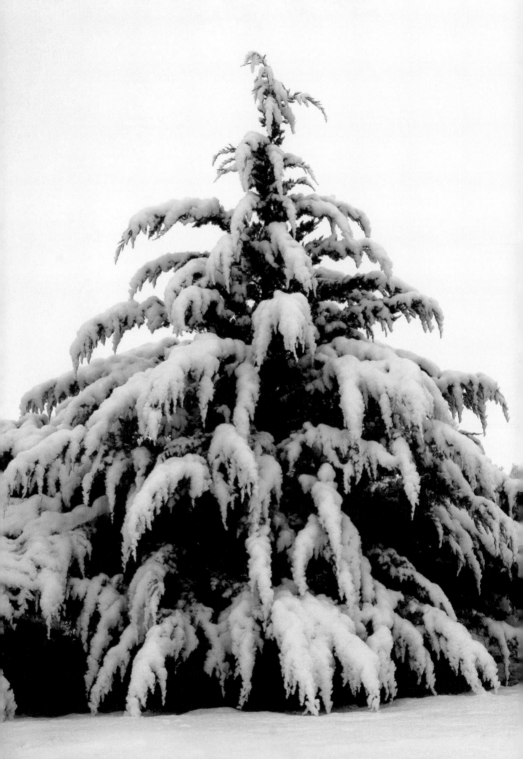

Christmas Tree
December 3

Today my shoulders felt empty as I went to cut the Christmas tree.
My daughters used to ride there, back in the magic years when
our kids were little. The whole family would bundle up and search
through pastures and woodlots for the perfect tree. Kids' idea of
"perfect" sometimes led to an odd specimen, but it never mattered.
By the time a tree was decorated, it was always just right. And it was
special because we'd found and cut it ourselves.

 I missed the old times as I headed out alone with my saw. What
was once an expedition was now merely a quick stop on the way

home from hunting. I chose cedar, as always—not because it was free, but because it was real. Cedar lives on the land where I live, and that makes it part of me.

I found the tree I'd preselected and sawed it down. As always, I counted the rings on the stump. The tree was eleven years old, sprouted in native grass under a cottonwood tree. Those years ago, it was planted by a bird or a raccoon that passed a seed after eating cedar berries somewhere else. The tree wasn't flawless, but it was thick and straight and better than dozens of others I looked at. And now I took it for a special purpose.

Darkness closed in as I loaded it up. At home, bedecked with lights and ornaments, it would smell of the outdoors: it would smell of Christmas. There were reasons to switch to safer and easier artificial trees, but it wouldn't be this December.

I cut a cedar. And it felt like old times in a Kansas year.

Frost Flowers
December 5

Early December finally quits flirting with winter and calls it a date. Nighttime lows drop to 20 degrees, shutting off the growing season at the main valve. Everything herbaceous freezes hard and starts disintegrating. These first, cold, calm nights produce frost flowers.

I saw them this morning near Mound City, looking like gems in the sere litter. The frost flowers were white rosettes more fragile than eggshells. They would last just a few hours before sunlight touched them. I eagerly studied their crystalline forms, knowing it might be years before I saw them again.

Frost flowers arise only a few days each fall. Temperature is the key. The ground must be unfrozen, while the air temperature plummets. This sets the stage for a final plant performance in November or December.

White crownbeard is the star of this production. The tall weed, scattered across much of far eastern Kansas, is obscure in summer. Its small, white flowers are scarcely noticed in their woodland settings. But sudden cold distinguishes crownbeard. Freezing causes heavy sap to expand and squeeze through cracks in the plant base. On contact with frigid air, ice petals develop. These curl and twist into exquisite patterns as the sap continues to push outward. Dawn reveals gardens of these small ice sculptures where crownbeard colonies grow.

Frost flowers are among Kansas' best natural secrets. When the mercury drops, their ethereal beauty marks a special overlook on the pathway through fall.

Incoming
December 6

Leaves were gone, and the onset of winter was now apparent.

A big, rising moon was nearly full. Late sunlight gave it a golden glow. You could tell the time of year by the moon's position on the northeastern horizon. In winter, the moon rides the northern sky, while the sun is far south. In summer, these tracks are reversed. The moonrise said *December*.

Geese were in the air. This time of year, thousands converge on local waters, and afternoon is shuttle time between water and grain fields. Ragged skeins dotted the sky, and the waxing moon made a beautiful backdrop to the constant activity.

Far away, river geese were taking flight. These birds, whose temporary homes were marshes near the Ninnescah, headed west to feed in milo fields. Drought had resulted in crop failures, and a few fields lay unharvested. This daily trek brought geese on a predictable route. Now the moon would provide a special opportunity.

It was a waiting game. Approaching flights crossed the eastern sky, some high, some low. I watched them for several miles, tracking them through the blue expanse with a telephoto lens. I hoped that some would cross the face of the moon. The late afternoon was pleasant, and I soaked up the goodness of the cool, late fall. Sounds of the geese added ambience.

Finally, it happened. A single family of Canadas, little more than a speck in the far distance, approached the glowing orb. As if scripted, the birds flew a perfect track until silhouetted against the moon—an idyllic end to a December day.

Cold Arrives
December 8

This morning's record low of 4 below zero is unheard of in a Kansas fall. It's brutal. Frigid air is hard on everything, especially when it comes after mild weather. You can count on plant damage. New growth caused by late summer rains wasn't hardened yet for a deep freeze. Invertebrates and cold-blooded animals poorly sheltered after autumn's recent warm spell no doubt froze. This weather surprise is costly.

The sun rises on a bitter calm, and snow glistens pink. Wildlife will be out in force today, seeking extra food to help keep warm.

Tomorrow, the white blanket will tell a story. Tracks will show how animals came and went. Following them might reveal a bobcat's den or a deer's bed. They'll show where a bobwhite covey slept, or maybe the tree where a raccoon lives.

Today, we'll reacquaint with winter birds. They'll spend the afternoon on sunny sides of food plants like cedars or hawthorns. They'll stay put there, making them easier to identify and study. If our feeders are up and running, we're in for a show. A congregation will camp on the high-energy seeds largely ignored just a few days ago. The cold will offer a wildlife review in front of our warm windows.

Ready or not, winter has arrived with this storm. Impolitely, it broke into line, but it's all just part of a Kansas year.

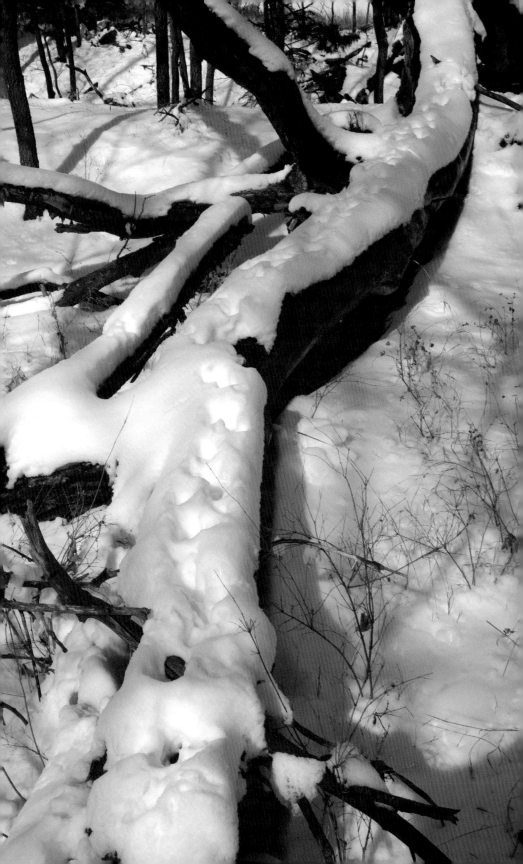

Sunset
December 11

I saw it coming early. The sky had a certain look—waves of ragged
clouds advancing slowly. It was a mackerel sky, so named for
its similarity to the scale pattern on a fish. The clouds indicated
moisture, and the broken pattern suggested trouble in the middle
atmosphere. But near the ground, the air was calm and dry.
Chances were, we'd miss a snow.

It was a rare sky, full of promise. Broken, repeating patterns like

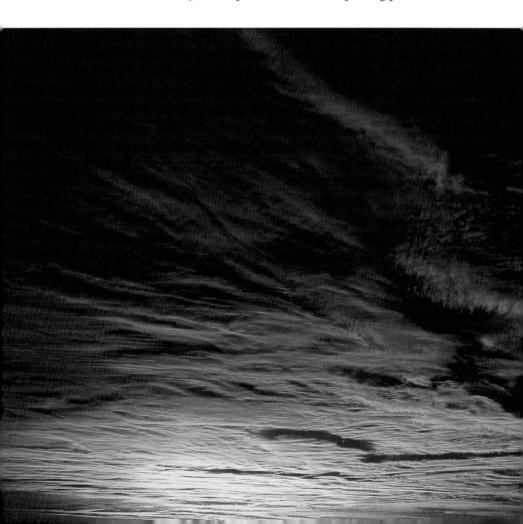

this would allow late sunlight to shine through and reflect off of hanging vapors. Flattened across half a sky, there was a chance for the cloud mass to create a spectacular sunset. I'd seen it in winters past. Not often, but enough to cross my fingers.

Kansas is famous for its sunsets. This is due mostly to open vistas that showcase the sky. Many kinds of sunsets are considered beautiful, but I've witnessed only a few that were truly awe-

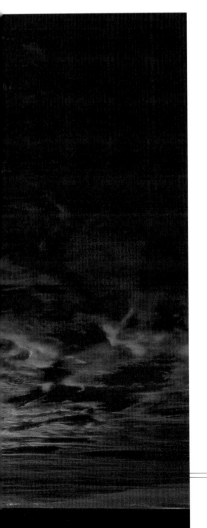

inspiring. All of them came from skies like this, where low light angled up from underneath. Caught in webs of dangling moisture, sunset's red light is breathtaking.

An hour passed as I watched for the clouds to fall apart. That's the catch: checkered clouds must appear at just the right place and time. Solid blankets seldom allow openings through which evening sunlight can perform magic.

But this was such a night. The cloud bank did thicken for several hours, but even so, it opened that rare window. With half a sun behind the horizon, the sky caught fire. Color deepened as the sun set, and sky intensity rose and fell in less than a minute. The world turned orange in reflected light.

The gift was extraordinary as a day and year faded.

Finding Food
December 15

Evening sunlight filtered through barren limbs. Everywhere, birds and squirrels foraged busily in the cool December air. I watched a red-bellied woodpecker hitch its way up a walnut tree, and then a flash of red caught my eye. A male house finch settled on a nearby ash twig and went to work. So engaged was the bird that he never saw me just a few feet away.

House finches are sparrow-sized birds with heavy beaks suited for cracking seeds. The slender green ash seeds were no problem for this bird's powerful mandibles, and I watched as the finch expertly chewed each germ from its winged structure. He reminded me of a human sunflower seed junkie: the kind who can crack and sort seed after seed with teeth and tongue, never taking eyes off the ballgame. The bird stretched through all kinds of contortions to reach nearby seeds from his perch. He stayed for several minutes, making a supper of the plentiful mast. Then he moved on.

It was a common event for him, but a rare observation for me. Momentarily, the finch let down his guard to enjoy a meal. Such moments may put him on the menu of a lurking Cooper's hawk one day, but not this time. It was all good, and he went to roost with a full crop. I became a little more familiar with the pathway of December.

Fireside
December 19

December's long nights are made for a fire. Six o'clock darkness means early supper and the welcome glow of a wood-burning stove. It's an earned luxury; somewhere back there, a truck and chainsaw were part of this deal. Sweat then means comfort now.

Life's creatures understand such preparation. There's a time to gather nuts and a time to eat; a time to lay up wood and a time to burn it. Provision makes for good living. Cold December nights promise holidays and family visits soon to come. A crackling fire is the perfect aura for such anticipations.

I add another log. The split ash catches fire at once. Ash is my favorite, a hard wood that dries suitably in less than a year and

burns hot. In a pinch, you can burn it green. Cut and split in early summer, ash is firewood fit for December. Tonight, it's just right—toasty warm, with hours to go until bedtime.

TV? No. It's not Monday night, so there's no football. A good book or magazine? Maybe. But you know what? I think I'll tie some flies. That might be just right on a fireplace kind of evening . . . especially when trout are biting at the trout pond.

Snowy Owl
December 22

Light fades as dusk approaches. The snowy landscape goes gray. The truck's heater feels good after my long day in the wind and cold. Christmas music plays on the radio, providing warmth of its own.

I see a large white bird along the road. On a fence post, it huddles against the cold wind. I recognize the snowy owl, a rare visitor from the arctic north.

These winged hunters are unmistakable. Juveniles and females are white marked with black, but the males are nearly pure white. Snowy owls are camouflaged for an icy world and able to stand extreme cold. But sometimes, lack of winter food drives them south. Only rarely do they make it this far; sometimes, it's years between Kansas sightings.

Snowy owls feed chiefly on lemmings. These small northern rodents fluctuate on roughly a four-year cycle. When lemmings are scarce, the white owls fly south for winter. A few of them may reach Pratt County. But it's always a special visit.

I pull over on the vacant road. Snowy owls are tame and tolerant of mild intrusion. Poor light shows this bird in its normal gloomy world. Snowys, unlike most owls, will hunt by day. They feed on the same prairie foods that native owls might take.

We study each other for several minutes. The bird's golden eyes, remarkable when seen in sunlight, are nearly hidden in its feathered face. The snowy owl sits patiently and scarcely moves. Then, it is off and flying, gliding low over the dusky field.

Seeing it is a rare gift . . . and a certain sign that winter has arrived.

Night Sky
December 27

My hometown is ten minutes from a dark sky. Out here in prairie country, long distances separate rural houses. That means it's a long way between lights. This advantage is an open window to one of Kansas' best natural secrets—the night sky. A beauteous place of discovery, the sparkling dome overhead is at its best in the dead of winter.

A telescope isn't necessary. Oh, it's fun to peer through an eyepiece and see Jupiter's moons or Saturn's rings. Most small telescopes will provide that look. But try it without a tracking motor, and the planets fly through the viewfinder with amazing speed. The whole universe is in motion, and that is apparent through a high-powered lens.

I set up a tracking telescope now and then. But mostly on a December night, I gaze through binoculars. High pressure and a dry, stable atmosphere offer a perfect look at the stars and planets. Binoculars have a wide field of view that takes in whole constellations. These are the star-geometries mapped on charts, and starting out, they're the best way to learn about the cosmos. While looking, I place a camera on a tripod and point it at the heavens. Earth's movement creates curved star trails that vary in color according to the stars themselves.

Constellations move through the heavens as the seasons change. The night sky is a natural calendar. Tonight, I look at Orion and its fuzzy nebula, M42, birthplace of stars. Also called The Hunter, this constellation is easy to find. Just above the horizon at 8 p.m. in the southeastern sky, it pinpoints Earth's journey at year's end.

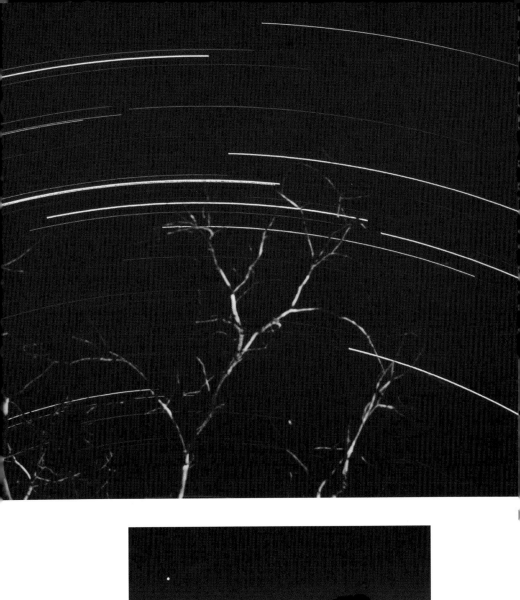

Winter Sleep
December 30

The timber's main game trail was deserted this morning. I walked along it like so many times before, but it felt different this time. A month ago, the trail was alive with traffic as deer and turkeys moved through the woods. Coyotes and bobcats took the common route, shadowing prey and keeping tabs on the trail activity. November's cool days catalyzed wildlife movement.

But now it was winter. Wind in the treetops caused a hollow roar, and it was cold. The naked land brought a bleak outlook to the day. Gray clouds added to the dour feeling. There was a sense of hard days ahead.

Something by the river caught my eye. An antler tip protruded from the ground litter. I walked over and found the scattered remains of a buck. The antlers weren't large, but were those of an older animal. The backbone and shoulder blades, gnawed clean, were strewn nearby. A pile of hair marked the deer's final resting place. Scavengers had scattered the bones. Already, time was covering the offal.

Nothing cared. The deer, like everything living, had come to an end. It would fade and disappear, not even a memory in the scheme of the natural world. Others would take its place, and they, too, would pass away.

Walking out of December, I saw the depth of it. Lives come and go, but life remains. Years come and go, but

time remains. Another year would soon expire, but order would continue. One day, I, too, would return to the One who made me.

I looked at the swaying treetops against gray clouds and listened to the rushing wind. For a moment, I saw the year again, a place where things changed, even while they stayed the same. The earth had traveled a great circle in its orbit. The seasons had traveled a great circle in their year.

And I stooped and grasped the old buck's skull, walking on to some distant place where the path would end for me.

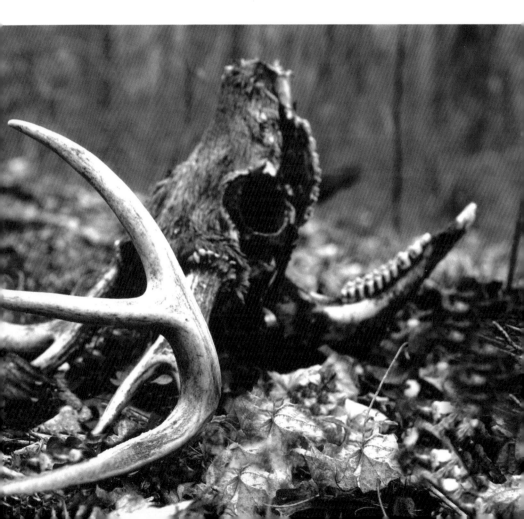